Impressionism *and* Post-Impressionism

IN THE ART INSTITUTE OF CHICAGO

Impressionism

and Post-Impressionism

IN THE ART INSTITUTE OF CHICAGO

SELECTED BY

James N. Wood, Director and President

THE ART INSTITUTE OF CHICAGO

Distributed by Hudson Hills Press, Inc.

Contributors

John Goodman: 15, 16, 17, 20, 21, 22, 23, 24, 29, 30, 31, 34, 40, 46, 56, 62, 77, 78–79, 80, 112, 113, 114, 115, 116, 117, 118, 119, 121, 126, 136, 137, 138, 139, 145, 146, 147, 148, 149

Adam Jolles: 26, 27, 36, 44, 50, 55, 59, 63, 66, 69, 86, 87, 98, 99, 122, 142, 143, 144, 151, 160, 161, 162

Paula R. Lupkin: 85, 90, 91, 92, 93, 94, 95, 106, 107

Debra N. Mancoff: 14, 19, 25, 35, 38, 47, 58, 68, 70, 84, 88, 89, 96, 97, 100, 101, 102, 103, 104, 105, 108, 120, 128, 129, 150

Britt Salvesen: 18, 28, 32, 33, 37, 39, 45, 48, 49, 51, 52, 53, 54, 57, 60, 61, 64, 65, 67, 71, 72, 73, 74, 75, 76, 123, 124, 125, 127, 130, 131, 132–133, 134–135, 140, 141, 152, 153, 154, 155, 156, 157, 158, 159, 163, 164, 165, 166

Produced by the Publications Department, The Art Institute of Chicago, Susan F. Rossen, Executive Director

Edited by Britt Salvesen, with Laura Kozitka and Susan F. Rossen

Production by Sarah E. Guernsey, Associate Production Manager, assisted by Stacey A. Hendricks

Designed and typeset by Joan Sommers Design, Chicago

Printed and bound by Mondadori Printing, S.p.A., Verona, Italy

Color separations by Professional Graphics, Rockford, Illinois

Photography by the Imaging Department, Alan B. Newman, Executive Director, with the following exceptions: pp. 70, 143, 154, 164

First Edition
09 08 07 06 05 04 03 02 01 00

Published by The Art Institute of Chicago, 111 South Michigan Avenue, Chicago, Illinois, 60603-6110

Distributed by Hudson Hills Press, Inc., 122 East 25th Street, 5th Floor, New York, New York 10010-2936
Editor and publisher: Paul Anbinder
Distributed in the United States, its territories and possessions, and Canada through National Book Network. Distributed in the United Kingdom, Eire, and Europe through Art Books International Ltd.

Library of Congress Card Number: 99-067929

ISBN 0-86559-176-8

Frontispiece: Claude Monet, *Water Lilies* (detail), 1906 (p. 163)

Contents

Acknowledgments

Initial support for this book came from many quarters: the curatorial departments, the Department of Museum Education, the Museum Shop, the Publications Department, and—most importantly—from our visitors, who consistently expressed their desire for a book featuring high-quality reproductions and informative texts on the Impressionist and Post-Impressionist works that they enjoy viewing in our galleries.

We are grateful for the participation of the curators who helped us to select the works included here and who reviewed the entry texts: Judith A. Barter, Field-McCormick Curator of American Arts; Stephanie D'Alessandro, Andrew W. Mellon Postdoctoral Curatorial Fellow in the Department of Twentieth-Century Painting and Sculpture; Douglas W. Druick, Searle Curator of European Painting and Prince Trust Curator of Prints and Drawings; Gloria Groom, David and Mary Winton Green Curator in the Department of European Painting; Daniel Schulman, Curator of Twentieth-Century Painting and Sculpture; Martha Tedeschi, Curator of Prints and Drawings; Andrew W. Walker, Assistant Curator of American Arts; and Ian Wardropper, Eloise W. Martin Curator of European Decorative Arts and Sculpture, and Ancient Art. For additional review of the entries, we thank Jane H. Clarke, Associate Director, Department of Museum Education. We would also like to thank Teri J. Edelstein, former Deputy Director, who helped shape the final selection of the works featured here.

We wish to extend our thanks to the enthusiastic team of authors who provided the texts that accompany the illustrations: John Goodman, Adam Jolles, Paula R. Lupkin, Debra N. Mancoff, and Britt Salvesen. Their words remind us that even the most familiar of images reward further contemplation.

The task of organizing, editing, and preparing the text for this book belonged to Britt Salvesen, Associate Editor; Laura Kozitka, Editorial Assistant; and Susan F. Rossen, Executive Director of Publications. Associate Production Manager Sarah E. Guernsey was responsible for its production, with the able assistance of Stacey A. Hendricks. The elegant design is by Joan Sommers, Chicago. Photography was provided by the Art Institute's Department of Imaging, Alan Newman, Executive Director; special thanks are due to Iris Wong and Sydney Orr of that department.

James N. Wood, DIRECTOR AND PRESIDENT

Introduction

"Do you really need so many paintings for America?" Claude Monet asked his dealer, Paul Durand-Ruel, in January 1886. The timing of his query is important. At this moment, Monet and Impressionist colleagues such as Mary Cassatt, Edgar Degas, Berthe Morisot, Camille Pissarro, and Pierre Auguste Renoir were at the height of their careers. In little more than a dozen years, they had successfully challenged existing art-world institutions and modes of patronage, while promoting an aesthetic of contingency, immediacy, and self-conscious modernity in opposition to academic conventions of monumentality, historicism, and classicism. Having accomplished their initial goals, the core members of the Impressionist group, who had met in the mid-1860s and exhibited together between 1874 and 1886, were beginning to move in their own individual directions. Their legacy could already be seen in the work of their immediate successors, the Neo-Impressionists (see pp. 78–79) and the disparate group of painters who are collectively described as Post-Impressionists (see pp. 110–11). Thus, Monet's anxiety that North American patrons might whisk his best canvases away from France reflects the unprecedented international impact of the Impressionist movement, and highlights the fact that this occurred while most of the style's first proponents were still actively working.

Impressionism was the first art that addressed modernity as such—with all the social and political upheavals, and the material and industrial advances of contemporary life—rather than evoking the past or portraying timeless idylls. The "new painting" (to use the phrase of French critic Edmond Duranty, an early supporter of the Impressionists) found a receptive audience in the United States, a nation barely as old as Europe's art academies, perhaps in part because Impressionism celebrates the present, nature, and novelty. Thanks to a prescient group of connoisseurs, The Art Institute of Chicago boasts one of the world's finest, most comprehensive collections of Impressionist and Post-Impressionist paintings, prints, and drawings. While the works that now hang in the museum's galleries provide an aesthetic history of the origins and evolution of modern art, the credit lines on the labels beside them offer a parallel history of patronage and philanthropy.

In the early 1860s, when Monet embarked upon the artistic experiments that would lead to Impressionism, Chicago and Paris were worlds apart. Within a decade, tragic occurrences would alter this situation. In 1871 Paris was devastated by the Franco-Prussian War and subsequent civil uprisings; that same year, Chicago was destroyed by the Great Fire. After these catastrophes, both cities rebuilt themselves and, in the process, redefined their identities. Chicago was to become a "Paris on the Prairie," according to architect Daniel Burnham, who modeled his famous "Plan of Chicago," published in 1909, on Baron Georges Haussmann's radical transformation of the French capital's streets and buildings between 1854 and 1870. Both men established templates for the great cities we know today.

Commerce and industry prospered in Chicago during the decades following the fire, and citizens began to recognize a lack of cultural institutions. Various groups formed to address this need: the Chicago Society of Decorative Art, founded in 1877, aimed to foster artistic taste and training, especially for artisans; the Chicago Academy of Fine Arts, established two years later, planned to offer classes in art and design and to display a permanent fine-arts collection to the public. The civic leaders involved in these ventures soon became aware of the advantages of consolidation. In 1882 the Academy changed its name to The Art Institute of Chicago, and the Society became one of its important affiliates, the Antiquarian Society. Deliberately designated an "institute" rather than a "museum," the Art Institute declared its responsibility to provide practical as well as aesthetic instruction, thereby linking commerce and culture. The first director, William M. R. French (brother of noted American sculptor Daniel Chester French), had a daunting task ahead of him.

Supported by a group of trustees who represented industrial and trade empires, French embarked on the expansion of a collection that, to this point, consisted primarily of plaster casts of Greek and Roman, Renaissance, and modern sculpture and architectural elements. With the help of Art Institute President Charles L. Hutchinson and others, the museum acquired some Old Master paintings. In March 1889,

French and Hutchinson went to Paris to attend the spectacular 1889 Exposition universelle, the highlight of which was Gustave Eiffel's monumental iron tower. They intended to evaluate the fair in view of the forthcoming World's Columbian Exposition in Chicago; at the same time, they went shopping for recent works for the Art Institute. French and Hutchinson, like many serious American connoisseurs of the late nineteenth century, were both civically progressive and aesthetically conservative. For example French admired the popular, but essentially academic, work of artists such as Jules Breton, whose technically polished, figurative paintings focus on picturesque, nonindustrial conditions. (The Art Institute's first major bequest, the Henry Field Collection, given in 1894, featured just such works.) Although French visited Durand-Ruel's galleries in Paris, he did not comment upon Impressionism in his notes.

American artists, meanwhile, also looked to Paris, many with eyes fully open to avant-garde painting. One can readily imagine the appeal of Impressionism to adventurous, ambitious Americans. With limited opportunities to examine art in their native country, those who could afford it traveled to Europe. James McNeill Whistler for example left the United States for France in the 1850s, immediately entered avant-garde circles, and remained abroad for the rest of his life, earning international fame. Whistler was followed by many others, some of whom went with the intention of studying the Old Masters and ended up being captivated by the new ones: Cassatt settled permanently in Paris in 1874, becoming a central member of the Impressionist group and a critical contact between her colleagues and American collectors of their works. In the mid-1880s, Theodore Robinson and a number of other American artists established a thriving colony at Giverny, where they absorbed the influence of the village's most famous resident, Monet.

By the final decades of the nineteenth century, Impressionist innovations had irrevocably altered the Paris art scene. The attempt—initiated by Degas, Monet, Morisot, Pissarro, Renoir, and others in 1874—to establish an alternative exhibition venue to the official Salon had been successful: the eight Impressionist shows held between 1874 and 1886 set a precedent for other artist-controlled ventures, such as Les Vingt (The Twenty), founded in 1883 in Brussels, and the Salon des indépendants, established in 1884 in Paris. Commercial dealers including Durand-Ruel, Boussod & Valadon, Georges Petit, and Ambroise Vollard actively marketed contemporary art. Thus, Impressionist painting, although it did not immediately find its way into museums and official, government-sponsored Salons, was public, in a new way. Displayed in metropolitan galleries and sold to members of the emergent middle class, this art not only depicted modern life but became part of it.

Paul Durand-Ruel, the pioneering art dealer most closely associated with Impressionism, was an astute observer of the European art market. In the early years of the movement, he hedged his bets by stocking canvases by established, reliable artists such as Camille Corot, Jean François Millet, and members of the Barbizon School alongside those of the maverick Impressionists. This allowed him to stay in business during an extended economic recession that crippled the French art market for most of the 1880s. In considering the American scene during this period, Durand-Ruel took a calculated risk. Just as the eighth and last Impressionist exhibition was held in Paris, the dealer opened a massive and generally well-received exhibition, "Works in Oil and Pastel by the Impressionists of Paris," at the American Art Galleries in New York City. The show included some three hundred pictures: forty-eight works by Monet, forty-two by Pissarro, thirty-eight by Renoir, twenty-three by Degas, seventeen by Edouard Manet, and fifteen by Alfred Sisley, as well as paintings by Eugène Boudin, Gustave Caillebotte, Armand Guillaumin, Morisot, and others.

Durand-Ruel's exhibition attracted new patrons, to be sure; but it is also important to note that some of the works on display were lent by Americans who had already begun to assemble important collections at an earlier date, such as Alexander Cassatt (brother of Mary Cassatt) and Louisine Havemeyer (Cassatt's close friend). These East Coast connoisseurs would soon be joined—and even rivaled—by a handful of remarkable Chicagoans who were determined to bring modern art to their midwestern city.

Chicago hosted the World's Columbian Exposition in 1893, an occasion that prompted the construction of a new, Beaux-Arts-style building (designed by the Boston firm Shepley, Rutan and Coolidge) for the Art Institute on city-owned park land in the heart of downtown. This structure's conservative style constituted a rejection of recent European engineering and aesthetics, represented by the Eiffel Tower; similarly, the exposition jury rejected Impressionist paintings, and most of the American art on display followed academic models. However, a ground-breaking special exhibition featured nineteenth-century European paintings that looked forward rather than back. The "Loan Collection of Foreign Masterpieces Owned in the United States," which included works by all the major Impressionists, was assembled by Bertha Honoré Palmer, wife of Chicago real-estate magnate Potter Palmer and chair of the fair's Board of Lady Managers, assisted by Paris-based art consultant Sara Tyson Hallowell.

The importance of the World's Columbian Exposition in the Art Institute's history cannot be exaggerated. Individuals who were already associated with the museum were motivated to collect art seriously or to do so more adventurously. The aim, held since the 1870s, to make Chicago a world-renowned cultural center, a rival to older cities

such as New York and Boston, and even to European capitals such as London and Paris, finally crystallized.

It was Hallowell who, in the late 1880s, first introduced Mrs. Palmer to Impressionism. The Palmers already owned important works by established artists Corot (see p. 34), Charles François Daubigny, and Eugène Delacroix; they bought their first pastel by Degas in 1889, and in 1892 they purchased a set of Cassatt's innovative color prints (see pp. 128–29). From this time on, the Palmers focused exclusively on contemporary art. Mrs. Palmer acquired astonishing numbers of paintings on trips to Paris and New York between 1888 and 1895. Before the century came to a close, the Palmers had purchased nearly one hundred paintings by Monet, whom they met in May 1892.

Mrs. Palmer not only observed Impressionist painting in evolution through her personal connections with artists, she also came to influence its history by means of her patronage. Concentrating on the individual artists whose work had initially appealed to her (she did not take up the Post-Impressionists), she considered her purchases carefully and watched the market vigilantly so as to assemble representative examples. Particularly noteworthy is the group of nine *Stacks of Wheat* paintings by Monet that she purchased on the occasion of their first exhibition, held by Durand-Ruel in Paris in 1891. Clearly, she understood the artist's intention that the serially produced canvases be seen together; three of her *Stacks of Wheat* (see p. 134) are among the six that hang today in the Art Institute. Mrs. Palmer also enjoyed the work of Renoir, favoring especially the canvases of his classic Impressionist period, as exemplified by *Lunch at the Restaurant Fournaise (The Rowers' Lunch)* (p. 45) and *Acrobats at the Cirque Fernando (Francisca and Angelina Wartenberg)* (p. 57). Mrs. Palmer loved the second work so much that it accompanied her on her extensive travels.

A different Renoir painting had pride of place in the home of another prominent Chicago collector: Martin A. Ryerson's wife installed *Woman at the Piano* (p. 52) above her own piano. Ryerson, one of the Art Institute's founding trustees and perhaps its single most important donor, took a different approach to collecting than did the Palmers. Adopting the museum's mission to represent art from all periods and styles as his own, Ryerson acquired important works by Old Masters and examples of textiles, decorative arts, and works on paper. After the World's Columbian Exposition, he energetically pursued late works by Monet. Visiting the artist at Giverny in 1920, Ryerson even attempted to purchase his magisterial water-lily murals, although Monet gave these compositions to the French government (they are now housed at the Orangerie, in Paris). Ryerson's Monets eventually numbered thirteen, ranging from *The Artist's House at Argenteuil* (p. 39), painted in 1874, to the quasi-abstract 1906 *Water Lilies* (p. 163).

The Palmers and the Ryersons willingly loaned items from their collections to the Art Institute during their lifetimes. In the 1920s and 1930s, their generous bequests entered the museum permanently: the Palmer Bequest was accessioned in 1922, and the Ryerson Collection was given in 1933. Also in 1933 the museum received the Mr. and Mrs. Lewis Larned Coburn Collection, with such outstanding Impressionist and Post-Impressionist paintings as Renoir's *Two Sisters (On the Terrace)* (p. 71), Degas's *Uncle and Niece (Henri Degas and His Niece Lucie Degas)* (p. 53) and *The Millinery Shop* (p. 72), Manet's *Woman Reading* (p. 56), Paul Gauguin's *Arlesiennes (Mistral)* (p. 117), and Monet's *Water Lily Garden* (p. 159). Prints and drawings by these and other artists came to the museum as well, many at the initiative of pioneering curators Carl Schniewind and Harold Joachim.

While the Art Institute's important collections of largely European works were being formed by Chicagoans, living American artists were not neglected. Somewhat cautiously, director William M. R. French had invited the progressive Society of American Artists to exhibit at the Art Institute in 1890. This perhaps helped pave the way for the museum's trustees to make some adventurous acquisitions. The Friends of American Art, founded in 1910 with the goal of purchasing work by living American artists, led the way. Among the paintings acquired by this group—whose members numbered approximately 175—are John Henry Twachtman's *Icebound* (p. 92), John Singer Sargent's *Fountain, Villa Torlonia, Frascati, Italy* (p. 101), George Bellows's *Love of Winter* (p. 108) and William Glackens's *At Mouquin's* (p. 107). Ryerson too was an important collector of contemporary American art; his 1933 bequest included Winslow Homer's *Herring Net* (p. 88), which had been shown at the World's Columbian Exposition, and Twachtman's *White Bridge* (p. 94).

The Art Institute began to assemble its remarkable holdings of Post-Impressionist paintings and works on paper in the 1920s and 1930s, the very years when its Impressionist collection took shape through the bequests of the Palmers, Ryersons, Coburns, and others. Perhaps this makes sense, as some of the most important Post-Impressionists—Cézanne, Degas, Monet—were themselves initially Impressionists. Especially noteworthy is the Helen Birch Bartlett Memorial Collection, given to the museum in 1926 by trustee Frederic Clay Bartlett in memory of his second wife, a writer who had inspired his interest in art. The collection's highlight is Georges Seurat's Neo-Impressionist masterpiece, *A Sunday on La Grande Jatte—1884* (p. 79). (This extraordinary and enigmatic work continues to shape the museum's holdings; subsequently acquired preparatory drawings and studies [see pp. 78, 80] enhance our understanding of Seurat's technique and aims.) In addition to the *Grande Jatte*, the Birch Bartlett Memorial Collection includes such spectacular Post-Impressionist examples as Vincent van Gogh's *The Bedroom* (p. 118), Henri de Toulouse-Lautrec's

At the Moulin Rouge (p. 145), and Cézanne's *Basket of Apples* (p. 139). Originally displaying these paintings in a single room, the Art Institute became the first American museum to install a gallery of Post-Impressionist art, three years before the opening of The Museum of Modern Art in New York, in 1929.

Another gift from the 1920s that continues to shape the museum's collections of modern and contemporary art is the Joseph Winterbotham Collection. In 1921 Winterbotham, a Chicago businessman whose daughter Rue Winterbotham Carpenter led the pioneering Arts Club of Chicago from 1916 to 1931, donated $50,000 to be invested and used as capital "for the purchase of works of art painted by European artists of foreign subjects." The unique stipulation of the Winterbotham Plan is that the collection can only number thirty-five objects; once this number is reached, any painting can be sold or exchanged to acquire a work of superior quality or significance. This farsighted gift has brought the museum some of its most important Post-Impressionist works, including van Gogh's *Self-Portrait* (p. 113) and Gauguin's *Portrait of a Woman in Front of a Still Life by Cézanne* (p. 137).

Museum installation practices have changed greatly during the past century. From the time of the Art Institute's opening at its present site, in 1893, until the Century of Progress Exposition, in 1933–34, works were grouped according to their donors, regardless of stylistic considerations. The exposition provided director Robert B. Harshe with the opportunity to reinstall the galleries along chronological and geographic lines, to better display the depth and range of the collection and to convey a historical, cross-cultural survey of aesthetic achievement. Today, evidence of an expanding canon can be seen in the museum's nineteenth-century galleries, which embrace academic art and works on paper, as well as Impressionist paintings. By inventively installing its permanent collections, and by organizing and hosting temporary exhibitions that juxtapose these works with examples belonging to other museums and private individuals, Chicago continues to be a center for Impressionist and Post-Impressionist art and scholarship.

The Art Institute's collections of Impressionist and Post-Impressionist art have been published in many formats: exhibition catalogues, popular guidebooks, journal articles, and so on. Of particular note are the books *French Salon Artists*, *French Impressionists*, and *Post-Impressionists*, written in 1984 by Richard R. Brettell, former Searle Curator of European Painting. As these volumes are now out of print, the time seems right for a new publication featuring the museum's remarkable holdings of nineteenth-century art. *Impressionism and Post-Impressionism in The Art Institute of Chicago* has several interrelated aims. First, it presents in glorious color masterworks that are beloved the world over—paintings such as Renoir's *Two Sisters* and Seurat's *Grande Jatte*, which people travel to Chicago expressly to see. Second, although subject to the inevitable limitations of space, this book reveals lesser-known objects (by artists such as Armand Guillaumin, p. 44; Eva Gonzalès, p. 68; and Antonio Mancini, p. 87), new acquisitions (Gauguin's sculpture *The Faun*, p. 115; and works from the recent Millennium Gift of Sara Lee Corporation, pp. 70, 143, 154, 164), and items that cannot be displayed on a regular basis due to conservation considerations (Whistler's *Green and Blue: The Dancer*, p. 140; and Edvard Munch's *Sin*, p. 160). Third, we hope to expand the reader's understanding of what constitutes Impressionism. The inclusion of objects by artists working outside France for example allows a thread of influence to be traced between the Dutch painter of seascapes Johan Barthold Jongkind (see p. 20) and the young Monet (see p. 32); Monet in turn passed lessons along to American Theodore Robinson (see p. 85), whose own paintings and publications disseminated the French master's art in the United States. Moreover, the present volume incorporates sculpture, prints, pastels, and watercolors alongside oil paintings, facilitating an appreciation of the full technical achievements of artists such as Degas and Whistler, who worked with great versatility in various media.

In 1874, when Monet entitled a painting *Impression—Sunrise* (1872–73; Paris, Musée Marmottan) and exhibited it with works by the group who subsequently came to be known as Impressionists, he initiated a revolution in art. The word "impression" has several definitions. Most literally, an "impression" is a physical mark resulting from contact between two material substances—for example an engraving tool produces an impression in the surface of a copper plate. More figuratively, an "impression" may be made upon the feelings, senses, or mind—we speak of "first impressions" or "an impressionable child." These connotations suggest to us that the nature (and appeal) of Impressionism is more complicated than it might first seem: impressions engage both the mind and the senses; they are objective and subjective; they can be either marked or indistinct; they may work instantly or over time; they may be original ideas or theatrical imitations. This is why Impressionist and Post-Impressionist paintings reward many kinds of looking, from appreciative glance to sustained contemplation. Certainly, the work of Monet and his colleagues and successors impressed Bertha Honoré Palmer, Martin A. Ryerson, and other pioneering Chicago connoisseurs. The collection they helped initiate continues to have a profound effect on countless visitors to the Art Institute.

James N. Wood, DIRECTOR AND PRESIDENT

Before Impressionism

New Approaches to Landscape and Figure Painting, 1830–1870s

Impressionism emerged in nineteenth-century France against a background of Romanticism and Realism. Both of these movements challenged the traditional subjects and style promoted by fine-art academies and displayed at the state-sponsored, annual Salons. Some artists abandoned large-scale, idealized history painting—which encompassed mythological, religious, and historical themes—and instead took up landscape, still life, and scenes of everyday life, genres that the academies ranked low. In addition, rather than striving to meet conventional standards of even tonality and smooth finish, they used brighter colors and looser brushwork to reflect their direct observations of nature.

Romanticism, a pictorial and literary aesthetic that emerged in the mideighteenth century, emphasized the freedom to express emotion and experience. Although some of the best-known Romantic painters, such as Eugène Delacroix, became known for narrative figure paintings, others dedicated themselves to nature—real, ordinary countryside unmarked by industrialization and undistinguished by dramatic features. In the 1830s, oil paint newly available in tubes, as well as recently established railway connections, allowed painters to make small-scale oil studies outdoors (*en plein air*), in forests and fields, which they took back to their studios and used as references for larger, more carefully finished canvases. These landscapists—including Narcisse Diaz de la Peña, Jules Dupré, Théodore Rousseau, and others—became known as the Barbizon School, because they worked

together in and around the village of that name, southeast of Paris. The Impressionists were to be profoundly influenced by their immediate predecessors' sketch techniques and dedication to uncorrupted nature; beginning in the 1860s, Claude Monet and his colleagues altered the status of the "sketch" so that it was considered a finished work on its own terms, a document of an individual's perception of nature at a particular moment in time.

Realism arose in the 1840s and 1850s, drawing upon the truth-seeking spirit and emotional honesty of Romanticism while also taking into account current scientific advancements and political upheavals. Gustave Courbet, a primary spokesman for Realism, deliberately addressed common subjects and employed rudimentary tools such as a palette knife. Courbet's more urbane colleague Edouard Manet outraged critics by radically updating traditional art-historical subjects with bold, flat brushwork. Among Manet's admirers were Frédéric Bazille, Edgar Degas, Henri Fantin-Latour, Monet, Camille Pissarro, Pierre Auguste Renoir, and James McNeill Whistler; these avant-garde artists sought to capture the changing world around them in a new pictorial language, one they could not learn in academies but had to invent on the spot and adjust to accommodate fleeting effects of weather, light, and movement. As the critic Théodore Duret later recalled, their meetings at Parisian cafés gave rise to "the powerful development of art that was to go by the name of Impressionism."

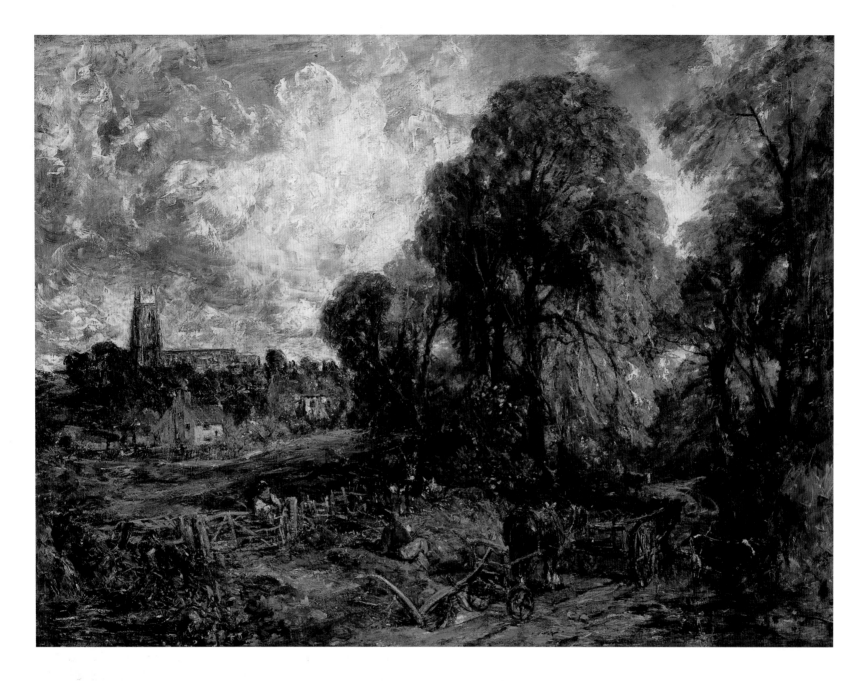

John Constable
English; 1776–1837

Stoke-by-Nayland, 1836
Oil on canvas
126 x 169 cm (49⅝ x 66½ in.)
Mr. and Mrs. W. W. Kimball Collection, 1922.4453

John Constable once reflected that his childhood rambles along the banks of the Stour River, near his native village of East Bergholt, Suffolk, had made him a painter. *Stoke-by-Nayland*, which dates from late in Constable's life, depicts a town located several miles north of his boyhood home. Rather than burnishing the scene with romantic or nostalgic sentiment, the artist portrayed a modest farmstead on the edge of a dense wood with the honesty of keen but appreciative observation, revealing that his original inspiration was undiminished by time or familiarity.

With its loose brush strokes and rough, thickly painted surface, *Stoke-by-Nayland* is a full-scale sketch. Although there is no evidence that Constable began a subsequent version of this subject, he typically used such studies to test atmospheric effects that later appeared in more finished works painted for public presentation in exhibitions. The artist allowed himself a freedom of execution that effectively captures his sensory response to a specific place at a particular time of day. He described the subject in a letter to his friend the amateur painter William Purton: "What say you to a summer morning? July or August, at eight or nine o'clock, after a slight shower during the night."

Constable sketched in oil out-of-doors as early as 1814. The glimmer of dew on the foliage in *Stoke-by-Nayland*, as well as the swiftly moving clouds in the sky, convey the freshness of execution associated with *plein-air* painting. His natural landscapes, first exhibited in Paris in 1824, were widely admired by French artists, and his work served as an important precedent for Impressionism.

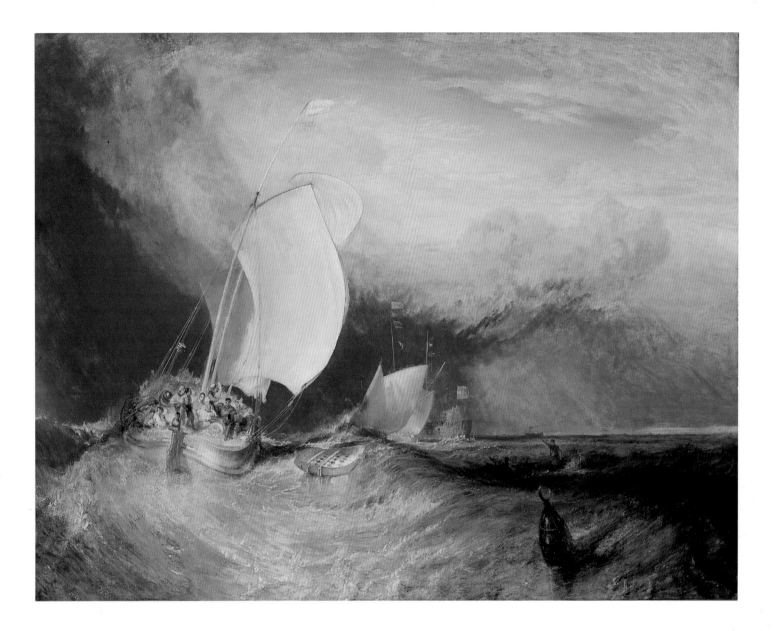

Joseph Mallord William Turner

English; 1775–1851

Fishing Boats with Hucksters Bargaining for Fish, 1837/38
Oil on canvas
174.5 x 224.9 cm (68¹⁄₁₆ x 88½ in.)
Mr. and Mrs. W. W. Kimball Collection, 1922.4472

Throughout his career, Joseph Mallord William Turner defied the Royal Academy's ingrained prejudice against landscape painting by producing ambitious canvases in this genre. Although he often treated academically sanctioned subjects drawn from history and mythology, even then he tended to emphasize ambient light and evocative setting over narrative elements. Thus, it is not sur-

prising that marine painting, with its vast prospects and shifting forms, proved an ideal vehicle for his gifts.

In *Fishing Boats with Hucksters Bargaining for Fish*, Turner deftly negotiated the conflicting dictates of tradition and innovation. The work shows a number of vessels plying a rough sea, most notably two fishing boats laden with a fresh catch in the foreground. At the right, a gesturing figure in a small rowboat—a commercial middleman—vies with the roar of the ocean to negotiate a purchase. The fishing boats' receding sails direct the viewer's eye toward two ships in the distance, emblems of the past and future of maritime technology: a majestic warship with towering stern under full sail and, barely visible on the horizon, a steamer trailing a plume of smoke.

In both subject and composition, the Art Institute's canvas is related to Turner's so-called *Edgewater Seapiece* (1801; private collection), a benchmark in his early career that had just been reexhibited. This suggests that the artist conceived the later work as a demonstration of the degree to which his work had evolved over the intervening years. Both paintings are indebted to seventeenth-century Dutch examples for features such as the low horizon line seen here, but *Fishing Boats with Hucksters* departs from these prototypes in its more audacious handling. The gold-tinged evanescence of the roiling waters, created through skillful manipulation of translucent and opaque pigments, points toward the experimental, increasingly abstract works of Turner's last years.

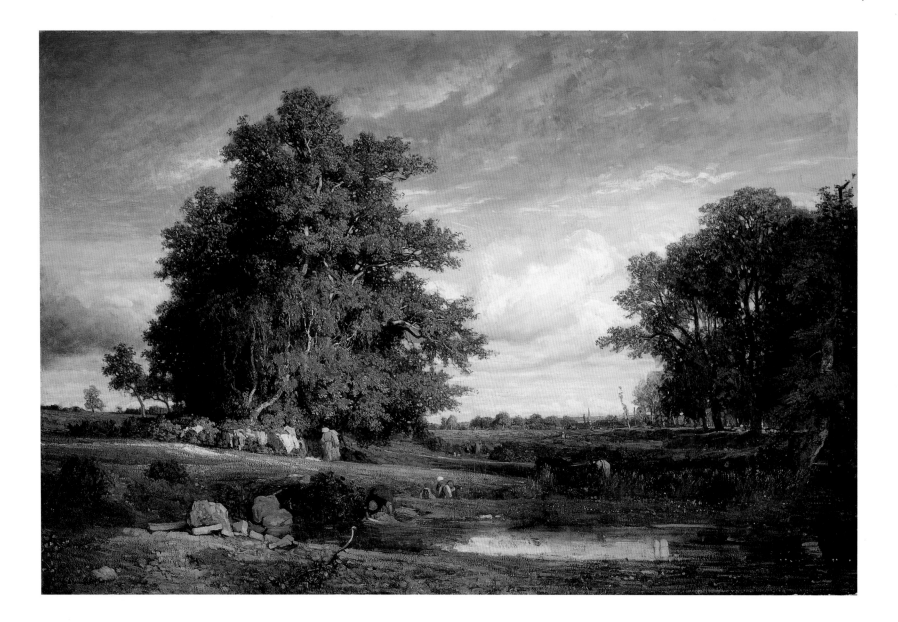

Constant Troyon
French; 1810–1865

The Marsh, 1840
Oil on canvas
93 x 140 cm (36½ x 55 in.)
Restricted gift of David and Mary Winton Green,
1996.649

Constant Troyon is best known for his relatively
conservative later works—rustic landscapes in the
seventeenth-century Dutch tradition, awash in
golden light and featuring domesticated animals—
but he began his career as something of an artistic
maverick. After a stint as a decorative painter at
the Sèvres Porcelain Manufactory, where his father
also worked, Troyon befriended Narcisse Diaz de

la Peña and Jules Dupré, members of the Barbizon
School (see pp. 12–13). Their back-to-nature aes-
thetic, influenced by Dutch landscape painters and
by the English artist John Constable (see p. 14),
shaped his vision. Beginning in the 1830s, he
sought out rural motifs in various regions of
France, including Normandy, Brittany, Touraine,
and Limousin. Troyon is first documented as
working in the Forest of Fontainebleau—the
Barbizon School's center of operations—in 1842
and 1843, but his penchant for large, thickly
painted depictions of untended scenery predates
those years, as *The Marsh* demonstrates.

Commanding in scale and vigorous in execu-
tion, the canvas shows several women doing their
wash in a shallow stream that meanders between

a sun-dappled plain and the edge of a forest, with
the church steeple of a distant town visible in
the distance. Troyon's deep affinity with other
Barbizon painters is apparent in his assertive
handling, notably the blocky brush strokes of the
boulders and the rough-textured impasto of the
foliage. Moreover, his overall approach to the sub-
ject privileges the unruly rhythms of nature over
the dictates of idealist convention. The vibrant
hues of the women's crimson blouses and of the
linens laid out to dry key up the picture's chro-
matic scale, a ploy later successfully used by
many of the Impressionists—for example Claude
Monet, who sought Troyon's advice when he first
arrived in Paris, in 1859.

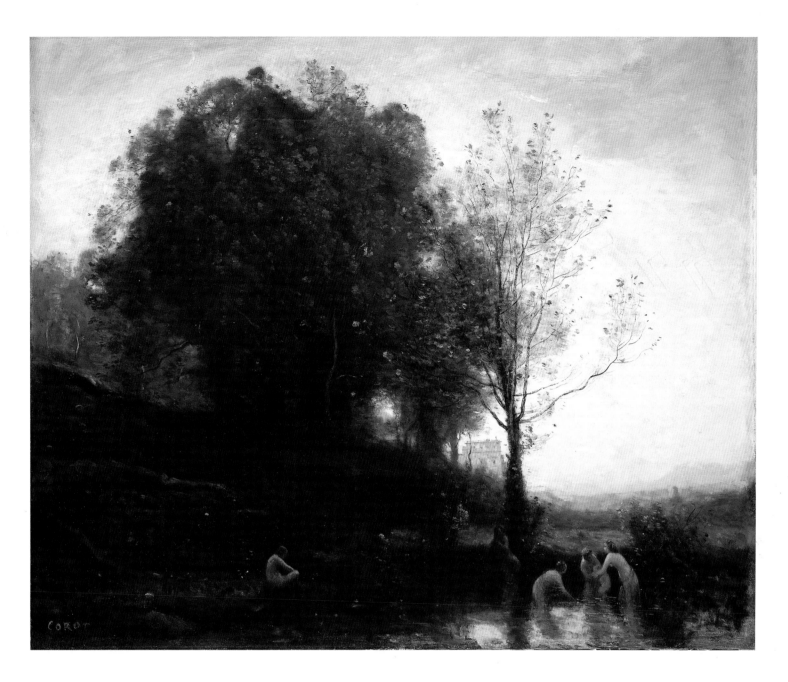

Jean Baptiste Camille Corot
French; 1796–1875

Bathing Nymphs and Child, 1855/60
Oil on canvas
82.6 x 100.3 cm (32 ½ x 39 ½ in.)
Mr. and Mrs. W. W. Kimball Collection,
1922.4454

In his youth, Camille Corot painted radiant landscape views—many executed in the open air—using a blonde palette and a bold touch. From about 1850, however, he favored feathery handling and silvery tones, reducing the role of color so radically that his canvases evoke calotypes, early photographic images printed in shades of brown, gray,

or green. In contrast to the bracing freshness of his early oils, Corot's later works have a retrospective quality, as if to suggest something recollected in tranquility. They brought him international fame and prompted critics to dub him the "poet" of contemporary landscape painting.

Some of the finest canvases from Corot's maturity depict actual sites, but *Bathing Nymphs and Child* is a frankly imaginary construct, an attempt to conjure an ideal world of sylvan grace. Here, characteristically, the artist infused the view of a waterway with a misty luminosity suggestive of early morning or late evening, the pale sky accentuating the allure of the scene's woody recesses. The mythological figures, hushed ambience, and

distant palace are reminiscent of the work of seventeenth-century master Claude Lorrain, a touchstone of the Western landscape tradition and much venerated by Corot. But here Corot filtered Claude's imagery through the lens of nineteenth-century French naturalism. In its quiet way, his delicate, ethereal handling is just as assertive as the rougher brush strokes favored by the Barbizon painters (see pp. 12–13), with whom he is sometimes grouped. For all its arcadian mystery and classical serenity, *Bathing Nymphs and Child* exhibits a distinctly contemporary attentiveness to fleeting atmospheric effects.

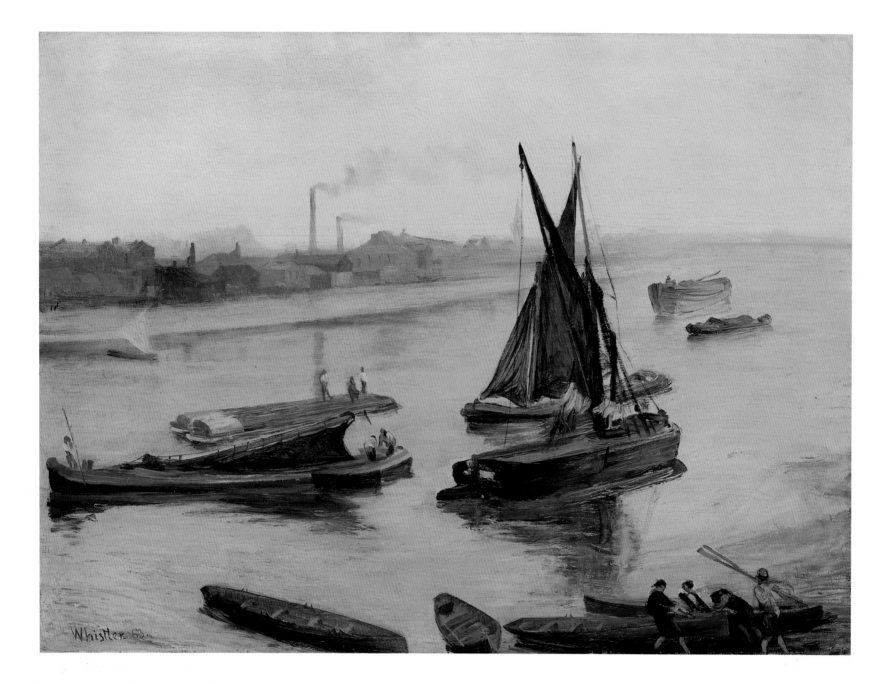

James McNeill Whistler
American; 1834–1903

Gray and Silver: Old Battersea Reach, 1863
Oil on canvas
50.9 x 69 cm (20 x 27 in.)
Potter Palmer Collection, 1922.449

James McNeill Whistler treated marine themes throughout his long career as a painter and printmaker, and his development of a unique, modern aesthetic sensibility can be traced in such scenes. Whistler was born in Lowell, Massachusetts, and in his youth traveled with his family to St. Petersburg, Russia, and to London. Determined to become an artist, he set out for France in 1855; during the next several years, he moved back and forth between Paris and London.

By December 1862, Whistler had settled in Chelsea, a neighborhood west of London's center, where he rented a studio with a view of the Thames River. Open to the influence of Realism, with its goal of revealing the often gritty details of urban life, Whistler looked upon the Thames as a site of labor rather than of leisure. In *Gray and Silver: Old Battersea Reach*, he depicted buildings on the Battersea, or south side of the river, including Morgan's Patent Plumbago Crucible Company's Works and the spire of St. Mary's Church; further down, toward the horizon, he sketched the recently constructed Battersea Railway Bridge. Giving equal attention to the activity and atmosphere of the scene, Whistler shrouded coal barges and factories in London's notorious industrial fog, which his brush transformed into a delicate veil. He conveyed a controlled sense of animation through a muted palette and a carefully organized composition of horizontal and diagonal lines. Whistler carried this tendency toward reduction of form and color to an extreme in his nocturne paintings of the 1870s (see p. 37).

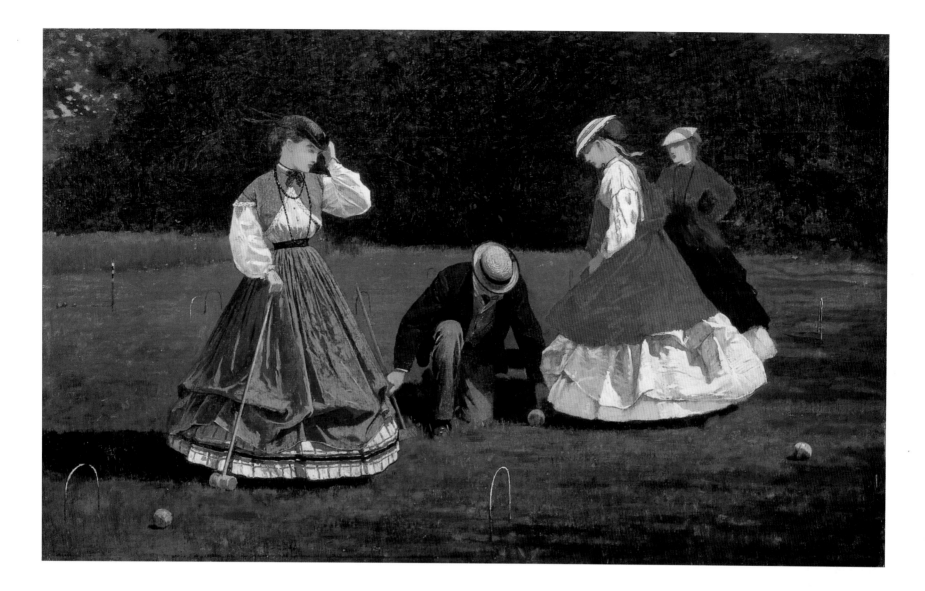

Winslow Homer

American; 1836–1910

Croquet Scene, 1866
Oil on canvas
40.3 x 66.2 cm (15⁷/₈ x 26¹/₁₆ in.)
Friends of American Art Collection; the
Goodman Fund, 1942.35

In the years following the Civil War, enthusiasm for the English game of croquet swept North America. Winslow Homer responded to this trend, depicting the fashionable pastime in two wood engravings and five oil paintings, including the Art Institute's *Croquet Scene*. Homer had begun his career as an illustrator, working from 1854 to 1857 as an apprentice in John H. Bufford's Boston lithography shop and then as a regular contributor and war correspondent to *Harper's Weekly*. This training gave him a keen eye for detail and an interest in documenting social convention.

Croquet Scene reveals Homer's familiarity with the game and its etiquette; the positions of the participants correspond to those illustrated in instruction manuals. As in his other croquet paintings, female figures predominate, reflecting the prevailing attitude that croquet provided a physical recreation in which women could compete with men while maintaining their modesty through strict, decorous comportment. Here, the exact moment in the game is evident: lifting her skirt hem to steady the ball with her foot, the woman in red prepares to "croquet," that is, to knock her opponent's ball off the field.

Despite this wealth of detail, *Croquet Scene* transcends the conventions of illustration. There is no explicit narrative, and the outcome of the game is irrelevant. Homer's close recording of contemporary life reveals a modern sensitivity to form as well as content. But unlike the French Impressionists, Homer was not interested in representing atmospheric disintegration of form. Rather, his work distinguishes itself by its very solidity. Here for example the bright primary colors of the women's dresses contrast with a background of subtle shades of green, and the afternoon sun plays upon—but does not erode or dissolve—their strong, simple shapes.

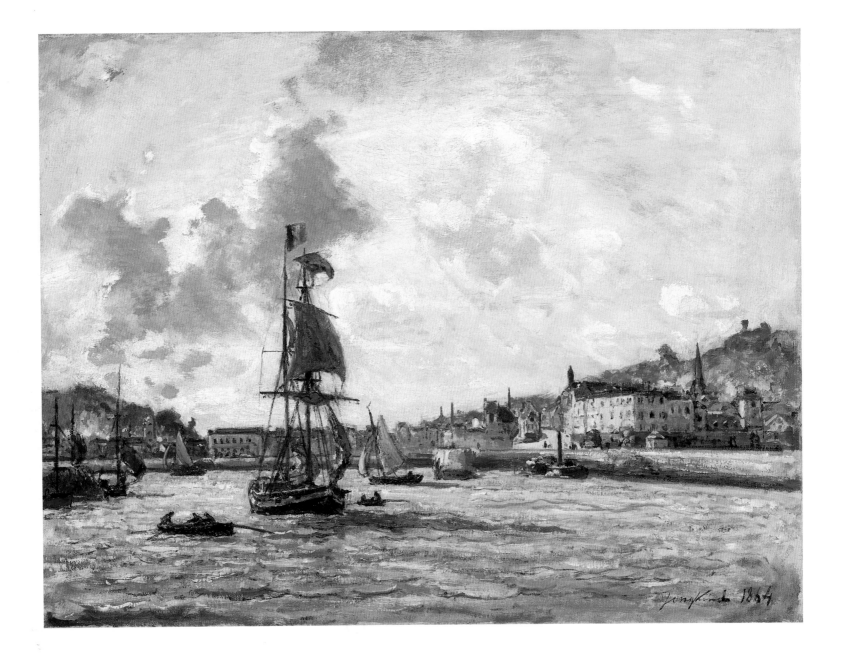

Johan Barthold Jongkind

Dutch; 1819–1891

Entrance to the Port of Honfleur, 1864
Oil on canvas
42.2 x 56.2 cm (16⅝ x 22¼ in.)
Louise B. and Frank H. Woods Purchase Fund in honor of the Art Institute's Diamond Jubilee, 1968.614

In 1900 Claude Monet remarked that Johan Barthold Jongkind had been responsible for the education of his eye. Indeed the two large pictures that Monet showed successfully at the Salon of 1865—his Paris debut—owed much to the Dutch painter, whose more reticent art was a crucial springboard to the bolder effects achieved by his younger colleague. The two men met in 1862, and the twenty-one-year-old Monet, who was finding his artistic feet, was immediately influenced by Jongkind's way of organizing compositions in broad planes and by his attentiveness to meteorological particulars: like John Constable (see p. 14), Jongkind often noted the time of day on the sketches he executed in the open air.

Jongkind's *Entrance to the Port of Honfleur* dates from 1864, when he, Monet, and Eugène Boudin (see p. 21) painted together in that city on the Seine estuary. A depiction of a ship navigating the harbor under sail, this canvas is characteristically understated. While it adheres to Dutch compositional formulas, notably in its low horizon line, the handling is loose, especially for a work of this date intended for exhibition (it was shown at the Salon of 1864). But the strokes are delicate and the paint thinly applied; Jongkind was not partial to the loaded brush. He occasionally resorted to summary passages—for example the slate-gray hills just beyond the wedge of buildings on the right—but these remain subsidiary to the larger compositional structure. The scene is infused with the yellowish light of the sun burning through the clouds; like Corot in his later years (see p. 17), Jongkind avoided brilliant hues and allowed tonal contrasts, rather than emphatic visual incident, to animate the scene. The result is an image of quiet lyricism with a discreetly modern inflection.

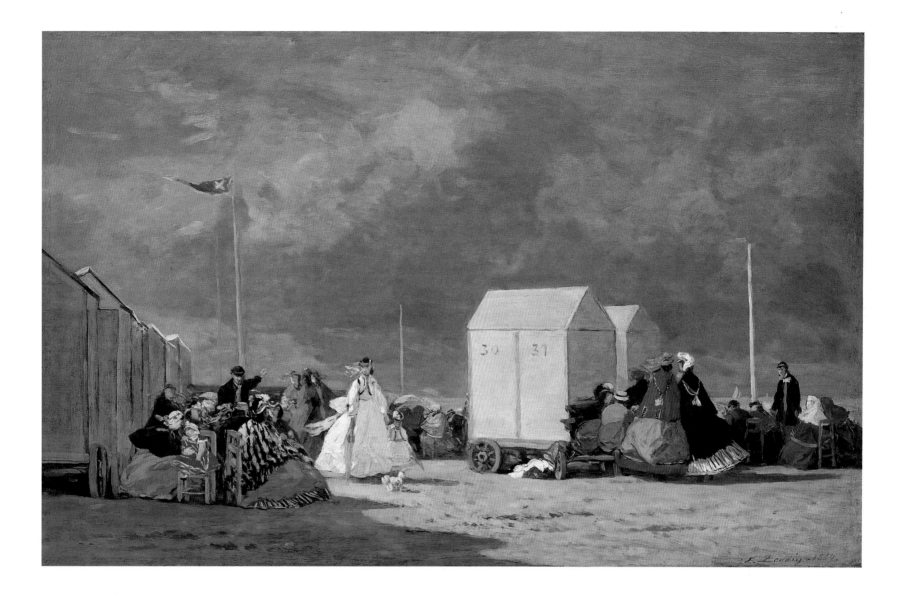

Louis Eugène Boudin
French; 1824–1898

Approaching Storm, 1864
Oil on panel
36.6 x 57.9 cm (14⅜ x 22¾ in.)
Mr. and Mrs. Lewis Larned Coburn Memorial
Collection, 1938.1276

Around 1850 vacationers began to flock in un-precedented numbers to the Normandy coast, made accessible by recently completed railroad lines. Eugène Boudin, a native of Honfleur then in his twenties, sensed the pictorial potential of the burgeoning resort industry; a self-trained artist, he became the region's visual chronicler. Punctuating superimposed bands of beach, sea, and sky with clusters of tourists, portable chang-ing huts, and the occasional distant ship, he por-trayed not only a new type of bourgeois leisure but also the hazy radiance of oceanside light. The young Claude Monet was struck by the brisk con-temporaneity of these small-scale images and by Boudin's practice of working in the open air. After they met, in 1858, Monet adopted the older artist as his principal mentor. It was partly at Monet's urging that Boudin began to exhibit at the Paris Salon, where he was a staple from 1863 to 1870.

Several elements in *Approaching Storm*, shown at the Salon of 1864, suggest that Boudin was trying to vary his usual formula for beach scenes. While three horizontal bands appear in their cus-tomary configuration, the water is all but obscured by an uninterrupted sequence of forms—changing huts and figures of varying posture, dress, and size—whose agitated rhythms generate a sense of incipient disquiet. This effect is intensified by four flagpoles—staccato streaks against the dark-ening sky—as well as by the stark contrasts be-tween shadow and sunlight: the central changing huts for example are blindingly white. Although Boudin vividly evoked the snap of the women's crinolines and scarves in the wind, he did not ex-aggerate this little meteorological crisis; we are never allowed to forget that shelter is near in this engaging rendering of a pleasant outing about to be thwarted by the forces of nature.

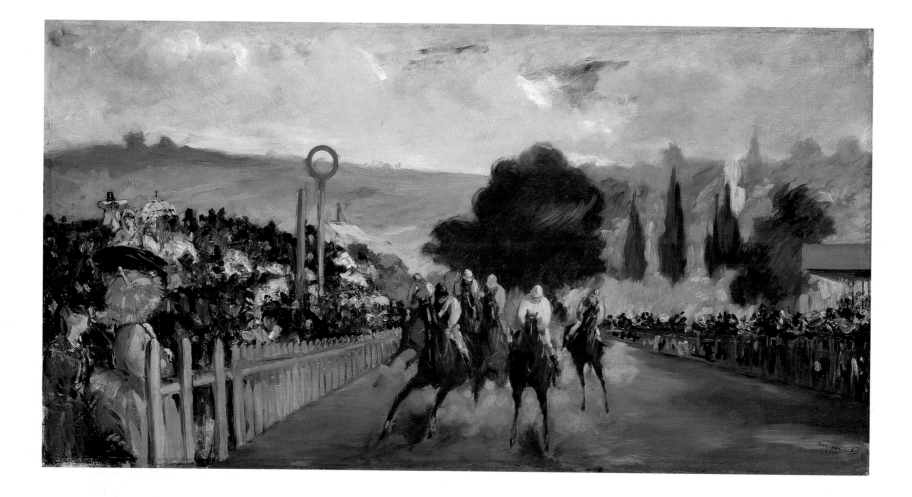

Edouard Manet

French; 1832–1883

The Races at Longchamps, 1866
Oil on canvas
43.9 x 84.5 cm (17 ¼ x 33 ¼ in.)
Potter Palmer Collection, 1922.424

The 1860s saw a sudden increase in the number of ambitious paintings devoted to the pleasures of Parisian life. Few of them, however, are as savory as those by Edouard Manet, who introduced into the contemporary Realist project a deadpan irony, offhand elegance, and historical self-consciousness that utterly transformed it. Combining cryptic allusions to art of the past with luscious paint handling and bold, sometimes awkward compositions, he reconciled a cosmopolitan sophistication with a new kind of pictorial directness.

Horse racing enjoyed a revival during the Second Empire (1852–70), when the Longchamps track was built in the Bois de Boulogne, a park on the outskirts of Paris. In 1863 Manet began to plan a large, horizontal work that would convey the bustle of its crowds and the dynamism of its races. He ultimately abandoned this panoramic composition, but the Art Institute's smaller variant retains the gist of it in more concentrated form.

As a pictorial conception, *The Races at Longchamps* is startling. We find ourselves on the racecourse with a cluster of onrushing horses and jockeys bearing directly down on us. With a few judicious exceptions—the vertical starting post left of center; the crisp rectangle of the viewing-stand roof at the right—everything is blurred, a device that heightens the sense of explosive movement of the galloping horses. Essentially, Manet here repeated the right two-thirds of his earlier, wider composition (an 1864 watercolor version of which survives in the Fogg Art Museum, Cambridge, Mass.). But he zoomed in on the horses, thereby increasing the energy generated by the juxtaposition of their advancing forms and the receding fences. The result, an audacious paean to speed and chic, implements the contemporary French poet Charles Baudelaire's dictum to seize the eternal in the contingent.

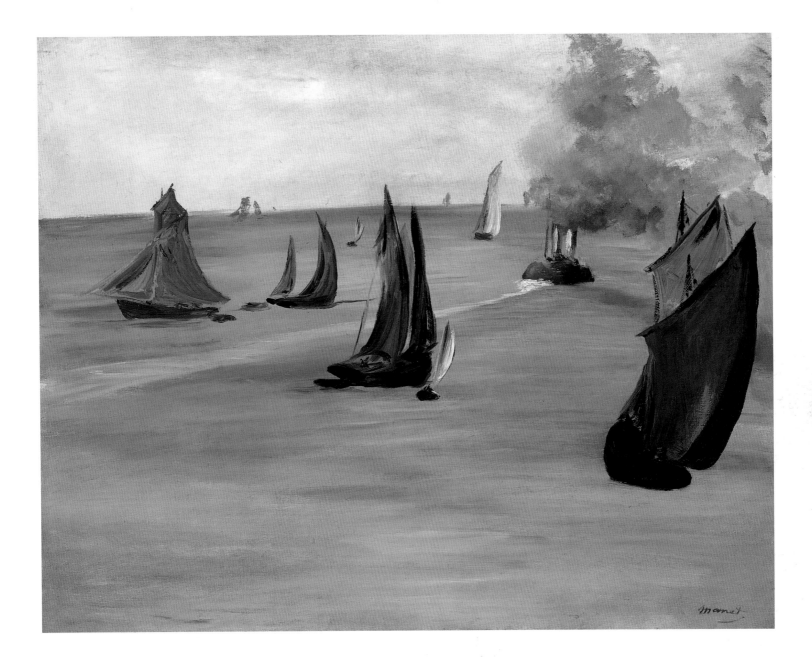

Edouard Manet

French; 1832–1883

Departure from Boulogne Harbor, 1864/65
Oil on canvas
73.6 x 92.6 cm (29 x 36½ in.)
Potter Palmer Collection, 1922.425

In the summer of 1864, perhaps seeking solace after the critical drubbing he had received at the Salon of that year, Edouard Manet sojourned for a time in the northern port city of Boulogne-sur-Mer, where he initiated a group of marine subjects and still lifes of fish. He completed the still lifes there, but he worked up the marines later, in his Paris atelier, on the basis of studies made on site.

All are formally audacious, featuring high horizon lines and wall-like expanses of water against which various ships stand out emphatically. But the Art Institute's canvas, the smallest of the group, is in some ways the most striking. Manet rendered the water in horizontal strokes of blue and green paint; in places, the weave of the canvas bleeds through. This minimizes the effect of spatial recession, evoked only by a slight narrowing of the strokes toward the horizon and by the diagonal wake of a departing steamer. The flattened composition recalls the spatial organization seen in Japanese woodblock prints, which had recently become fashionable with the Parisian avant-garde. These images perhaps encouraged

Manet to dare the schematic, almost calligraphic forms of the dark ships, which give the entire work a rhythmic, decorative character. The example of James McNeill Whistler may also lie behind this reductive approach; on friendly terms with Manet at this time, the American artist had recently begun to experiment with similarly evocative river- and seascapes (see p. 18). The influence of contemporary photography should also be taken into account: Gustave Le Gray's widely admired collodion-on-glass images of ocean and sky, exhibited in the 1850s, have a high-contrast quality and an eery stillness that Manet may have been emulating here.

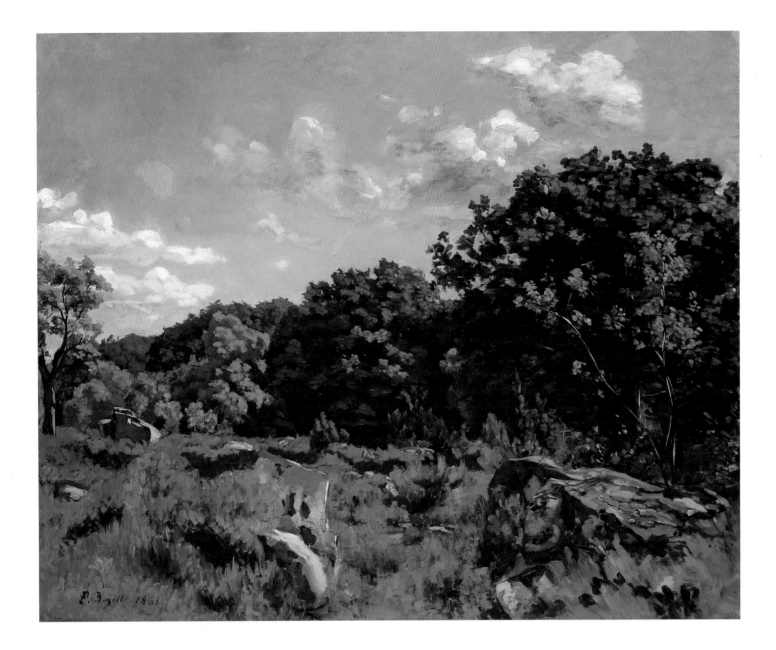

Frédéric Bazille
French; 1841–1870

Landscape at Chailly, 1865
Oil on canvas
81 x 100.3 cm (31⅞ x 39½ in.)
Charles H. and Mary F. S. Worcester Collection,
1973.64

Frédéric Bazille was an important figure in the formative decade of Impressionism. Born into a prosperous household in Montpellier, he started to paint early in his life but, at his family's urging, set out to become a doctor. Soon after arriving in Paris in 1862 to pursue his medical studies, he began to frequent the studio of Charles Gleyre, where he met and befriended Claude Monet,

Pierre Auguste Renoir, and Alfred Sisley. Bazille committed himself fully to art in 1864, and produced an idiosyncratic body of work that, while closely related to that of his young colleagues, is more blunt in its handling and less overtly innovative in its ambitions. Tragically, just as Bazille was coming into his own artistically, he was killed in the Franco-Prussian War.

Late in 1865, Monet convinced Bazille to join him in the Forest of Fontainebleau to pose for his projected large composition *Luncheon on the Grass* (Paris; Musée d'Orsay). Executed during this sojourn, Bazille's *Landscape at Chailly* pictures a site not far from the village of Barbizon. The overgrown boulders, flecked foliage, and jagged treetops bring to mind the work of Barbizon masters

such as Théodore Rousseau or Jules Dupré; other aspects, such as the impenetrable blacks, recollect similar passages in Gustave Courbet's landscapes (see p. 27). But the uninflected azure of the sky and the evocation of brilliant, almost merciless light strike an innovative note, as do the molten strokes on the rocks and the delicate, white linear accents in the tree trunks at the right. Although *Landscape at Chailly* is an experimental oil study and not a work intended for exhibition, it was precisely while elaborating such ambitious "sketches" in the late 1860s that Bazille, Monet, and Renoir began to question the viability of such a distinction, with results that were to change the course of Western painting.

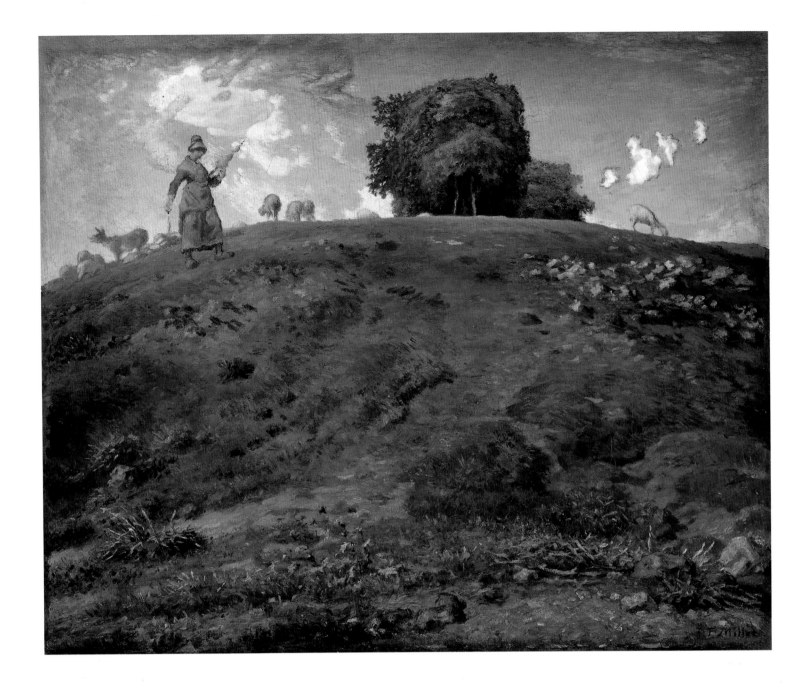

Jean François Millet

French; 1814–1875

In the Auvergne, 1866/69
Oil on canvas
81.5 x 99.9 cm (32 1/16 x 39 1/4 in.)
Potter Palmer Collection, 1922.414

The broad rise of a rock-strewn hill dominates the foreground of Jean François Millet's *In the Auvergne*. The painting's low perspective forces a dramatically high horizon, marking a greater emphasis on landscape than that seen in Millet's previous rural genre scenes. During the 1850s, he had achieved critical acclaim with his portrayals of agricultural workers as iconic forms: monumental, anonymous, and innately dignified. Placing his figures close to the viewer, the artist had anchored these compositions with their grand, solid silhouettes, stable and enduring as the earth itself. But in the Art Institute's *In the Auvergne*, the land assumes the primary position, and the figure of a young woman, spinning wool on a crude hand spindle as she tends her flock, appears almost as an incidental detail.

Painted in the last decade of Millet's life, *In the Auvergne* represents his embrace of pure landscape. In the summers of 1866 and 1867, he accompanied his ailing wife to a spa in Vichy. To fill the long hours his spouse spent in the medicinal baths, Millet roamed the surrounding countryside. The rugged and unpredictable terrain, with its gullied slopes and rising cliffs, stirred the artist's memories of his native Normandy. He made rapid sketches of the region, and, upon returning to his studio in Barbizon, used pastel and oil to record his memories of the textures and colors he had observed there. The thick brush strokes and vivid tones of the grassy hillside in the foreground of *In the Auvergne* recall the calligraphic immediacy of drawing in pastel, and the work's bold composition reveals Millet's heightened, direct response to a new and stimulating environment.

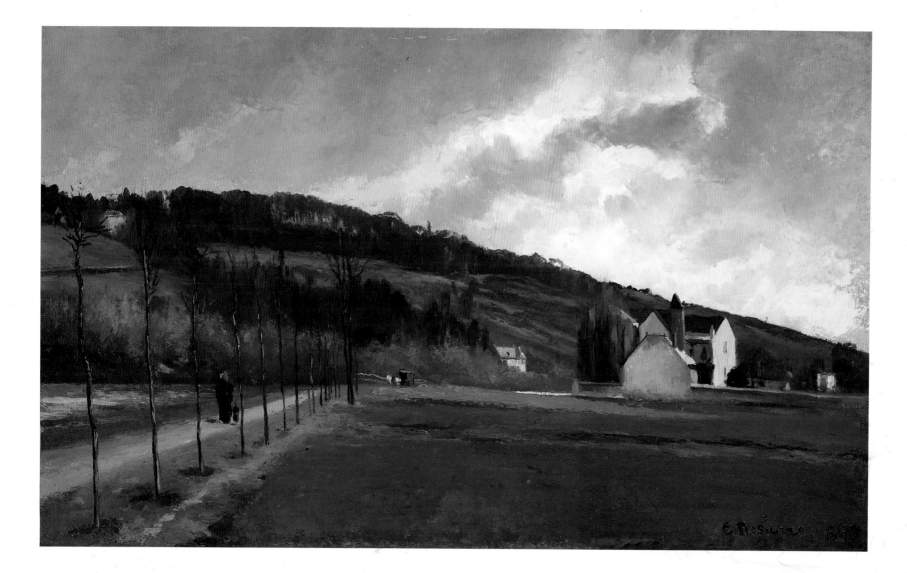

Camille Pissarro

French; 1830–1903

The Banks of the Marne in Winter, 1866
Oil on canvas
91.8 x 150.2 cm (36⅛ x 59⅛ in.)
Mr. and Mrs. Lewis Larned Coburn Memorial
Collection, 1957.306

Born on the Danish-governed Caribbean island of St. Thomas to French Jewish parents, Camille Pissarro arrived in Paris in time to see the immense Exposition universelle of 1855, which included several fine-art exhibitions. Already determined to be an artist, Pissarro was essentially self-taught and open to new influences. In the display devoted to contemporary painting, he encountered the thickly textured but delicately brushed canvases of Camille Corot (see p. 17), a prominent landscapist whom he sought to emulate.

But Pissarro also responded to the example of Gustave Courbet (see p. 27), and in this large, bleak work of 1866, he boldly declared his independence from Corot, defining the vast field that occupies much of the composition's right side in solid planes of color applied with a palette knife. A depiction of a quiet country road near Pissarro's home in La Varenne-St.-Hilaire, west of Paris on the Marne River, the painting captures the damp, dark stillness of a rural, winter afternoon through the use of drab olives and muted browns.

The Banks of the Marne in Winter became Pissarro's first major success, receiving widespread critical acclaim at the Salon of 1866. The painting seemed remarkable to Pissarro's contemporaries in that here the artist sought not to hide a banal and vulgar subject behind a veneer of virtuoso technique, but rather to underline the very plainness of the setting through its direct, even crude execution. Lauding the work's audacious sincerity, novelist and art critic Emile Zola characterized the somber canvas as "no feast for the eyes. It is an austere and serious painting, showing an extreme concern for the truth."

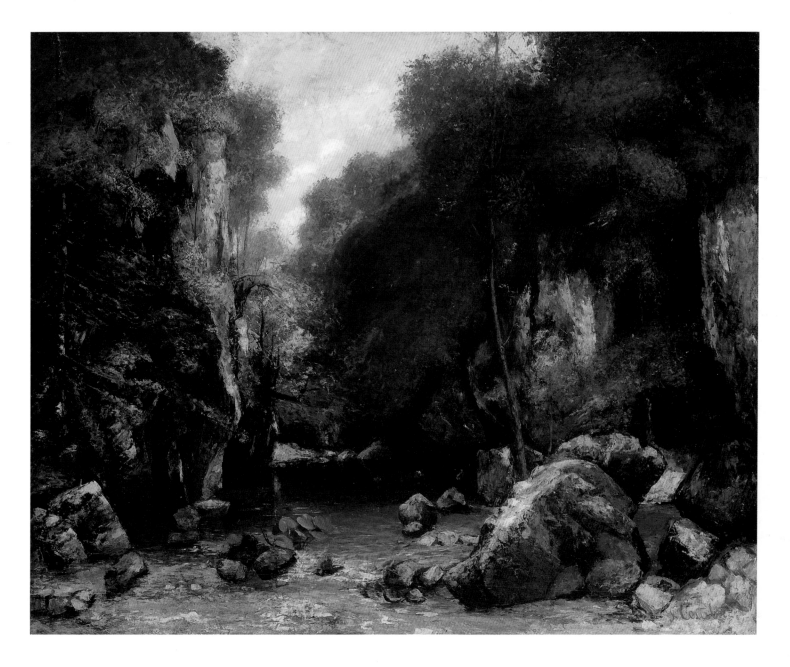

Gustave Courbet

French; 1819–1877

The Valley of Les Puits-Noir, 1868
Oil on canvas
111.1 x 137.8 cm (43¾ x 54¼ in.)
Gift of Mr. and Mrs. Morris I. Kaplan, 1956.762

Fiercely independent and notoriously vain, Gustave Courbet was one of the leading practitioners of Realism in France, and an important stylistic antecedent for the Impressionists. Best known for his monumental images of rural labor, executed in the late 1840s and early 1850s, this passionate Republican sympathizer was also an accomplished painter of landscapes, often portraying the untamed countryside around Ornans,

his birthplace, in the Franche-Comté region, near the Swiss border. His dense, compact forms, which he occasionally fashioned with a palette knife instead of a brush, effectively capture the dense forests and precipitous cliffs that distinguish this harsh, isolated region. At its most extreme, Courbet's technique produced vivid patterns of almost unmodulated shapes, anticipating the work of Paul Cézanne (see p. 112)—another artist whose native region was his constant inspiration —and even pointing toward abstraction.

In this painting, Courbet depicted Les Puits-Noir, a brook that runs through a gorge in the Jura Mountains before joining the Loue River near Ornans. Imposing trees on either side of the stream and massive rock formations in the fore-

ground contribute to a brooding sense of enclosure. Yet, as if by sheer will, the artist admitted rays of strong sunlight into the scene, aggressively modeling bright highlights on the boulders, foliage, and water.

Courbet returned repeatedly to favorite sites such as this one, often working on five or six canvases at a time. The Art Institute's version of *The Valley of Les Puits-Noir* duplicates, with few alterations, a work dated 1865, now in the Musée d'Orsay, Paris. The recurrence of the theme with only slight variation both predicts the Impressionists' later interest in painting in series and demonstrates the great personal significance of the topography around Ornans to Courbet.

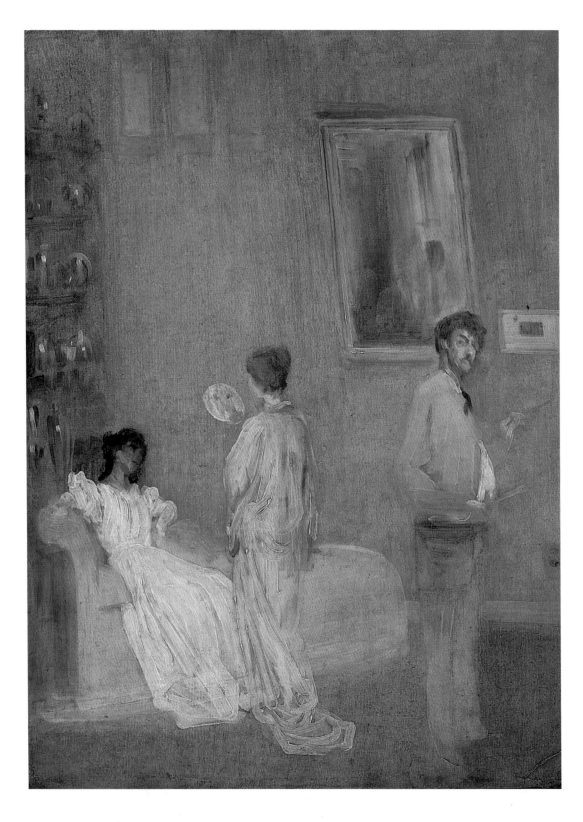

James McNeill Whistler
American; 1834–1903

The Artist in His Studio, 1865/66
Oil on paper, mounted on panel
62.9 x 46.4 cm (24¾ x 18¼ in.)
Friends of American Art Collection, 1912.141

In this delicate and revealing self-portrait, James McNeill Whistler displayed his creative concerns while asserting his place in the history of art. He originally intended to make a monumental, ten-foot-high painting that would, in its size and subject, refer to Diego Velázquez's famous studio scene, *Las Meninas* (1656; Madrid, Museo del Prado). It would also, as Whistler explained to his friend the painter Henri Fantin-Latour, be "an apotheosis of everything that could scandalize the Academicians." *The Artist in His Studio* may represent a preliminary idea for the never-realized, larger project.

Because Whistler earned a significant portion of his income by filling portrait commissions, he maintained an elegant studio where his sitters could pose. This setting is evoked here, in an imaginative rather than literal manner. Although we cannot observe the canvas on which Whistler is working, we see a framed mirror and an etching hanging on the wall behind him, and, at the left, his collection of blue-and-white porcelain displayed on shelves. The costume, fan, and graceful posture of the standing woman attest to the painter's interest in Asian art; this model converses with Whistler's mistress Joanna Hiffernan, who is seated casually on a chaise longue. Hiffernan's dress is similar to the one she wears in Whistler's painting *The White Girl: Symphony in White, No. 1* (1862; Washington, D.C., National Gallery of Art), shown in 1863 at the controversial Salon des refusés (Salon of Rejected Works) in Paris.

Whistler lent a certain immediacy and spontaneity to this intimate scene through his thin, gestural application of paint; yet he refrained from encumbering it with the narrative or allegorical elements favored by conservative critics. Rather, he made a commentary on his self-image as an artist inspired by muses of his own choosing.

Frédéric Bazille

French; 1841–1870

Self-Portrait, 1865–66
Oil on canvas
108.9 x 71.1 cm (42⅞ x 28⅜ in.)
Restricted gift of Mr. and Mrs. Frank H. Woods in memory of Mrs. Edward Harrison Brewer, 1962.336

In this self-portrait, Frédéric Bazille—an important member of the group of emerging artists later to become known as the Impressionists—responded to the effects of tone and contrast achieved by Edouard Manet. Manet's 1863 exhibition at the Martinet gallery, Paris, had utterly seduced the younger painter: "You wouldn't believe how much I'm learning by looking at these pictures," he wrote to his parents. "One of these sessions is worth a month's work." The white form of Bazille's left shirtsleeve stands out starkly against dark surroundings, taking on a life of its own. The same could be said of the palette, which is held vertically and parallel to the picture plane, a contrivance that gives maximum exposure to its pigment-smeared surface. These gestures intensify our awareness of painting as artifice in ways very much in the spirit of Manet. But Bazille was already capable of genuine originality.

The disposition of the figure generates unease. The torso is angled away, but the head turns toward us, creating a torsion and muscular strain that we sense unawares. The oddly disparate levels of the elbows and the angle of the left forearm establish an upward diagonal. Furthermore, there is something subtly distorted about the configuration of the facial features; given that Bazille was exceptionally tall, we see more of the top of the head than we should. Taken together, these observations suggest the primary reason for the portrait's exceptional presence: Bazille painted it while looking at himself in a mirror hung high on the wall and pitched at a slight forward tilt, the consequences of which he duly recorded. As a result, viewers standing before the image can experience a subliminal sense of levitation, as if held momentarily in mid-air by the artist's unremitting gaze.

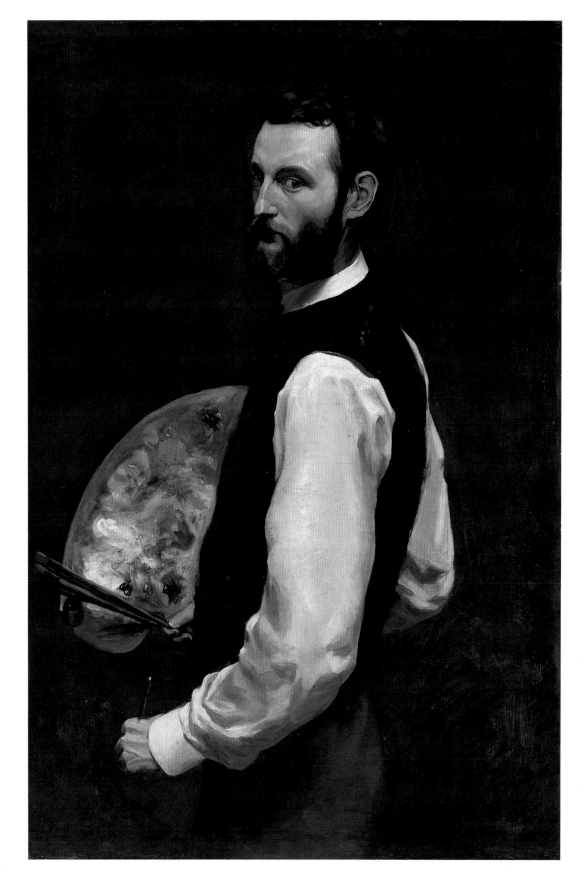

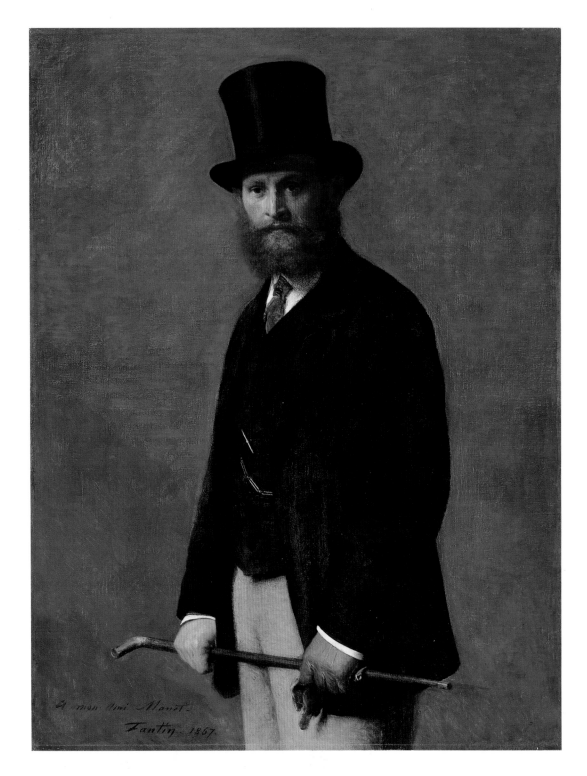

Henri Fantin-Latour
French; 1836–1904

Edouard Manet, 1867
Oil on canvas
117.5 x 90 cm (46¼ x 35⁷⁄₁₆ in.)
Stickney Fund, 1905.207

"To my friend Manet / Fantin 1867." This inscription in the lower-left corner of the Art Institute's canvas was an indication to the Salon public of Henri Fantin-Latour's continuing support for his embattled colleague, whose art had become a focus of controversy. Fantin, who had Realist allegiances, was rather reserved by temperament and had not yet made a strong impression on the Parisian scene. Depicting his subject wearing the elegant attire he favored in public—that of a fastidious boulevardier, replete with chamois gloves, top hat, and cane—Fantin set out simultaneously to demonstrate his own gifts and to belie the pervasive notion that Manet was a wild nonconformist. The result, one of the Fantin's finest portraits, won him a new level of critical respect.

The paint is thinly applied, the handling discreet and controlled; even so, many of the contours seem blurry and the fabrics plush, as if softened by the surrounding atmosphere. Fantin used color here with extreme restraint; a blue cravat provides the only strong accent in an otherwise subdued palette of brown, black, gray, and olive. Perhaps this color scheme was influenced by Raphael's portrait of Baldesar Castiglione in the Musée du Louvre, Paris, which Fantin had copied. The three-quarter length, neutral ground, and unmodulated tonal blocks may have had a more contemporary precedent in the photographs of eminent Parisians then issuing from the studio of Nadar. The pose, conveying decorous determination, was chosen by Manet himself. The facial expression is approachable but alert, fairly glowing with intelligence and resolve. Present at the Salon in this surrogate form (having refused to submit his own works), Manet seems to register his judgment upon the standards of the official art world.

Edouard Manet

French; 1832–1883

Beggar with a Duffle Coat (Philosopher), 1865
Oil on canvas
187.7 x 109.9 cm (73⅞ x 41¼ in.)
A. A. Munger Collection, 1910.304

Shortly after the critics had vilified his submissions to the Salon of 1865, Edouard Manet embarked on a long-contemplated trip to Spain, where he was overwhelmed by the works of Baroque artist Diego Velázquez in the Museo del Prado, Madrid. Upon his return to Paris, he set about producing two large canvases depicting beggar-philosophers, both of which are in the Art Institute's collection.

The notion of the social outcast possessing rare insight gained a new currency in nineteenth-century France. Ragpickers (nocturnal scavengers of garbage suitable for resale) held a particular fascination for Realist artists and writers, who saw these figures as resourceful, appealingly nonconformist members of the urban underworld. Manet's "philosophers" of 1865–66 interpret this type in terms that are both historicist and innovative. Rendered in dark earth tones and set against nondescript grounds, they resemble analogous paintings by Velázquez, but they are not straightforward essays in emulation. In *Beggar with a Duffle Coat (Philosopher)*, the man's hands are rendered with deliberate crudity, and the brown cloak is an impudent cascade of broad brush strokes. Manet was thus testing his own brand of fleet, summary handling against that of Velázquez, while simultaneously weighing his painterly options against the alternative representational mode of photography. This is perhaps most apparent in the way he blunted and stilled certain bravura passages, as if imitating the photographic blur.

The slapdash quality of Manet's *Beggar* evokes a milieu regarded as threatening by government authorities. The figure's outstretched hand is confrontational, almost a provocation to the viewer. Much about this disarming image remains inscrutable, but it seems likely that Manet's depiction of a member of the "dangerous classes" in a monumental portrait format was intended to unsettle.

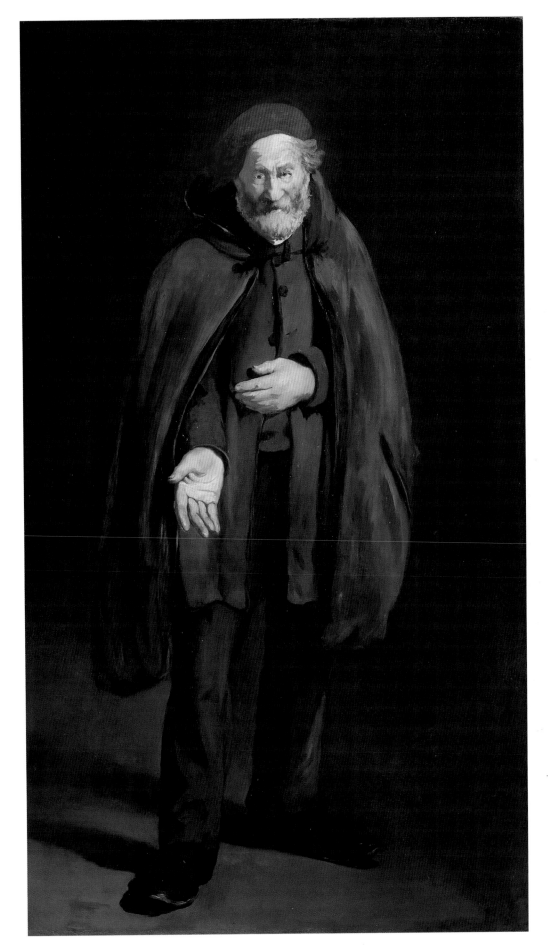

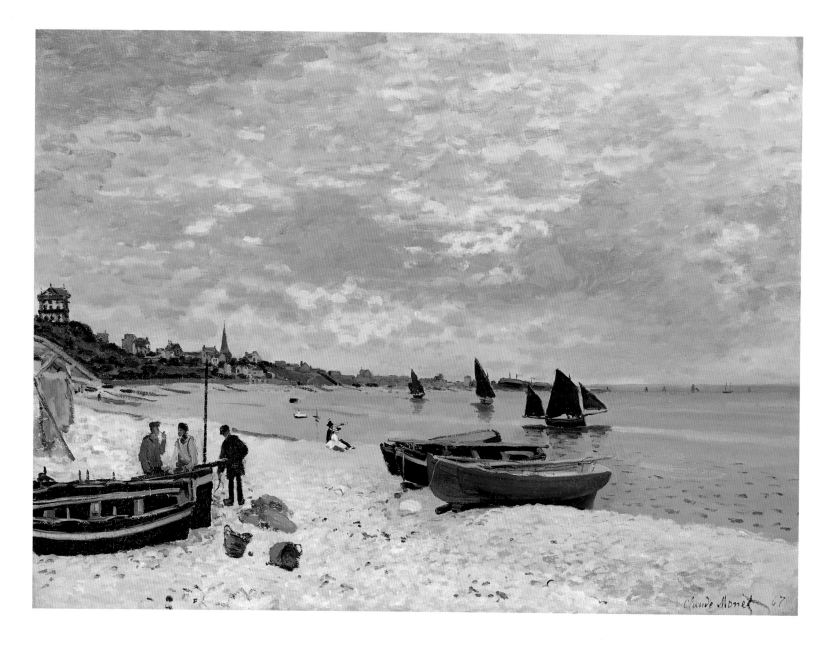

Claude Monet

French; 1840–1926

The Beach at Sainte-Adresse, 1867
Oil on canvas
75.8 x 102.5 cm (29 ¹³/₁₆ x 40 ⁵/₁₆ in.)
Mr. and Mrs. Lewis Larned Coburn Memorial
Collection, 1933.439

This unconventional beach scene by Claude Monet shows the influence of Eugène Boudin (see p. 21), who in 1856–57 urged his reluctant, younger colleague to paint outdoors along the Normandy coast, where they both lived. Monet later recalled the decisive impact of Boudin's advice: "It was as if a veil suddenly lifted from my eyes and I knew that I could be a painter." Ten years after learning

this lesson, Monet executed *The Beach at Sainte-Adresse*, working in the midst of nature and liberating himself from traditional standards of finish —both technical and compositional.

The day depicted here is cold and gray. Fishermen are at work, while a bourgeois couple seated on the beach watches a regatta through a gleaming telescope. Perhaps their careful scrutiny of the scene is meant to signal the painter's own. Monet devised a complex system of brush strokes and selected his subtle palette in response to what he observed. The clouds are fluffy but opaque, borrowing their hue from the white of the canvas and also from the clear blue of the water below; the sand picks up tone from both sea and sky, but has a distinctly gritty, scumbled texture. Into this

silvery tapestry, Monet inserted the solid hulls of vessels pulled up on the beach, silhouettes of sailboats on the water, the outlines of the village in the background, and almost puppetlike fishermen and tourists.

For all its charm, *The Beach at Sainte-Adresse* was produced during a difficult period in the artist's life. The Salon jury had rejected most of his recent submissions, and he was about to become a father for the first time in desperately strained financial circumstances. Setting aside these practical concerns, Monet confidently forged ahead in his art, laying the foundations for the style that would become Impressionism.

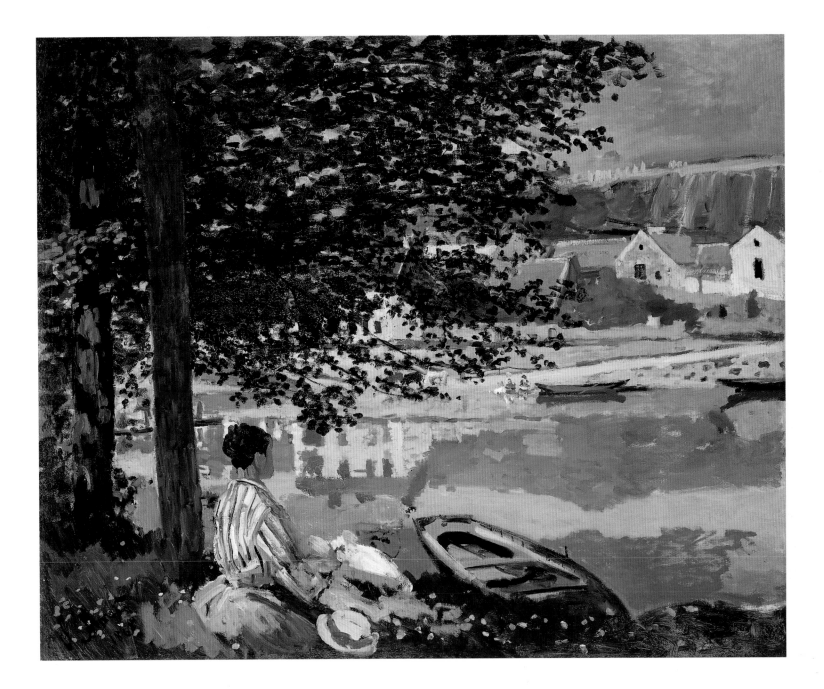

Claude Monet
French; 1840–1926

On the Bank of the Seine, Bennecourt, 1868
Oil on canvas
81.5 x 100.7 cm (32 1/16 x 39 5/8 in.)
Potter Palmer Collection, 1922.427

Claude Monet spent the summer of 1868 with his future wife, Camille Doncieux, and their infant son, Jean, in the small Seine-side village of Gloton. Despite the fact that his monetary situation remained difficult and the reception of his works disappointing, Monet was on the verge of an unprecedented artistic breakthrough. *On the Bank of the Seine, Bennecourt*, which has been called the "first Impressionist landscape," documents that moment.

Monet's subject—quite simply, a glorious day, enjoyed quietly by a young woman—became a quintessential Impressionist theme. The artist's gaze followed that of his model, Doncieux, across the river to the town of Bennecourt, one of the many Paris suburbs that were favored leisure spots in the second half of the nineteenth century. Monet was not the only artist to depict a typical moment of sun-dappled relaxation in such a site, but the means he employed were revolutionary.

Boldly handling brushes loaded with paints in a high-keyed range of blues, greens, and yellows, Monet seemingly created this strong composition on the spot, without premeditation. While he certainly did allow his fleeting perceptions to guide his hand, he also exercised control and selection. Patches of color exist independently, but they also retain coherent representational value: Monet used the same blue pigment for the bit of sky reflected in the water and for the actual sky; yet we instantly understand the difference and the relationship between the two. *On the Bank of the Seine, Bennecourt* constitutes a wholly new kind of painting—not a rehearsal for a fully finished studio picture, but rather a record of light and color, reduced to their most basic and powerful elements.

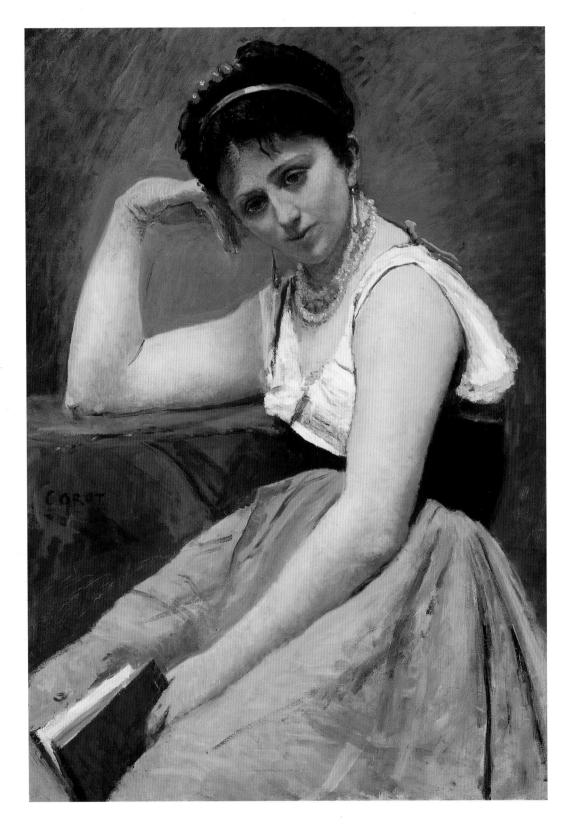

Jean Baptiste Camille Corot
French; 1796–1875

Interrupted Reading, c. 1870
Oil on canvas, mounted on board
92.5 x 65.1 cm (36⁵/₁₆ x 25⁵/₈ in.)
Potter Palmer Collection (Bequest of Bertha
Honoré Palmer), 1922.410

Although best known for his landscapes (see p. 17), Camille Corot executed some 350 figure paintings, few of which he exhibited during his lifetime. Among the most remarkable are a number of depictions of women, dating from the final phase of his career, that have an elusive, altogether compelling poetry and psychological acuity. Some, like *Interrupted Reading*, reveal Corot pondering the innovations of the younger generation, notably the sketchy handling and exploration of posing as artifice found in Edouard Manet's figure paintings of the 1860s (see p. 31).

Here, the woman's slumped posture, unfocused gaze, and general lassitude suggest not so much a placid daydreamer as a weary model; the book she holds seems mere premise. Her vaguely picturesque dress and jewelry—vestiges of genre-painting conventions—reaffirm the image's contrived nature. Technically, the work is audacious: Corot dragged rough strokes of paint across the canvas to form the skirt; created flecked, opaque shadows dappling the arms; and used pasty, white pigment to render the blouse's delicate fabric. This invites the viewer to contemplate the nature of pictorial illusionism, as do numerous *pentimenti*, or evidently altered passages, which afford a glimpse into the artist's compositional methods (scarcely disguised adjustments are visible in the placement of the woman's right earring, right arm, and upper edge of the dress). Corot kept conventional modeling to a minimum and allowed the figure to occupy the whole of the pictorial field. Yet, for all its formal boldness, the end result is pure late Corot: subtly integrated, tonally understated, and imbued with a gentle melancholy.

Art historian Lionello Venturi, the great cataloguer of Paul Cézanne's oils, was especially lavish in his praise of this work, largely because of its proto-modernist elements. But it is the judicious layering of these over Corot's essentially late-Romantic sensibility that gives *Interrupted Reading* its special poignancy.

Mary Cassatt
American; 1844–1926

After the Bullfight, 1873
Oil on canvas
82.5 x 64 cm (32 ⅛ x 25 ³/₁₆ in.)
Gift of Mrs. Sterling Morton, 1969.332

As a young woman, American-born Mary Cassatt refused to allow the limited opportunities open to female art students in her native land to curtail her decision to become a professional painter. Upon completing a five-year curriculum at the Pennsylvania Academy of the Fine Arts, Philadelphia, in 1865, Cassatt took advantage of the superior training and extensive art collections in Europe, making two ambitious study tours. In 1874, at the end of her second trip, she settled permanently in Paris. Earlier in that second sojourn, in October 1872, she fulfilled a long-standing desire to visit Spain. She traveled alone, spending her first three weeks in Madrid, where she visited the Museo del Prado to examine and copy paintings by Bartolomé Estéban Murillo and Diego Velázquez. Her next destination was Seville; there, she set up a studio and, in the course of the next five months, produced a distinctive group of works on Spanish themes, including *After the Bullfight*.

Cassatt's choice of subject reflects an ongoing fascination in Europe and North America with Spanish culture that began with the Napoleonic occupation of Spain in 1808 and that culminated with the staging of Georges Bizet's opera *Carmen* in 1875. There is no evidence to suggest that Cassatt actually attended a bullfight. Her *torero* is in fact a posed model, but she depicted him with all the glamor and swagger of a romantic figure, perhaps inspired by the descriptions of matadors in Théophile Gautier's popular 1845 travel guide to Spain. While the vigorous handling, bold palette, and deft rendering of detail reveal Cassatt's indebtedness to the work of Velázquez, her realistic approach suggests her awareness of Edouard Manet's treatment of similar subjects in the 1860s.

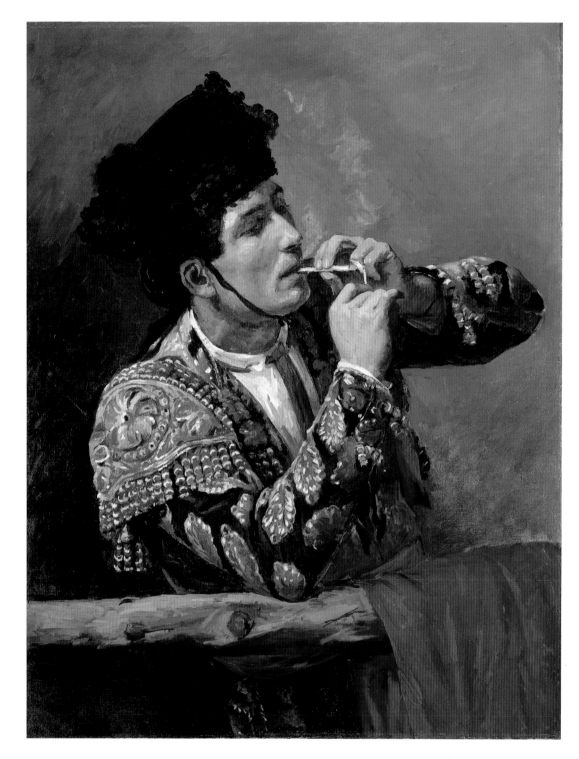

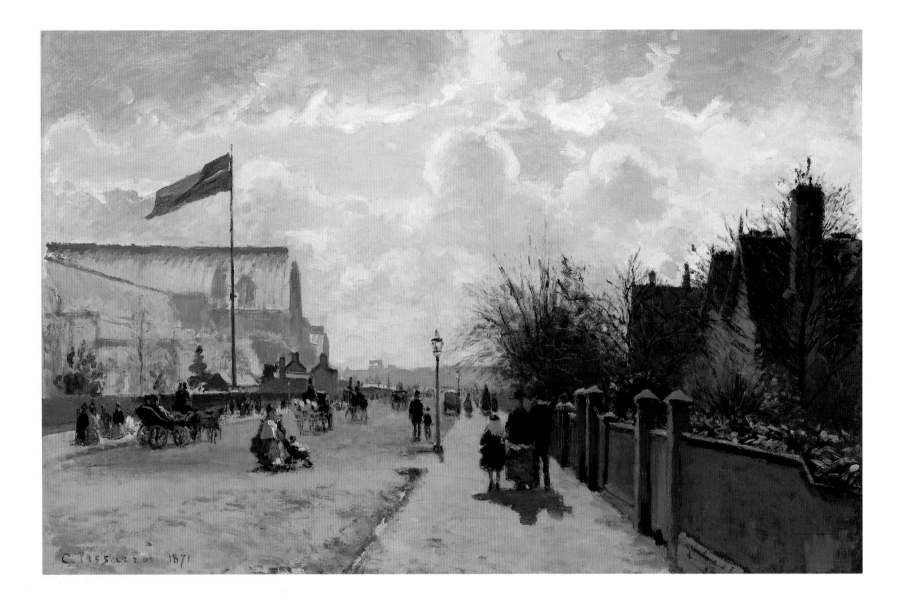

Camille Pissarro
French; 1830–1903

The Crystal Palace, 1871
Oil on canvas
47.2 x 73.5 cm (19 x 29 in.)
Gift of Mr. and Mrs. B. E. Bensinger, 1972.1164

Camille Pissarro painted nearly a dozen works, including *The Crystal Palace*, during his brief, self-imposed exile in England at the time of the Franco-Prussian War and the Paris Commune (1870–71). Fleeing his home in Louveciennes, near Paris, to avoid the Prussian invasion of France and subsequent civil uprising in the streets of the capital, he moved his family first to Brittany, on the coast of the English Channel, and then to Lower Norwood, outside of London. In the neighboring suburb of Sydenham, he encountered the soaring, glass-and-iron Crystal Palace. Originally designed by Joseph Paxton in 1851 to house Prince Albert's "Great Exhibition of the Works of Industry of All Nations" in London's Hyde Park, the structure—immediately acknowledged as a landmark of modern architecture—was dismantled and reassembled in Sydenham in 1853. (Fire destroyed it in 1936.)

Surprisingly, Pissarro chose to relegate what had been labeled the world's largest building to the left portion of the composition, while giving equal space to the recently constructed middle-class homes at the right and to the families and carriages parading down the street in the center. Perhaps the artist, who typically depicted rural settings, was initially captivated by the play of sunlight across two very different forms of contemporary construction; he established a striking juxtaposition between Paxton's impressive edifice and the ordinary row houses across the way by focusing on atmosphere rather than on disparity of scale. Rendering the Crystal Palace in a range of translucent, aquatic blues that blend into the swirling sky beyond, Pissarro lent the spectacular exhibition hall a light airiness that contrasts with the weighty solidity of the brick residences. Yet the painting accommodates both, presenting a balanced view of a unique, suburban landscape.

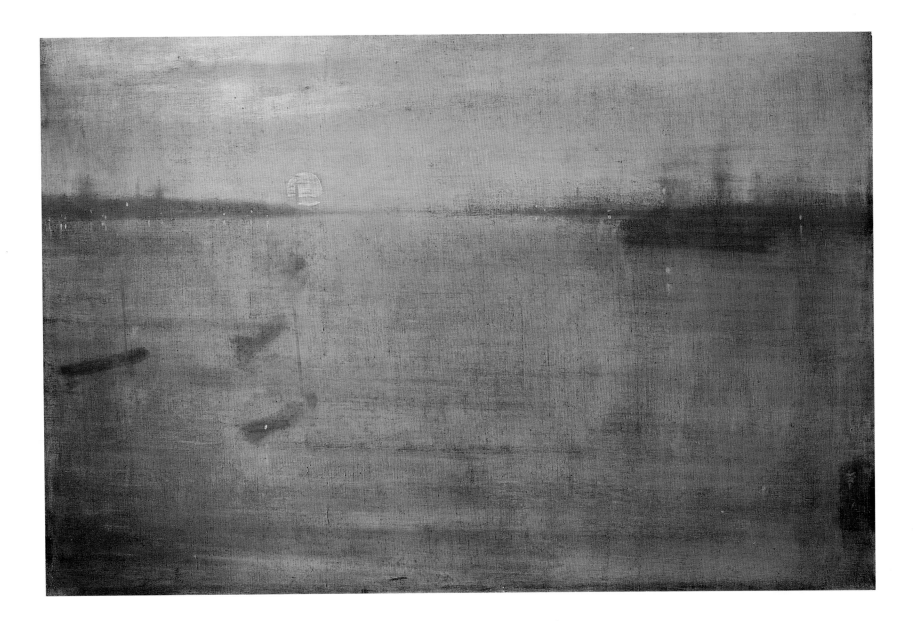

James McNeill Whistler
American; 1834–1903

Nocturne: Blue and Gold—Southampton Water,
1872
Oil on canvas
50.5 x 76 cm (19 7/8 x 29 15/16 in.)
Stickney Fund, 1900.52

In the early 1870s, James McNeill Whistler created a series of nearly abstract riverscapes that he called "nocturnes," in reference not only to their evening subjects but also to the harmonious musical compositions bearing the same name. Having abandoned his youthful adherence to Realism (see p. 18), Whistler now insisted that a painting should be an interpretation, rather than a literal depiction, of nature. *Nocturne: Blue and Gold—Southampton Water* exemplifies this aim. While it does represent an actual site—an inlet of the English Channel about eighty miles southwest of London—mood and atmosphere dominate, established by a subtle palette of blues and grays illuminated with touches of gold.

Victorian art critics responded to Whistler's nocturnes with incomprehension and even hostility. At this time, people generally valued works of art according to the amount of labor and ambition involved in their production; they were unprepared for the revolutionary idea that aesthetic considerations could take precedence over realistic observation. Even Whistler's title was provocative in its rejection of representation.

He explained, "By using the word 'nocturne' I wished to indicate an artistic interest alone, divesting the picture of any outside anecdotal interest which might have been otherwise attached to it. A nocturne is an arrangement of line, form, and colour first. The picture is throughout a problem that I attempt to solve. I make use of any means, any incident or object in nature, that will bring about this symmetrical result."

In his nocturnes, Whistler made a significant break with tradition, positing a new relationship between the artist and nature, and pointing the way toward nonobjective art. Mood is the work's true subject; tones and shades translate Whistler's nuanced perceptual experience of a specific scene into a two-dimensional pattern of paint on canvas.

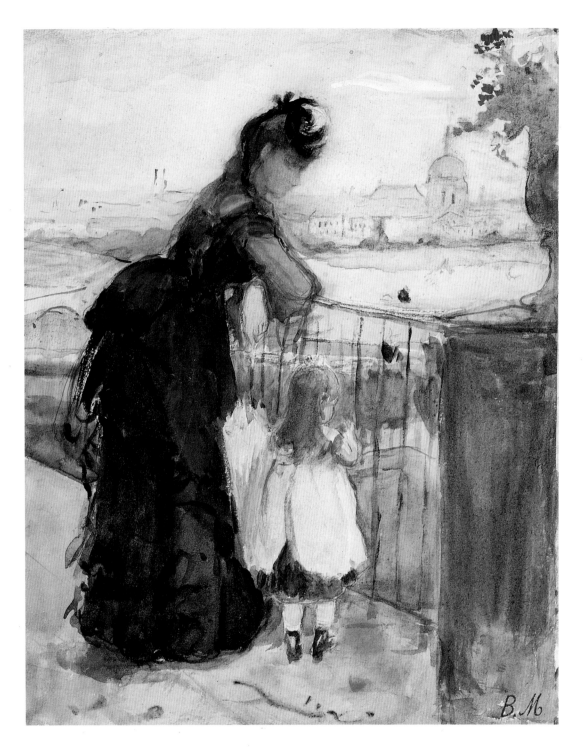

Berthe Morisot
French; 1841–1895

On the Balcony, 1871–72
Watercolor and gouache over graphite on off-white wove paper
20.6 x 17.3 cm (8⅛ x 6¹³⁄₁₆ in.)
Gift of Mrs. Charles Netcher in memory of Charles Netcher II, 1933.1

In 1876 Albert Wolff, writing in the popular Paris newspaper *Le Figaro*, described the artists who organized the first Impressionist exhibition as "five or six lunatics of which one is a woman." That woman was Berthe Morisot. Trained by Camille Corot (see p. 17) and mentored by Edouard Manet (see p. 46), Morisot had shown at the annual Salon as early as 1864. Ten years later, she rejected the conventional route to recognition and became a founding member of the Impressionist movement, remaining a staunch supporter through its final group exhibition, held in 1886.

Like her male colleagues, Morisot selected her subjects from the life that surrounded her. But as a bourgeois woman, her experiences were circumscribed by society's definitions of what was suitably feminine. The public sphere depicted by the male Impressionist painters—the café, the racetrack, the city street—was not Morisot's domain. Rather, as seen in *On the Balcony*, she drew her subjects from her own environment. While sheltered, she was by no means cut off from the world.

Here, Morisot infused the traditional mother-and-child theme with a refined, distinctively contemporary sensibility. The brush strokes that articulate the details of the woman's fashionable dress are as delicate and diaphanous as the material of the garment. A child stands near the adult, secure but not restricted. Together, they lean against the wrought-iron railing, sharing a view across the river of the Paris skyline, golden against a hazy sky. In devising her composition, Morisot may have recalled Manet's *On the Balcony* (1868–69; Paris, Musée d'Orsay), for which she had posed. However, whereas Manet's sitters face forward, Morisot preferred to turn her figures away from the viewer, preserving their modest anonymity.

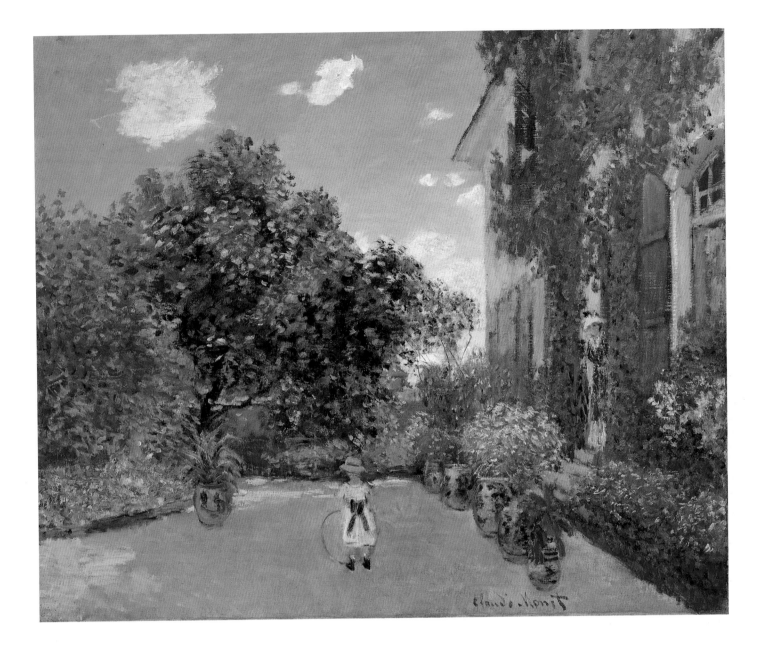

Claude Monet

French; 1840–1926

The Artist's House at Argenteuil, 1873
Oil on canvas
60.2 x 73.3 cm (23¹¹/₁₆ x 28⅞ in.)
Mr. and Mrs. Martin A. Ryerson Collection,
1933.1153

By 1873 Claude Monet's ongoing commitment to open-air painting and to unconventional, sketch-like finish forced him to seek exhibition venues outside the official Salon. He found a loyal dealer, Paul Durand-Ruel, and began to make plans with his artist colleagues to hold a series of independent shows, the first of which was held in Paris in 1874 (see p. 42).

Monet spent the summer before that historic exhibition in Argenteuil, a pleasant town fifteen minutes away from Paris by train. Enjoying—thanks to Durand-Ruel's purchases—a degree of prosperity for the first time in his career, Monet reveled in the comfort of his home. He designed and cultivated the lush garden seen here, and probably purchased the Dutch blue-and-white pots on a trip to Holland in the fall of 1871. His wife, Camille, appears in a doorway, and their son, Jean, plays with a hoop on the terrace. Weaving together short, staccato brush strokes, Monet created harmonious textures of leaves and light, figures and flowers. Even the shadow cast by the house is warm in tone, made up of yellow, mauve, and mellow gray. It is as if the artist wished to render permanent every aspect, however fleeting, of this idyll.

Unfortunately, Monet's success of the early 1870s did not last. In 1874 he and his family moved to cheaper quarters in Argenteuil, and, four years later, they returned to Paris. However, the artist did not relinquish his dream of an Impressionist garden. In 1883, almost twenty years later, Monet settled in Giverny, where he would again take up the landscape design that he had found so rewarding in Argenteuil (see p. 159).

Henri Fantin-Latour
French; 1836–1904

Still Life: Corner of a Table, 1873
Oil on canvas
96.4 x 125 cm (37¹⁵⁄₁₆ x 49³⁄₁₆ in.)
Ada Turnbull Hertle Fund, 1951.226

Although Henri Fantin-Latour produced many portraits (see p. 30) and subject pictures, the bulk of his output consists of still lifes, most of them flower pieces. The Art Institute's example is characteristic of Fantin in its meticulous draftsmanship and restrained handling, but its large size and formal audacity reflect his briefly held ambition to create still lifes expressly for the Salon, where he hoped to attract a French clientele. However, England remained the primary market for such works.

Fantin here reconfigured select still-life elements from *A Corner of the Table* (Paris, Musée d'Orsay), a group portrait of eight young poets he had painted the previous year, into an essay in refined decorative effects. A stark contrast between the dark walls and white tablecloth functions as the composition's organizing principle. Perhaps influenced by Edouard Manet's elimination of halftones, this strategy also reflects Fantin's fascination with the simplifications of Japanese woodblock prints. The rhododendron at the lower right, eccentrically cropped in the best Japanese manner, is silhouetted against the tablecloth to showcase the intricate pattern of its foliage; its purple blossoms sound delicate color chords with the yellow and orange fruits and maroon wine above. The silver, crystal, and porcelain objects are almost evenly distributed over the tabletop, another studiously artificial gesture. Below them is the superb linen tablecloth, its glistening threads rendered with discreet mastery.

Even more than Manet or Japanese prints, this work is redolent of English Aestheticism and its emphasis on rarefied formal effects. In particular Fantin's unorthodox use of a broad, white field was probably influenced by the "symphonies" in white by his friend the American expatriate painter James McNeill Whistler (see p. 28). *Still Life: Corner of a Table* thus reveals Fantin's divided aesthetic allegiances. Reconciling his commitment to visual "truth" with a more abstract, "musical" approach influenced by poet Charles Baudelaire and composer Richard Wagner (whose operas the artist represented many times), Fantin here produced a singular work that fuses the Realist and proto-Symbolist aspects of his art.

The French Impressionist Circle

Modern Subjects, Modern Styles, 1874–1886

Between 1874 and 1886, the painters who came to be known as "Impressionists" held eight independent exhibitions in Paris. At the first of these, Claude Monet showed a seascape entitled *Impression—Sunrise* (1872–73; Paris, Musée Marmottan) that gave the group its name. The Impressionist installations defied the standards of the annual, state-sponsored, juried Salons in several ways. Not only were the works (selected by the artists themselves) conspicuously innovative in terms of style and content, but they were hung in a single row at eye level, comfortably spaced and, in some cases, enclosed in plain frames painted white or in colors that complemented their palettes. All of this stood in contrast to the highly conventional, academically finished, ornately framed canvases that crowded, floor to ceiling, the walls of the Salon. In addition to Monet, the participants in the first Impressionist exhibition included Paul Cézanne, Edgar Degas, Berthe Morisot, Camille Pissarro (the only artist whose works appeared in all eight exhibitions), Pierre Auguste Renoir, and Alfred Sisley. Gustave Caillebotte, Mary Cassatt, Paul Gauguin, Odilon Redon, and Georges Seurat were among those who contributed to subsequent shows.

The painters who participated in the Impressionist exhibitions were extremely diverse, with differing styles, backgrounds, personalities, and political views. Some studied their craft at the Ecole des beaux-arts, Paris, but they learned different lessons from the work of slightly older colleagues including Camille Corot and Edouard Manet, from new sources such as the Japanese

woodblock prints that had recently become available in Europe, and, perhaps most importantly, from one another. With technical innovations such as broken, flickering brushwork; irregularly cropped compositions; and bright, high-keyed color schemes, the Impressionists transformed the traditional artistic genres of landscape, portraiture, and still life. They also addressed self-consciously modern themes: the spaces of the expanding, industrial city; the boundaries between public and private life in bourgeois society; and the relationship between nature and the work of art.

Critical response to the paintings, pastels, prints, and sculpture produced by the Impressionists was often quite vehement. Caricaturists and conservative critics were offended by what they perceived as lack of finish and disregard of academic notions of beauty and composition. However, other writers and a few enlightened patrons recognized the importance of the Impressionist revolution. The Art Institute's collections demonstrate the wide range of subjects and styles that comprised Impressionism at the very moment of its definition: from the airy, colorful harmony conveyed by Renoir's *Lunch at the Restaurant Fournaise (The Rowers' Lunch)* (p. 45), included in the second Impressionist exhibition, in 1876; to Seurat's scientifically based *Sunday on La Grande Jatte—1884* (p. 79), displayed in 1886 at the eighth and last group show, which effectively marked the culmination of Impressionism and inaugurated a new era in modern painting.

Jean Baptiste Armand Guillaumin

French; 1841–1927

The Arcueil Aqueduct at Sceaux Railroad Crossing, 1874
Oil on canvas
51.5 x 65 cm (20¼ x 25⁹⁄₁₆ in.)
Restricted gift of Mrs. Clive Runnels, 1970.95

During the early years of his career, Armand Guillaumin—whose working-class family did not support his ambition to become an artist—held a series of low-ranking administrative posts to make ends meet. While employed by the Paris–Orléans railway, he began painting the countryside around the capital. The subject of this canvas is a new aqueduct, constructed in early 1874, that crosses over the tracks of the suburban Sceaux line in Arcueil, just south of Paris. Listed in contemporary guidebooks as a major tourist site, this was the latest in a series of regional water channels dating back to the Roman era.

In Guillaumin's painting, passengers await the train at a small, covered station just beyond the aqueduct, while pedestrians, notably several well-dressed women with parasols, can be seen strolling along the road at the left. Between the tracks and the road lies a triangle of foliage, which Guillaumin sketched in thick, short strokes of brightly colored pigment that demonstrate his refined Impressionist technique.

The railroad symbolized modern technology for many of Guillaumin's contemporaries. It also played a crucial role in allowing the urban middle class (to which most of the Impressionists belonged) to make leisurely excursions to the suburbs and outlying villages. Around this time, Arcueil became an increasingly popular retreat, situated as it was in a picturesque valley only a short distance from Paris. *The Arcueil Aqueduct at Sceaux Railroad Crossing*, painted the year of the first Impressionist exhibition, may have been one of the dozen canvases Guillaumin contributed to the group's third show, held in Paris in 1877. There, it would have joined other representations of the train motif: Claude Monet's paintings of Gare St.-Lazare (see p. 54).

Pierre Auguste Renoir

French; 1841–1919

Lunch at the Restaurant Fournaise (The Rowers' Lunch), 1875
Oil on canvas
55.1 x 65.9 cm (21¹¹⁄₁₆ x 25¹⁵⁄₁₆ in.)
Potter Palmer Collection, 1922.437

Pierre Auguste Renoir is beloved for his images of bourgeois leisure in urban and suburban Paris, such as the radiant *Lunch at the Restaurant Fournaise (The Rowers' Lunch)*, shown at the second Impressionist exhibition, in 1876. Painted at Chatou, a village along the Seine, it is a paean to the joys of youth and summer, a celebration of the rituals of friendship and the bounties of nature, with its seasonal rhythms of rest and play. Two young men lounge at a table; between them is a young woman seen from the back, wearing the blue flannel then favored by female boaters. The interchange between the figures is unclear, since Renoir avoided linking his picture to a specific narrative. Instead, he evoked a mood of conviviality. The fruit, wine, and wineglasses on the table and the way the boater languidly reclines in his chair, casually holding a cigarette, indicate that lunch is over.

Renoir's loose brushwork suggests the slightly fuzzy state of torpor that accompanies satiety. Contours blur, merging into one another and into the surrounding atmosphere, immersing the whole scene in soft and shifting light, with whites tinted by reflections and bluish shadows. The resulting dappled effect is enclosed in the stricter rhythm of the trellis, which serves as a permeable barrier between terrace and river.

Suffused with warmth, *Lunch at the Restaurant Fournaise* is a picture of perfect harmony, a vision of a golden age located not in the ancient past but in the present. Although Renoir's world is distinctly modern, the good life he portrayed is based on simple pleasures: friendship, food, wine, sunshine. His focus on people and the lively delicacy with which he conjured softly flickering light mark his uniquely appealing contribution to Impressionism.

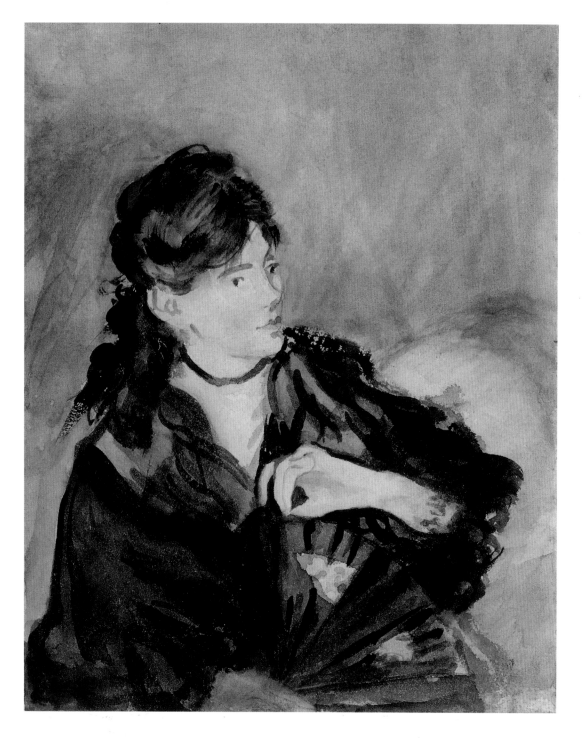

Edouard Manet
French; 1832–1883

Portrait of Berthe Morisot, 1874
Watercolor over traces of graphite on
off-white wove paper
20.9 x 16.8 cm (8³/₁₆ x 6⁵/₈ in.)
Helen Regenstein Collection, 1963.812

Edouard Manet met the artist Berthe Morisot (see
p. 38) in 1868, when they were introduced by
Henri Fantin-Latour. Over the next several years,
Morisot often served as Manet's model, figuring
in no fewer than ten of his paintings, most of
them intimate, informal portraits that reveal his
fascination with her as a physical presence. The
end of their collaboration roughly coincided with
Morisot's marriage to Manet's brother Eugène in
1874. This watercolor is closely related to a paint-
ing, traditionally regarded as the last in the series,
in which Morisot appears in the same pose but set
against palm leaves and a bit of upholstery (1874;
Paris, private collection). The freshness, delicacy,
and freedom of the Art Institute's sheet suggest
that it is a preliminary study for the oil rather
than a copy after it.

Here, as in many of Manet's depictions of
her, Morisot strikes an eccentric pose: leaning
slightly to the left and gazing off to the right, she
holds in her right hand an open fan, steadying its
vertical tip between the thumb and two middle
fingers of her left hand, the remaining two digits
of which are splayed. The tremulous forms of the
latter stand out against her black shawl, donned in
mourning for her father, who had died the previ-
ous January. Morisot's prominent chin, upturned
nose, and lips—more voluptuous here than in
the painting—are rendered with a gentle econ-
omy, as are her eyes, which telegraph a nervous
vulnerability. Even so, the figure as a whole con-
veys intelligence, grace, and social aplomb.
Although Manet further accentuated these quali-
ties in the more considered oil, it is this sheet that
most strongly conveys the intensity and complex-
ity of his immediate response to Morisot.

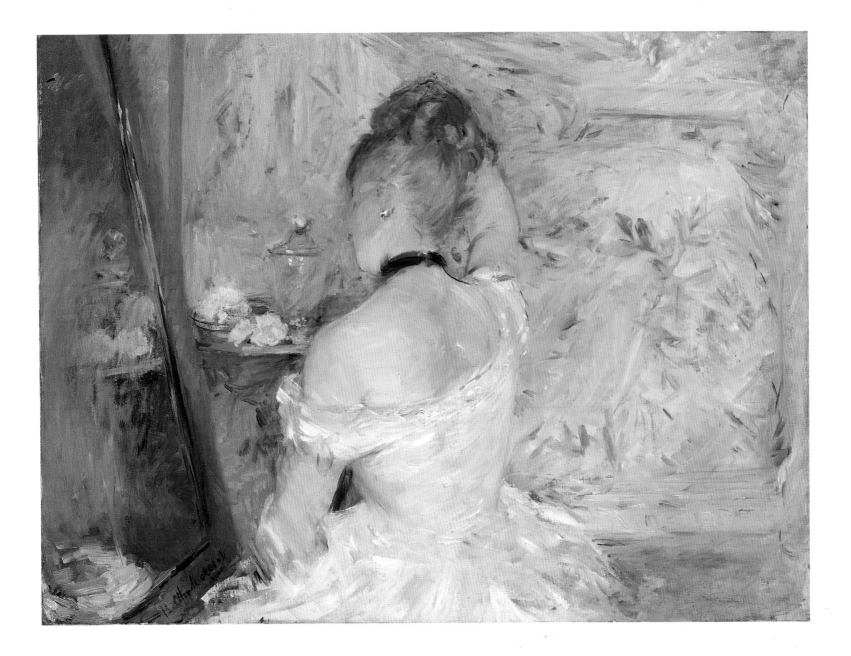

Berthe Morisot
French; 1841–1895

Woman at Her Toilette, c. 1875
Oil on canvas
60.3 x 80.4 cm (23¾ x 31⅝ in.)
Stickney Fund, 1924.127

The image of a woman before a mirror intrigued diverse artists of the nineteenth century, including Jean Auguste Dominique Ingres, Edouard Manet, and Mary Cassatt. At first glance, Berthe Morisot's *Woman at Her Toilette* appears to conform to typical examples of the subject. A woman, seated at a dressing table in the privacy of her chamber, is lost in a reverie; she seems to contemplate her reflection before her. However, a closer examination of Morisot's composition, following the angle of the woman's inclined head, reveals that she gazes downward rather than into the mirror. And the reflection shows not her features but the sheen of the cosmetic containers and the pale petals of the flower on a nearby table. By denying us a glimpse of the model's face, Morisot broke with the convention of using the mirror as a means to double the voyeuristic pleasure of glancing at a woman unawares. As a result of this unexpected complication, we are made to consider the state of being looked at, even while engaged in the act of looking.

The painting's sensuous quality resides as much in Morisot's technique as in her subject. Every tone of her subtle palette—silver gray, pastel pink, pale blue, and pearlized white—shimmers with a rich opalescence. Applying her creamy paint in feathery brush strokes, Morisot dissolved the surface of the wall behind the figure, whose gracefully curved back and columnar arms appear as the only solid forms in the room. Whereas Cassatt's images of women are descriptive, the result of keen observation and firm draftsmanship, Morisot's are suggestive, implied by nuance of color and lightness of touch.

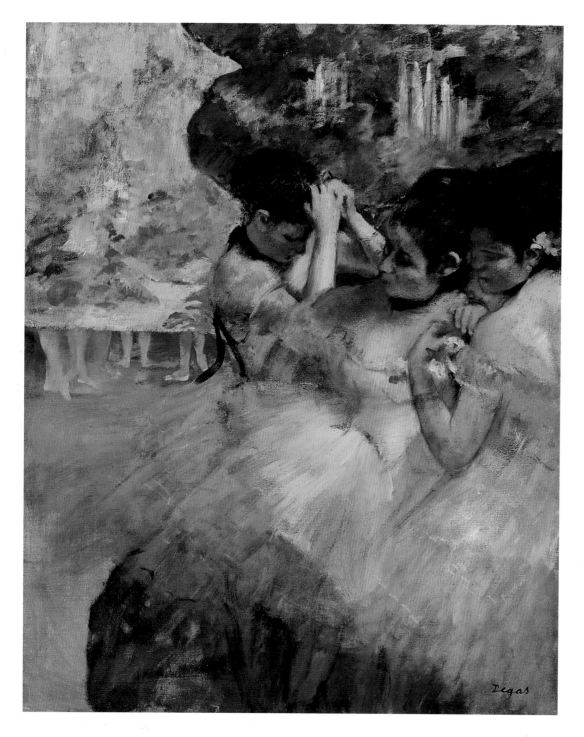

Hilaire Germain Edgar Degas
French; 1834–1917

Yellow Dancers (In the Wings), 1874/76
Oil on canvas
73.5 x 59.5 cm (28¹⁵/₁₆ x 23⁷/₁₆ in.)
Gift of Mr. and Mrs. Gordon Palmer, Mr. and
Mrs. Arthur M. Wood, Mrs. Bertha P. Thorne,
and Mrs. Rose M. Palmer, 1963.923

Approximately half of Edgar Degas's entire output of paintings and pastels concerns dancers. Perhaps he recognized a parallel between their art—in which precise, demanding techniques are made to appear effortless and beautiful—and his own. Examining the dancer at rest, in rehearsal, behind the scenes, and onstage, he took an almost documentary approach to this subject. Among the twenty-four works shown by Degas at the second Impressionist exhibition, in 1876, were several ballet scenes, including the Art Institute's *Yellow Dancers (In the Wings)*.

Degas executed *Yellow Dancers* quickly and confidently, applying paint thinly and making few alterations after it had dried. Three ballerinas preen in the foreground of this radical composition. Absorbed in the task of adjusting their costumes, they are bathed in light that seems to be filtered through golden gauze. Their curvaceous forms echo the shape of the stage flat behind them; beyond that artificial barrier, we glimpse the calves and feet of a number of dancers. Such unexpected juxtapositions, cut-off forms, and two-dimensional patterning—effects Degas had absorbed from Japanese woodblock prints—heighten the sense of immediacy.

Degas's preoccupation with dancers was social as well as formal: he often made quite explicit references in his work to the backstage interactions that took place between female performers and their gentlemen patrons. The women's primping, therefore, is not only for the ticket-holding audience, but for other onlookers as well—in this case, the artist himself and the painting's viewers.

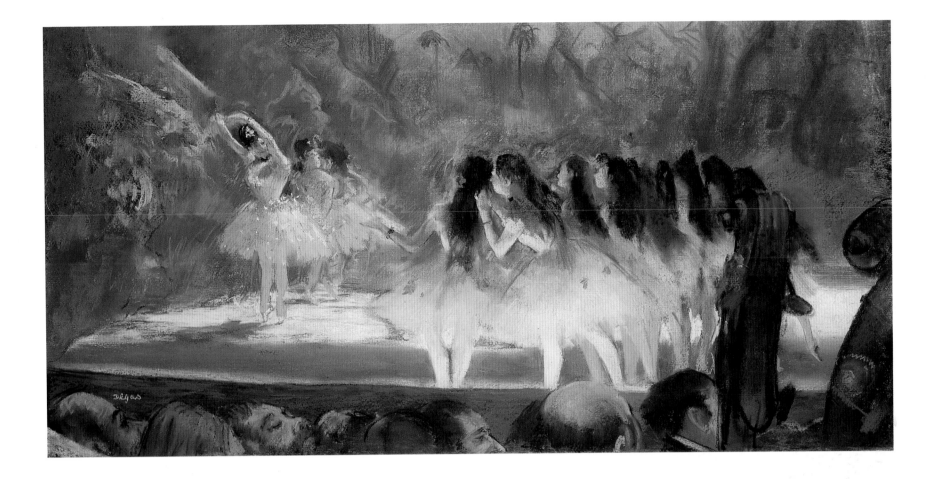

Hilaire Germain Edgar Degas
French; 1834–1917

Ballet at the Paris Opéra, 1876/77
Pastel over monotype on cream laid paper
Plate: 35.2 x 70.6 cm (13⅞ x 27¹³/₁₆ in.);
sheet: 35.9 x 71.9 cm (14⅛ x 28⁵/₁₆ in.)
Gift of Mary and Leigh Block, 1981.12

Probably displayed at the third Impressionist exhibition, in 1877, Edgar Degas's *Ballet at the Paris Opéra* provides a view of a stage from the orchestra pit, where the artist stationed himself to observe various activities taking place during a rehearsal. Along the bottom of this bold composition, musicians and male admirers crane their necks to catch a glimpse of their favorite ballerinas; at the near edge of the stage, several young dancers flutter hesitantly, fidgeting with their costumes and whispering in one another's ears. They watch the principal dancer, who is on point, bathed in a pool of pinkish light; behind her are the faint forms of other dancers preparing to move forward into the spotlight. The stage flats seem to depict a tropical scene.

Degas experimented with mixed-media techniques throughout his career. For *Ballet at the Paris Opéra*, he first created a monotype—a unique print made by drawing and painting with black-brown ink on a metal plate and running it through a printing press—and then covered it with pastel. The dark monotype image, although obscured by the chalky pigment placed over it, gives the picture a shadowy, mysterious aura, while the pastel mimics the effects of artificial light and the textures of hair, skin, tulle, wood, and glitter.

The Opéra was more than a theater where performances took place; it was also an institution for teaching, training, and rehearsing, as well as a club for subscribers, who were allowed backstage. Degas was irresistibly drawn to the visual, musical, and social spectacle of the Opéra. With unsurpassed acuity, he captured both the harsh reality and lush fantasy that characterized this quintessentially modern realm.

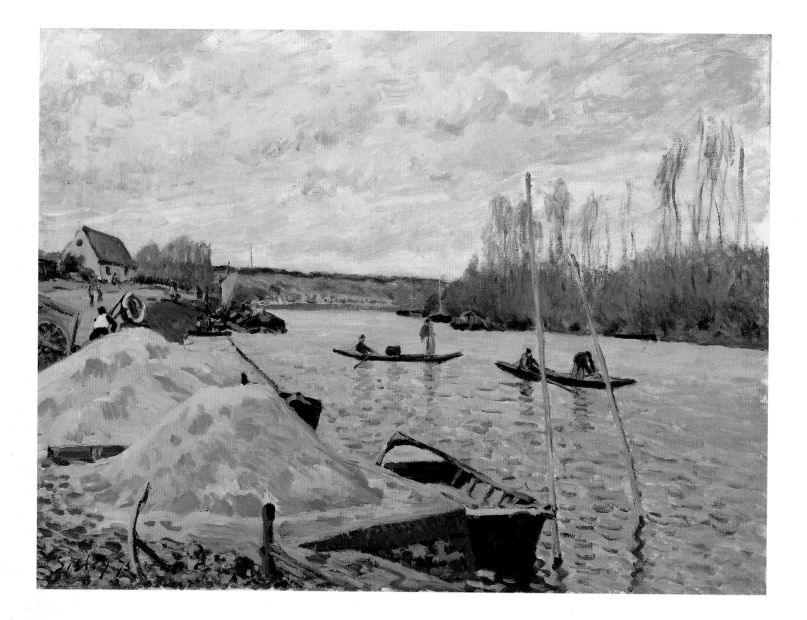

Alfred Sisley
French; 1839–1899

The Seine at Port-Marly: Piles of Sand, 1875
Oil on canvas
54.5 x 73.7 cm (21⁷⁄₁₆ x 29 in.)
Mr. and Mrs. Martin A. Ryerson Collection,
1933.1177

Alfred Sisley painted this river scene within walking distance of the house in which he briefly lived in Marly-le-Roi, a western suburb of Paris. Concentrating almost exclusively on landscape throughout his career, Sisley never developed a dedicated following among critics or patrons associated with Impressionism. Perhaps this was because he resisted portraying bourgeois leisure activities, preferring instead to record the routine tasks of local inhabitants in their rustic environs. Sisley's focus on labor, as seen in *The Seine at Port-Marly: Piles of Sand*, distinguishes his work from that of his artist colleagues such as Claude Monet and Pierre Auguste Renoir, who often depicted rivers as sites for pleasure boating (see pp. 33, 45).

The subject of this canvas is the dredging of sand from the bottom of the Seine in order to permit the passage of large, heavy barges between the port city of Le Havre and Paris. Standing in small boats, workers lower buckets into the water. The sand they collect was then massed on the riverbank, in piles such as those at the lower left, and sold to building contractors and gardeners. Two slender poles at the lower right, used by the laborers as moorings, anchor the composition.

While living in Marly-le-Roi, Sisley dramatically increased his artistic productivity and developed his mature Impressionist style, which is distinguished by a high-keyed, harmonious palette and skillfully balanced but never overworked compositions. Here for example he sketched the trees across the river with only a bare minimum of strokes, and applied cool turquoise and aquamarine in the river so loosely as to reveal the primed canvas beneath. When Henri Matisse asked Camille Pissarro in 1902, "Who is a typical Impressionist?" Pissarro answered without hesitation, "Sisley."

Pierre Auguste Renoir
French; 1841–1919

Alfred Sisley, 1875/76
Oil on canvas
66.4 x 54.8 cm (26⅛ x 21⁹⁄₁₆ in.)
Mr. and Mrs. Lewis Larned Coburn Memorial
Collection, 1933.453

Pierre Auguste Renoir and Alfred Sisley (see p. 50) had known each other for more than ten years, having met in the studio of Charles Gleyre in 1862, when Renoir executed this portrait. Although the two men were of different backgrounds—Sisley came from a middle-class family and had initially intended to join his father's business, while Renoir, the son of a tailor and a dressmaker, had trained as an apprentice porcelain painter—they shared a passion for art. Renoir later recalled their student excursions to picturesque areas outside of Paris: "I would take my paint box and a shirt, and Sisley and I would leave Fontainebleau, and walk until we reached a village. Sometimes we did not come back until we had run out of money a week later."

In Renoir's portrait, Sisley sits casually astride a bamboo chair, resting his head on his left hand, his eyes lowered and gently averted. The shallow, dark room is pierced only by a window at the upper right. Although the composition's dominant tonality is blue, its mood is not melancholy; rather, Sisley appears thoughtful and serene, something of a dreamer. No clues, such as brushes or a palette, hint at his vocation, so perhaps Renoir intended to refer to his subject's identity as an artist more indirectly, through his romantic characterization.

This was one of six portraits that Renoir sent to the third Impressionist exhibition, held in 1877. The work can be seen as a document of the two men's shared aim, at this point in their careers, to achieve artistic success through avant-garde rather than official means, and of Renoir's specific aspiration to become known as a portrait painter. More importantly, however, its affectionate quality makes it a represention of friendship.

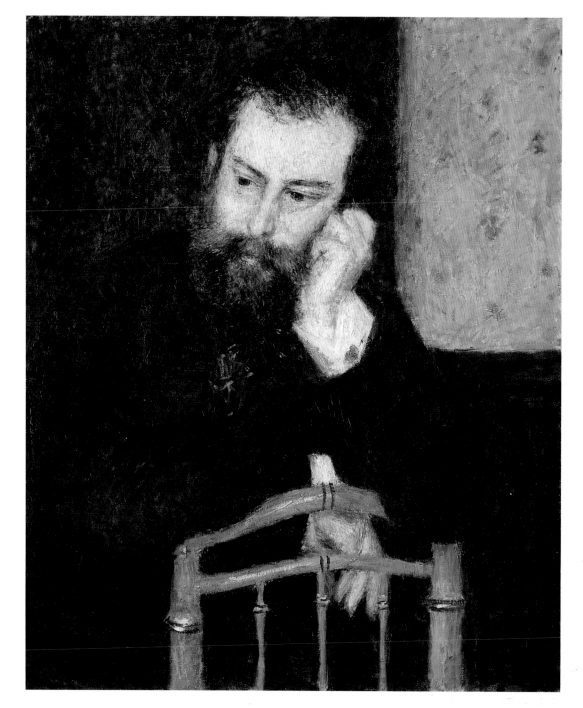

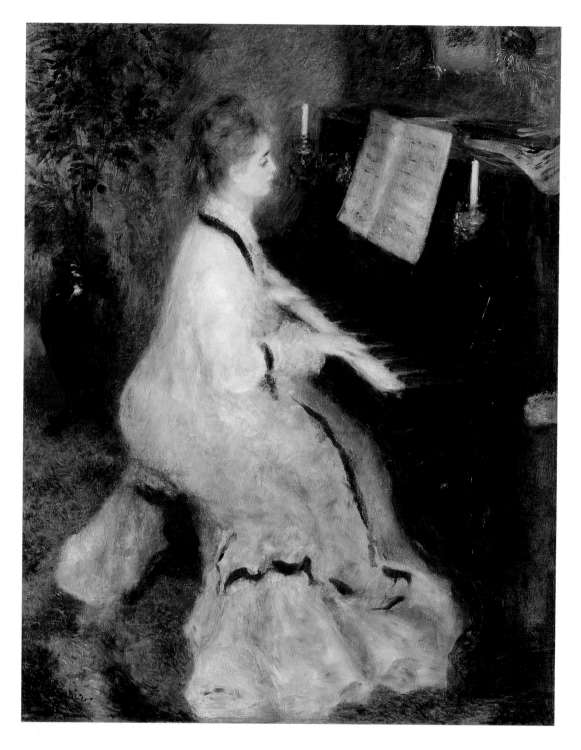

Pierre Auguste Renoir

French; 1841–1919

Woman at the Piano, 1875/76
Oil on canvas
93.2 x 74.2 cm (36⅝ x 29½ in.)
Mr. and Mrs. Martin A. Ryerson Collection,
1937.1025

Pierre Auguste Renoir was one of the most dedicated figure painters among the Impressionists. Enveloping his subjects, who were usually female, in an aura of fantasy and sensuality, he created a confident, immensely appealing art. Like Camille Corot (see p. 34), Mary Cassatt (see p. 58), and others, Renoir often painted women in domestic interiors, either daydreaming or reading. In this painting, he depicted for the first time a model playing the piano, a subject to which he would frequently return.

The setting is richly appointed, with a patterned carpet, fabric-covered walls, a potted plant, and luxurious curtains. A pretty, young woman sits before a piano, her luminous, pink hands caressing the keyboard. Her performance seems effortless, like her beauty, as if the ravishing visual harmony she embodies extends naturally into the realm of sound. Her dress is a confection of white, diaphanous fabric over a bluish underdress, offset by a winding, dark band; it takes on, through the magic of Renoir's brush, a life of its own, its brilliant play of chromatic harmonies and counterpoint of sinuous and cascading rhythms suggesting the notes produced by the instrument. Designed to conceal, the garment also reveals, as we see from the glints of pink flesh picked out on the musician's shoulder and arm.

Woman at the Piano is not a portrait of an individual, nor a study of a social type. It is a portrayal of ideal womanhood, of a goddess transported from the heavens to a modern drawing room uncomplicated by the contingencies of the real world. The artist/performer is Renoir, the palette is his keyboard, and the woman at the piano is wholly his creation.

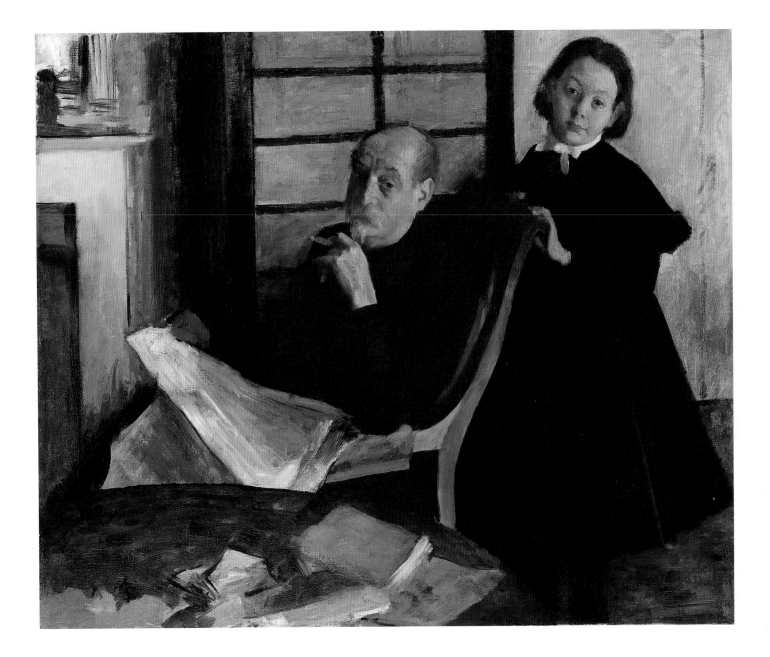

Hilaire Germain Edgar Degas
French; 1834–1917

Uncle and Niece (Henri Degas and His Niece Lucie Degas), 1875
Oil on canvas
99.8 x 119.9 cm (39¼ x 47³/₁₆ in.)
Mr. and Mrs. Lewis Larned Coburn Memorial Collection, 1933.429

Edgar Degas is often thought of as a quintessential Parisian—yet his family was as much Italian as it was French, and more of his relatives lived in Naples and Florence than in Paris. In the mid-1870s, when the Impressionists were organizing their first group exhibitions in the French capital, Degas had to make several trips to Naples to deal with family business. During a four-month stay in 1875, he painted this double portrait of his young, orphaned cousin Lucie and her bachelor uncle Henri, in whose care she had recently been placed. The work sensitively depicts two people separated by many years in age, who are tentatively accepting their new circumstances. Having lost his own father the previous year, Degas empathetically captured the atmosphere of loneliness and melancholy that must have suffused the household. Both Henri and Lucie wear heavy, black mourning clothes; they tilt their heads at the same angle and direct their gazes toward the artist.

Degas created this complex portrait with very economical means. He limited his palette to yellows, browns, black, and white, and applied the paint in long, straight strokes, deliberately leaving some areas of the canvas unresolved. Because the two figures seem to have been interrupted by his arrival in the room, the scene has an almost photographic aspect. Yet it is far from casual: Degas organized the composition into careful, even rigid, geometric areas that both link and divide uncle and niece. Although they share a home and engage in quotidian activities together—Lucie has probably just been reading the newspaper over her uncle's shoulder—their future together is unclear. *Uncle and Niece (Henri Degas and His Niece Lucie Degas)* is a penetrating study of familial relationships, with their implied physical and psychological resemblances, and their potential affinities and estrangements.

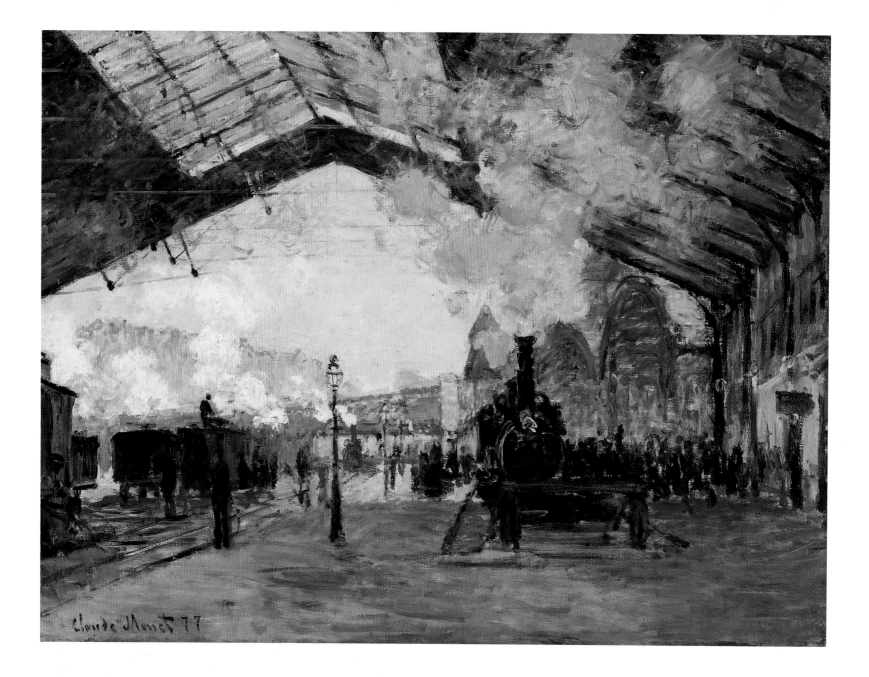

Claude Monet
French; 1840–1926

Arrival of the Normandy Train, Gare Saint-Lazare, 1877
Oil on canvas
59.6 x 80.2 cm (23 ½ x 31 ½ in.)
Mr. and Mrs. Martin A. Ryerson Collection,
1933.1158

Among Claude Monet's contributions to the third Impressionist exhibition, in 1877, was a groundbreaking group of seven paintings of Gare St.-Lazare, the famous Parisian train station serving the suburbs along the Seine valley, as well as Normandy and Brittany. Installed together in one room, these works constituted Monet's first series, a deliberate attempt to explore in multiple canvases a single subject at different times of day and under various atmospheric conditions.

The railway system effectively linked the country with the city. Monet frequently rode trains into and out of Paris, and although he was not a committed urbanite—in contrast to his Impressionist contemporary Edgar Degas for example—he was clearly aware of and fascinated by agents of industrial change. Rather than celebrating modern machines and buildings for their own sake, however, Monet explored in his art their power to transform nature. In *Arrival of the Normandy Train, Gare Saint-Lazare*, he seems to have asked: how do steam clouds pervade the air; how does a glass-and-iron roof filter sunlight; how do individuals disappear in a crowd?

Monet established this apparently straightforward composition by balancing the left-of-center peak of the shed over a train that thunders in toward the right. Order and disorder, in equal measure, pervade both the surface of the canvas and the scene itself; legend has it that Monet persuaded a station master to load standing engines with coal so that they would generate steam for him to portray. Thus, the quintessential painter of landscape evoked the controlled chaos of the urban environment, and of modernity itself.

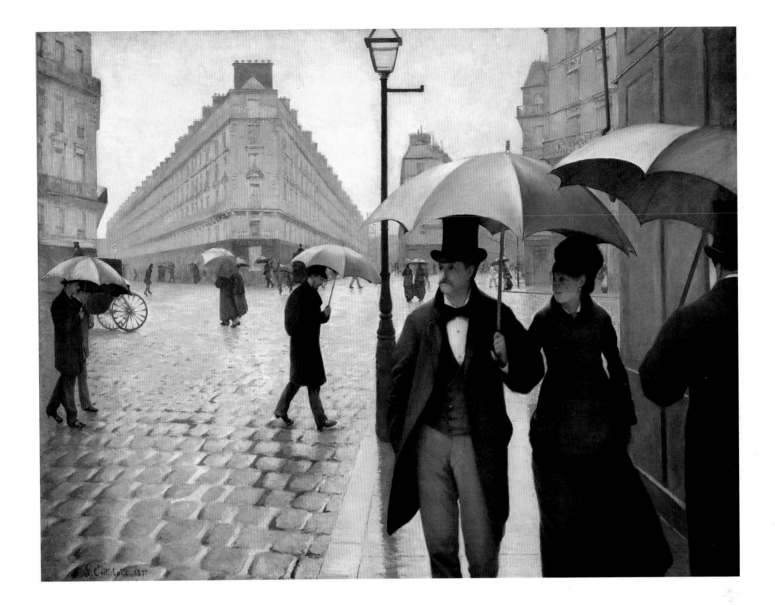

Gustave Caillebotte
French; 1848–1894

Paris Street; Rainy Day, 1877
Oil on canvas
212.2 x 276.2 cm (83½ x 108¾ in.)
Charles H. and Mary F. S. Worcester Collection,
1964.336

Gustave Caillebotte, who was independently wealthy, helped to finance and organize several of the Impressionist exhibitions, including the third, which was held in Paris in 1877 and featured his own monumental *Paris Street; Rainy Day*. This painting is a spectacular portrait of the French capital, with its broad boulevards and tunneling vistas, as it was radically reconfigured under Prefect Baron Georges Eugène von Haussmann. Scaffolding is visible in the far background, just to

the right of the center lamppost, suggesting that the city's controversial "Haussmannization" was still in progress. Caillebotte himself owned property near this intersection in the prosperous eighth arrondissement. Populated with fashionable women and men, as well as with workers of various sorts, the canvas is an impressive rendition of the new urban environment that the artist both observed and inhabited.

Caillebotte and his Impressionist colleagues shared an interest in the strikingly modern spaces of Paris. But Caillebotte's work—unlike Claude Monet's atmospheric renderings of train stations (see p. 54) or Pierre Auguste Renoir's anecdotal images of popular entertainment venues (see p. 57)—focuses on the psychology of individual experience. Relying on draftsmanship more than on texture or color, in *Paris Street; Rainy Day* he cre-

ated a composition that combines apparent spontaneity with precise choreography. Each well-dressed couple or individual strolls in a different direction, avoiding eye contact; no narrative incidents result from their random proximity. Yet the figures do relate to one another formally, for their glances, postures, and relative sizes all complement and reinforce the converging diagonals that dictate the painting's perspective.

With its large scale, methodical design, and curious stillness, Caillebotte's *Paris Street; Rainy Day* perhaps finds its closest counterpart not in the work of the Impressionists but in that of their successor Georges Seurat, who painted his *Sunday on La Grande Jatte—1884* (p. 79) less than a decade later.

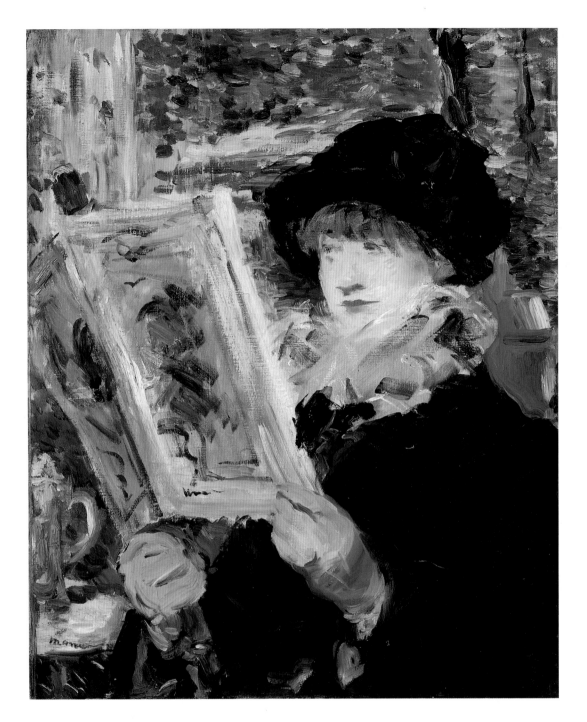

Edouard Manet

French; 1832–1883

Woman Reading, 1878/79
Oil on canvas
61.2 x 50.7 cm (24 1/16 x 19 7/8 in.)
Mr. and Mrs. Lewis Larned Coburn Memorial
Collection, 1933.435

Around 1870 Edouard Manet adopted the blonde palette favored by the Impressionist circle, at the same time selectively transmuting his own brand of summary handling into a still more immediate, rapid-fire manner. *Woman Reading* is one of several paintings from this phase of his career, during which he portrayed Parisian drinking and theatrical venues. The sketchiest of the series, this canvas also appears to be the simplest. However, looks can be deceiving.

Manet here depicted a fashionably dressed young woman sitting in a café or brasserie—presumably outside, for she remains bundled up. She holds an illustrated journal, one of the periodicals provided for the establishment's clientele. But it is not clear that she is reading; she might be using the large pages to screen surreptitious looks coming from her right. In any event, there seems to be a hint of avidity in her expression. The landscape behind her, rendered in quick dabs of green, blue, and red, might be an adjacent garden; then again it could be a decorative mural, as is suggested by the waterfall-like passage of blue over her left shoulder.

In *Woman Reading*, Manet seems to have reveled in the commercialized pleasures and studied self-presentations that animated Paris. Following his lead, we delight in the smeary yet elegant gloved hands; the lightly applied, "whipped" strokes of the collar; and the teasing evocation of the journal's cover illustration, which hovers on the brink of legibility. Far from being incidental, such virtuosic, playfully ambiguous passages embody Manet's response to the Impressionism practiced by his younger colleagues. Shaped by his urbane pictorial intelligence, this active surface, like the image as a whole, celebrates the elusive, equivocal character of modern representation.

Pierre Auguste Renoir

French; 1841–1919

Acrobats at the Cirque Fernando (Francisca and Angelina Wartenberg), 1879
Oil on canvas
131.5 x 99.5 cm (51¾ x 39⅛ in.)
Potter Palmer Collection, 1922.440

In works such as *Acrobats at the Cirque Fernando (Francisca and Angelina Wartenberg)*, Pierre Auguste Renoir signaled his interest in the themes of urban leisure favored by fellow Impressionists such as Edgar Degas (see p. 49). The Cirque Fernando, which opened in Montmartre in June 1875, was a venue that attracted enthusiastic crowds, including many artists. Here, Renoir depicted Francisca and Angelina Wartenberg, members of an itinerant German acrobatic troupe, gracefully taking their bows and gathering the tissue-wrapped oranges that appreciative audience members have tossed into the ring.

Although Renoir's brother, an art critic, described this work as "a faithful painting of modern life," in fact the artist adjusted and transformed the reality of the Cirque Fernando in several ways. He portrayed Francisca and Angelina Wartenberg as being much younger than their actual respective ages of fourteen and seventeen. Moreover, he had them pose in his studio, where he could paint them in natural light, which he found to be more flattering than the gaslight of the circus.

Renoir created a visual harmony by building up forms with thin washes of paint, using delicate, multidirectional brushwork. His highly arbitrary color scheme emphasizes this, with the yellows and oranges of the circus floor appearing in the girls' costumes, as well as in the delicate reflections of their skin tones. Situating the black-clad male spectators along the top of the sunny scene, Renoir scarcely hinted at their potential role as patrons of female circus performers such as the Wartenbergs. His vision of modern life sought only its poetry, not its unsavory side, and *Acrobats at the Cirque Fernando* appears no less fresh and spontaneous for having been carefully constructed.

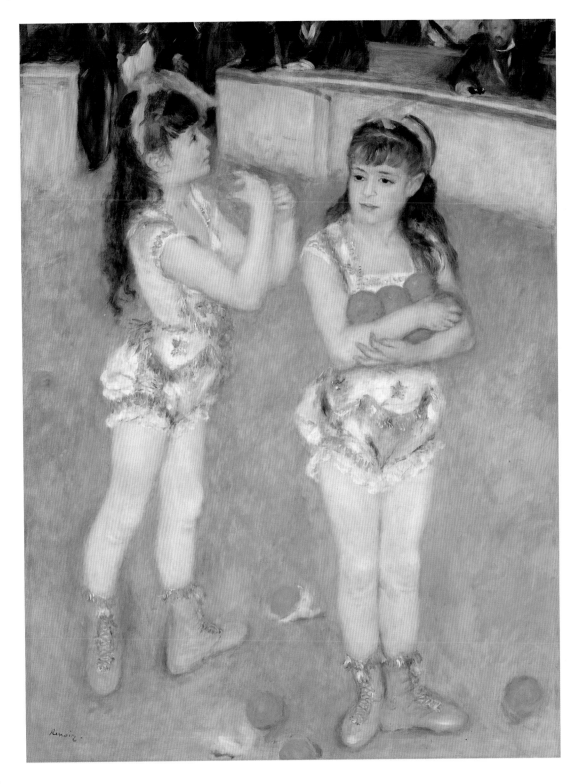

Mary Cassatt

American; 1844–1926

Evening, 1879–80
Soft-ground etching and aquatint on cream
laid paper
Plate: 19.2 x 21.8 cm (7⁹/₁₆ x 8⁹/₁₆ in.);
sheet: 23.7 x 32.1 cm (9⁵/₁₆ x 12⁵/₈ in.)
Albert H. Wolf Memorial Collection, 1938.33

In the print *Evening*, Mary Cassatt evoked the
tranquility of domestic life. Although in close
physical proximity, the two figures seem barely
aware of each other. Absorbed in their own en-
deavors—one reading, the other mending—they
enjoy a quiet night at home. While comfortable

together, they are also respectful of each other's
need for individual concentration. Well before
Cassatt accepted Edgar Degas's invitation in 1877
to exhibit with the Impressionists, she explored
subjects of modern life, keenly observing the daily
activities of her own household. The models for
Evening were her mother, Katherine, and her sis-
ter, Lydia; by presenting them from a close but el-
evated point of view, Cassatt struck a delicate
balance of familiarity and objective distance.

The mood of *Evening* is further enhanced by
Cassatt's bold approach to her medium. She es-
tablished the structure of the composition in soft-
ground etching, in which a sticky, tallow-based
ground is covered with a sheet of drawing paper

to allow the artist to create the design with a pen-
cil rather than a needle. For rich tonality, Cassatt
applied broad areas of aquatint, a resinous ground
that creates a subtle textural surface when the
plate is immersed in acid. Degas had urged
Cassatt to try printmaking, planning in 1879 to
produce a journal entitled *Le Jour et la nuit* (Day
and Night) that would feature their etchings.
Evening may have been intended for this publica-
tion, but the project was never realized. Cassatt's
interest in the medium continued, and she be-
came one of the most innovative printmakers in
the Impressionist circle.

Camille Pissarro

French; 1830–1903

Twilight with Haystacks, 1879
Aquatint and drypoint in red-orange ink
on ivory laid paper
Plate: 10.3 x 18.1 cm (4 1/16 x 7 1/8 in.);
sheet: 12.7 x 20.3 cm (5 x 8 in.)
Clarence Buckingham Collection, 1979.650

Twilight with Haystacks, 1879
Aquatint and drypoint on paper
Plate: 10.3 x 18 cm (4 1/16 x 7 1/8 in.);
sheet: 12.7 x 20.3 cm (5 x 8 in.)
The Berthold Lowenthal Fund, 1921.217

Camille Pissarro was one of a small number of
Impressionists who experimented with printmaking
during the late 1870s and early 1880s. This group,
which also included Edgar Degas (see p. 73) and
Mary Cassatt (see p. 58), sought to reinterpret
traditional artistic media through the lens of
contemporary stylistic and technical innovations.
Their brief but intense collaboration culminated
in the installation of a broad selection of prints
at the fifth Impressionist exhibition, held in Paris
in 1880. These extraordinary works on paper
address concerns that were also central in the
group's paintings, particularly an interest in
rendering light effects and atmosphere through
tonal variation.

Pissarro prepared several different versions of
this rustic scene of two peasants returning home
from a day of work in the fields, varying the in-
tensity and color of the ink, the texture of the
paper, and the force of the impression. Degas,
who printed the red-orange example shown here,
encouraged his colleagues to combine unortho-
dox techniques. Pissarro's use of drypoint—in
which marks are gouged directly into the metal
plate—resulted in delicate, velvety lines, such as
those seen in the leaves of the trees along the
horizon and the church steeple toward which the
road gently winds. Another process, aquatint, pro-
duced subtle gradations of tone and texture;
Pissarro may have employed unconventional sub-
stances, including brandy and his own saliva, to
render the grainy shadows in the fields and the
staccato clouds in the sky.

A prolific printmaker throughout his career,
Pissarro helped to liberate graphic media from
their primarily reproductive function and elevate
them to the level of fine art. In addition his sys-
tematic treatment of this particular motif points
toward Claude Monet's *Stacks of Wheat* series (see
pp. 132–35), initiated a decade later.

Hilaire Germain Edgar Degas
French; 1834–1917

Portrait after a Costume Ball (Portrait of Mme Dietz-Monnin), 1879
Distemper, with metallic paint and pastel, on fine-weave canvas prepared with a glue size
85.5 x 75 cm (33⅝ x 29½ in.)
Joseph Winterbotham Collection, 1954.325

Edgar Degas's insightful portrayals of family and friends have earned him the reputation as the finest portrait painter among the Impressionists. This is a rare example of a commissioned work by him in that genre. Its subject is Adèle Dietz-Monnin, the wife of a prominent businessman and politician, who took an interest in the arts, especially music. Here, Dietz-Monnin's posture is surprisingly informal, which was perhaps the cause for a dispute that arose between her and the artist while the work was in progress. Ultimately, she rejected—but paid for—the portrait.

Despite the difficulties he experienced with this patron, Degas seems to have taken a lively interest in his subject, devising a highly original setting for her: a costume ball at the moment of its conclusion. Although Dietz-Monnin's frothy, pink costume and festive feather boa convey a jaunty, gregarious air, she seems to droop with exhaustion at the end of a long evening, listlessly waving to a fellow guest. Lights and shapes bounce off the mirror behind her and appear as indistinct patches of color at right and left, suggesting the blurred effect of the surroundings on her tired senses.

Degas matched the inventiveness of the composition with improvisational brushwork and an unorthodox, mixed-media technique. Instead of making a traditional pastel on paper or oil on canvas, the artist combined various materials, including distemper, metallic paint, and pastel. Clearly, he was interested in reproducing the reflective qualities and flickering effects of surfaces such as mirrors, satin, and gilded chairs. Although not conventionally flattering, Degas's *Portrait after a Costume Ball (Portrait of Mme Dietz-Monnin)* is a brilliant, highly authentic work. Unmistakably the likeness of a particular individual in an unguarded moment, it is also an incisive study of a bourgeois woman in a prescribed social role.

Hilaire Germain Edgar Degas

French; 1834–1917

The Star, 1879–81
Pastel on cream wove paper
73.3 x 57.4 cm (28⅞ x 22⁹⁄₁₆ in.)
Bequest of Mrs. Diego Suarez, 1980.414

Edgar Degas portrayed dancers throughout his career (see pp. 48, 49, 67, 141), most often as types rather than as individuals. In this glowing pastel, however, he described his model's features and gesture precisely, allowing us to identify her as Rosita Mauri, a popular young ballerina who made her debut at the Paris Opéra in 1878. The receding lines of the floorboards, the curve of the stage at the upper left, and the halo of tutus along the right all focus attention on Mauri, who stands in third position and looks up toward the balconies.

Degas handled the delicate medium of pastel with evident confidence. Laying it on the paper in long, sweeping strokes, he established the planks of the stage, modeled the exquisite forms of the dancer's neck and collarbone, and clothed her in an embroidered satin bodice with matching shoes. Modifying his application, Degas created the floating, lavender-blue tutus of the corps de ballet, so indistinct in form—particularly in comparison with the detail of the principal figure's gauzy skirt—that he had to anchor them with seemingly random pink legs, raised arms, and tilted heads.

The contrast between the solidity of the star and the ephemerality of the dancers behind her points to a shift in Degas's interests. He had begun to move away from the informal lightness of his early Impressionist works of the 1870s and toward the classicism that characterizes much of his subsequent production. It is surely no coincidence that at about this time he made his first sculptures, many of which depict dancers (see p. 67).

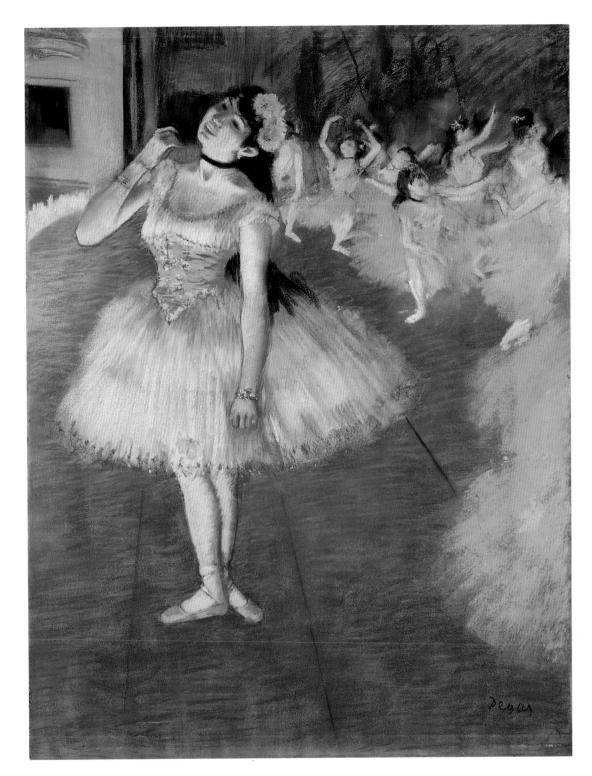

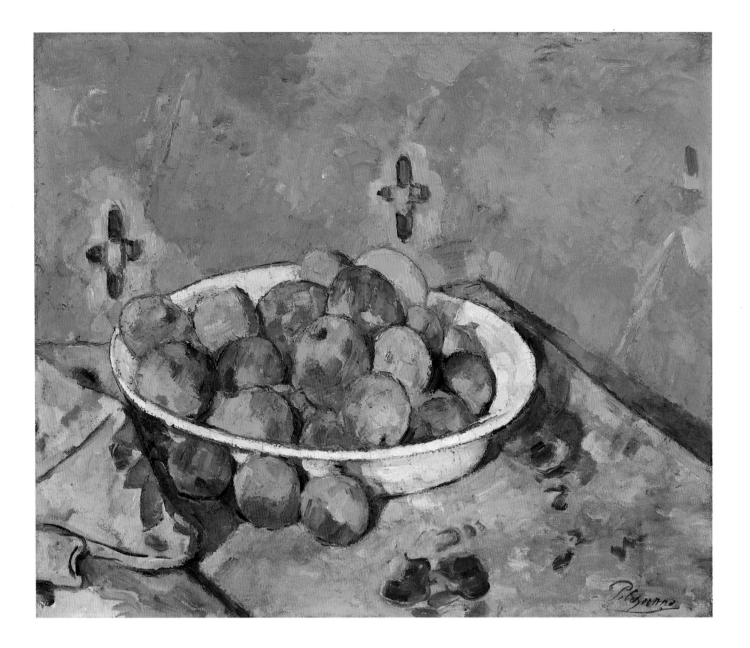

Paul Cézanne

French; 1839–1906

The Plate of Apples, c. 1877
Oil on canvas
45.8 x 54.7 cm (18 x 21½ in.)
Gift of Kate L. Brewster, 1949.512

Paul Cézanne was a loner by temperament. He spent most of his life in his native Aix-en-Provence, in southern France, but his intermittent contact with the Impressionist circle (he participated in two of the group's exhibitions) was crucial to his development, prompting him to lighten his palette and transform his deliberately crude early style into a manner that is both rugged and elegant.

The Plate of Apples shows Cézanne assimilating lessons he had learned from Camille Pissarro (see p. 26) in 1873–74, when the two men painted together in Auvers and Pontoise, but the work retains something of the crusty intransigence of Cézanne's previous efforts. Brusque strokes of saturated reds, yellows, and greens form the apples; the artist used a palette knife to apply much of the color and to incise contours around the fruits. The blue crosses on the wallpaper seem like talismans hovering in a mustard-yellow sky, generating a subdued aura of mystery. The whole has a rough-hewn quality; we sense that such formal resolution as it possesses was not easily achieved.

Cézanne had begun to place what he termed the "little sensation"—or focused, momentary perception—at the center of his practice, but in an idiosyncratic way. Manipulating perspective, he fashioned fractured compositions that reconcile the eye's mobility with pictorial solidity. This approach, evident in the tilt of the tabletop, its indeterminate spatial relationship to the wall, and the "squaring" of its left edge with that of the canvas, sets Cézanne's work apart from that of the Impressionists. Eschewing the notion that a painting represents a fleeting retinal image, Cézanne chose instead to stress the deliberative aspect of the creative process—and of perception itself—by building pictures that assertively acknowledge the passage of time.

Camille Pissarro
French; 1830–1903

Young Peasant Woman Drinking Her Café au Lait, 1881
Oil on canvas
65.3 x 54.8 cm (25¹¹/₁₆ x 21⁹/₁₆ in.)
Potter Palmer Collection, 1922.433

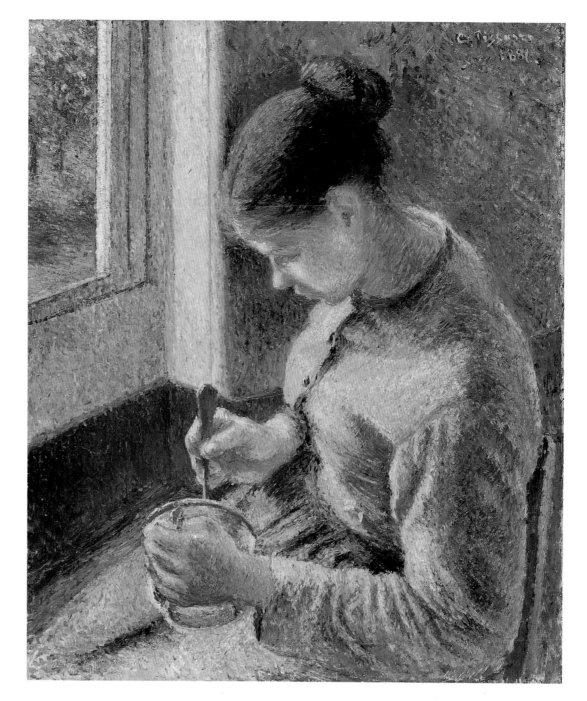

The oldest of the Impressionists, Camille Pissarro was the only artist in the group whose work appeared in each of its eight exhibitions. In 1882, when *Young Peasant Woman Drinking Her Café au Lait* was included in the seventh show, critics praised Pissarro's paintings for their rustic charm. A young woman attends earnestly to the task of capturing with her perfectly vertical spoon the last of her café au lait; she carefully tilts her cup toward her, so that its contents are hidden from our view. As in many of the artist's compositions from this period, the space is compressed, with the figure in the immediate foreground positioned at a slightly oblique angle to the picture plane.

In the 1870s, Pissarro began to use coarse, patterned brushwork to integrate his figures with their surroundings. Here, he wove a web of roughly sketched, uniform strokes, rendering the play of light on the figure's hair, face, and blouse in a great range of contrasting colors: olive green, grayish blue, beige. Through these thick, precisely applied dabs of paint—and without recourse to linear draftsmanship—Pissarro modeled his forms and gave volume to the spaces they occupy, thereby refining his earlier, gestural Impressionist technique.

Young Peasant Woman Drinking Her Café au Lait was received much less enthusiastically in London, where it was shown in 1883, than it had been in Paris. Disappointed, Pissarro wrote a reflective letter to his son: "I shall never do more careful, more finished work. Nevertheless, these paintings were regarded as uncouth in London. . . . The eye of the passerby is too hasty and sees only the surface—being in a hurry, he will not stop for me!"

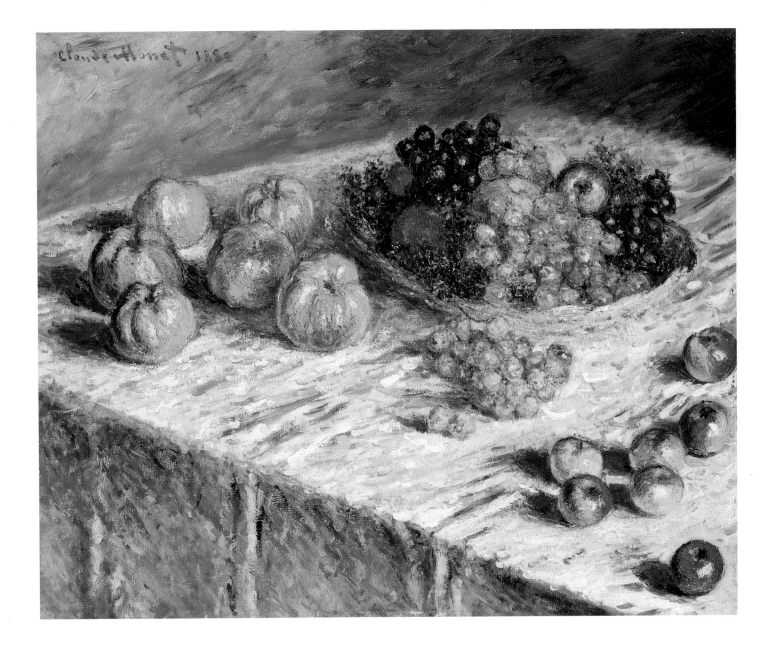

Claude Monet
French; 1840–1926

Still Life with Apples and Grapes, 1880
Oil on canvas
66.2 x 82.3 cm (26¹/₁₆ x 32³/₈ in.)
Mr. and Mrs. Martin A. Ryerson Collection,
1933.1152

Claude Monet took up still-life painting for a
time around 1880. This traditional genre may
seem an unlikely arena in which to stage a career
shift, but Monet hoped to expand his market dur-
ing a period of economic recession. He renewed
his attempts to gain access to the Salon and tried
to form associations with dealers other than Paul
Durand-Ruel. In addition to being easier to sell
than landscapes, still lifes allowed the artist to
continue his experimentation with the textures
and colors of nature during periods when bad
weather prohibited him from painting outdoors.

Here, Monet depicted an assortment of two
different kinds of apples, together with green and
red grapes, and introduced an element of anima-
tion, even suspense. This still life is anything but
still: the smaller apples at the lower right seem
ready to roll off the steeply angled table, and the
folds of the cloth appear to ripple like waves. Yet
the artist's control over the objects is evident, giv-
ing the composition a sense of stability and vital-
ity. Not only did Monet adopt a magisterial view

from above, but he also anchored the fruits and
basket with palpable, grayish-green shadows.
Exploring the possibilities of materials at hand—
one of the central challenges of still-life painting—
Monet found several ways to use the same dabs
of white pigment: on the grapes, they represent
translucent fragility; on the large apples, matte
solidity; and on the little apples, glossy sheen.

Still life never became central to Monet's
repertory, but it is tempting to look from this
brief experiment to those of his colleagues—
most notably Paul Cézanne (see pp. 62, 139),
who would bring the genre to new heights of
complexity and beauty.

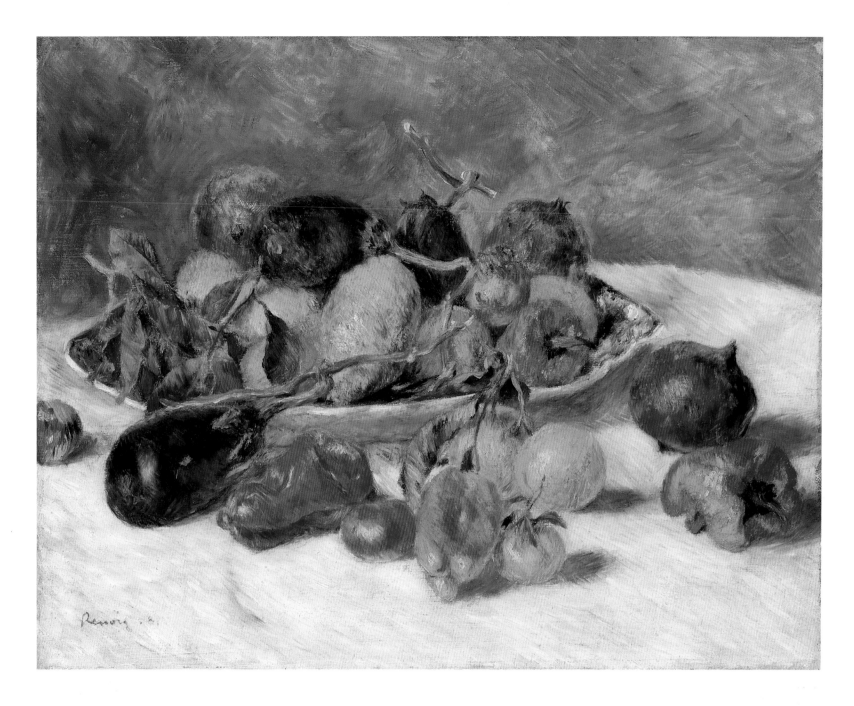

Pierre Auguste Renoir
French; 1841–1919

Fruits of the Midi, 1881
Oil on canvas
50.7 x 65.3 cm (19^{15}/$_{16}$ x 25^{11}/$_{16}$ in.)
Mr. and Mrs. Martin A. Ryerson Collection,
1933.1176

Pierre Auguste Renoir came from humble origins
(see p. 51), and he always felt that his art lacked
refinement. In 1881, confronting the limitations of
the Impressionist style he had practiced up to that
point, he decided to fill an educational gap by
going to Italy to study ancient and Renaissance

masterpieces. He probably painted this still life en
route, in the south of France (along the Mediterra-
nean coast, or Midi). It features an exotic combi-
nation of fruits and vegetables—peppers, eggplants,
tomatoes, pomegranates, citrons, lemons, and
oranges—breaking the unwritten rule that
painters should select foods for their culinary
compatibility rather than their visual appeal.

Renoir's arrangement of objects in and
around a blue-and-white plate is abundant but
stable, and the background elements—a plain,
white tablecloth and solid, blue-green wall—are
even austere. The still-life genre allowed the artist
to concentrate on form and local color. He delib-

erately weighed the relative placement of each
fruit and vegetable, lending them a certain monu-
mentality by using long, diagonal brush strokes.
As unpretentious as this work appears, it repre-
sents a significant attempt on Renoir's part to
bring a classical sense of pictorial structure and
balance to the fleeting luminosity of Impression-
ism—a goal that was pursued even more avidly
by Paul Cézanne (see p. 112). Indeed, Renoir vis-
ited Cézanne in Provence on his journey back to
Paris from Italy, and, although *Fruits of the Midi*
was not painted under Cézanne's direct influ-
ence, it does show that these two very different
artists shared some fundamental aims.

Auguste Rodin
French; 1840–1917

Adam, c. 1881
Bronze
198.1 x 76.2 x 75.6 cm (78 x 30 x 29¾ in.)
Gift of Robert Allerton, 1924.4

With his right leg raised and his torso tensed and
wrenched into an unnatural position, Auguste
Rodin's *Adam* appears horribly disfigured, despite
his idealized proportions and serene facial expres-
sion. His right arm and hand, perhaps drawn
from Michelangelo's figure of Adam at the center
of the Sistine Chapel ceiling, point emphatically
downward, as if to indicate the fall of man, while
his left hand desperately clutches his right knee.
"I . . . tried to express the inner feelings of the man
by the mobility of the muscles," wrote the artist
about this piece. The rigid musculature of the
figure's hands and legs, the twisted trunk of the
body, and the emphatic straining of the head, as
neck and shoulder collapse into a nearly horizon-
tal plane, all serve to convey a sense of physical
pain, certainly related to the emotional torment
of having been banished by God from Paradise.

Rodin originally intended his towering, con-
torted sculpture of *Adam* and its pendant, *Eve*, to
flank the *Gates of Hell*, a monumental bronze
doorway of bas-reliefs illustrating various cantos
from Dante's *Divine Comedy*. The doorway —
capped by looming representations of the three
shades, which repeat the basic form of Adam —
was commissioned by the French government in
1880 for a new museum of decorative arts in
Paris. The museum was never built, and Rodin
left the portal unfinished at his death. Never-
theless, the project became well known during the
artist's lifetime, for he cast individual figures and
groups, some of which appeared in a large exhibi-
tion of works by Rodin and Claude Monet held
at the prestigious Parisian gallery of Georges Petit
in 1889.

Hilaire Germain Edgar Degas

French; 1834–1917

Spanish Dance, c. 1883
Bronze
43.2 x 15.9 x 21 cm (17 x 6¼ x 8¼ in.)
Wirt D. Walker Fund, 1950.111

This is one of two known sculptural studies by Edgar Degas treating a Spanish theme. Degas may have chosen this pose—called a *cambré*, or bend from the waist—after seeing Edouard Manet's painting *Spanish Dance* (1862; Washington, D.C., Phillips Collection), which includes two dancers posed in a similar manner, at a retrospective of the artist's work in 1883. Degas was probably also influenced by an 1837 bronze by Jean Auguste Barre of the ballerina Fanny Elssler, who achieved her greatest success performing the *cachucha*, a Spanish dance featured in a ballet choreographed by Jean Coralli.

Of the more than one hundred fifty wax sculptures that Degas produced, he exhibited just one and sold none. Only after his death were seventy-three of the waxes cast in bronze. Why did the artist make sculptures if he did not intend to display them in a permanent form? The answer lies in his compositional methods. Degas characteristically explored poses from various angles and experimented with reversals and tracings. Sculpture came to play an important role in this process, supplementing his life studies and allowing him to examine a figure from all points of view. Furthermore, because Degas made his sculptures on a small scale and with malleable materials, he could adjust their contours and lines to create new positions.

In *Spanish Dance*, Degas displayed his typical interest in the fine points of posture. With a flourish, the figure reaches her right arm over her head, curves her left arm in front of her torso, and bends back, thrusting her left hip to the side. Somewhat surprisingly, given Degas's interest in various ethnic dance styles, he did not explore Spanish dance themes in a sustained manner; this dramatic pose does not appear in any of the artist's known two-dimensional work.

Eva Gonzalès
French; 1849–1883

The Milliner, c. 1877
Pastel and watercolor on canvas
44.8 x 37.2 cm (17⅝ x 14⅝ in.)
Olivia Shaler Swan Memorial Collection, 1972.362

The distinctive features of the woman in Eva Gonzalès's pastel *The Milliner* have the force of portraiture. Dressed in a fashionable day dress trimmed with bright ribbons and pleated lace, the young hatmaker sorts through a box of trimmings. In one hand, she holds a bouquet of silk roses, similar to those that grace the hats on the stands to her left. Her other hand hovers over the bandbox, while her focused and inquiring expression, directed to a point beyond the image, suggests that her attention has been temporarily diverted, as if a customer has just entered the shop. With a simple glance and a small gesture, Gonzalès raised the expectation for a narrative, but no tale is told.

Gonzalès never exhibited with the Impressionists; like her teacher Edouard Manet, she sought to establish her reputation at the official Salon. But her spontaneous handling of medium, as seen in the vivid palette and calligraphic strokes of her pastel work, allies her with the Impressionists' aesthetic aims. Gonzalès also revealed a sympathy with the group's sensibility in her choice of subjects. *The Milliner* (for which Gonzalès's cleaning woman posed) features a distinctly modern type—a working woman of uncertain circumstance—favored by Edgar Degas and Pierre Auguste Renoir. But unlike Degas, whose radical composition *The Millinery Shop* (p. 72) sets up an indeterminate relationship between the female figure and the viewer, Gonzalès sought to engage us in a direct encounter with this woman. The artist's subtle evocation of character, expressed with an economy of means, links her to another progressive development in contemporary French culture: the Naturalist novel as written by Gustave Flaubert and Emile Zola.

Camille Pissarro
French; 1830–1903

Woman and Child at the Well, 1882
Oil on canvas
81.5 x 66.4 cm (32⅛ x 26⅛ in.)
Potter Palmer Collection, 1922.436

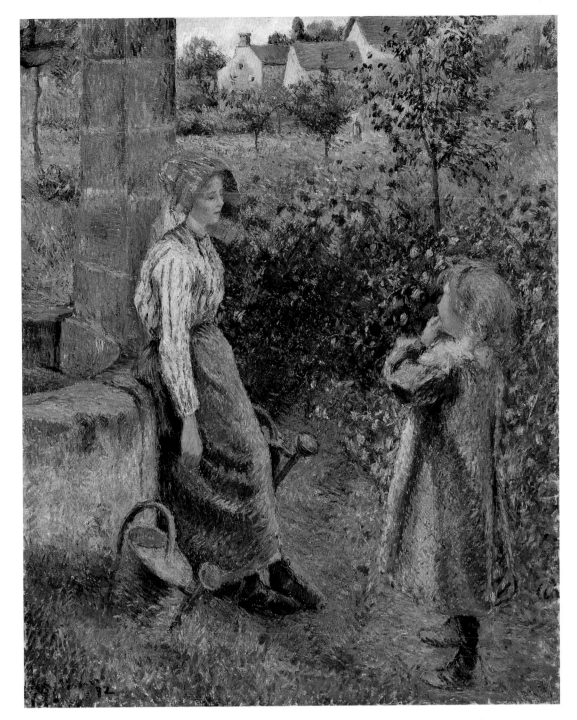

Painted in the secluded, rustic community of Eragny, where Camille Pissarro was to settle permanently with his family in 1883, *Woman and Child at the Well* captures the day-to-day activities of rural life that preoccupied the artist throughout his career. The young woman depicted here was probably a domestic servant in Pissarro's household, and the child may have been Ludovic Rodo Pissarro, the artist's fourth son.

The apparent subject of this painting is an idle moment shared by the two figures in the foreground. Their contrasting poses juxtapose the strains of physical labor with the innocent exuberance of childhood. A peasant woman slouches listlessly beside the watering cans she must fill; she will soon rejoin the other women in the far background, who diligently irrigate rows of young vegetables in the garden beside the farmhouse. Her exhaustion from this strenuous task is evident as she slumps back against the wall of the well while gazing blankly at a child who, oblivious to the woman's toils, raises its hand whimsically to its mouth.

With its high horizon line, compressed space, and thick, hatching brush strokes strewn loosely across the surface, particularly in the foreground flora, the Art Institute's canvas is typical of Pissarro's work from this period. Facing something of a stylistic crisis as his Impressionist colleagues began to move in different directions, Pissarro was determined to assert his ability to produce large-format figure paintings. Here, however, he seems to have devoted as much attention to the lush, verdant setting as to the interaction between woman and child. In a manner reminiscent of the work of Jean François Millet (see p. 25), Pissarro portrayed human activity wholly embedded in the forms and rhythms of nature.

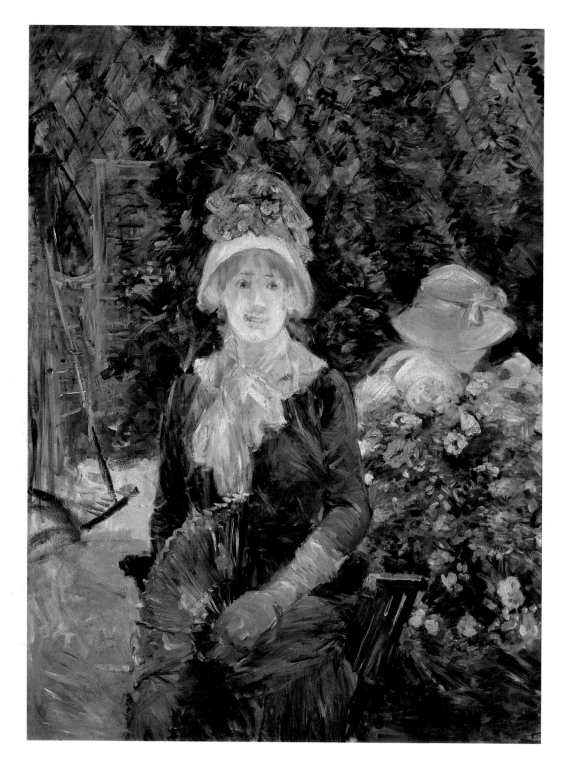

Berthe Morisot
French; 1841–1895

The Garden, 1882–83
Oil on canvas
123.2 x 94 cm (48½ x 37 in.)
A Millennium Gift of Sara Lee Corporation,
1999.363

The image of a young woman in a garden has an enduring and fascinating history in European art. Although the Garden of Eden in the Judeo-Christian tradition provided the setting for Eve to lead Adam into temptation, by the late Middle Ages, the *hortus conclusus* (enclosed garden) became a symbol of female chastity; by the eighteenth century, a woman alone in a flowering bower conveyed a provocative promise: she was waiting for a tryst with her lover. But when Berthe Morisot painted her models in the private garden of her own house on the rue de Villejust in Paris, she transcended conventional associations to express a distinctly contemporary sensibility.

The Garden's central figure is a professional model named Milly, who often worked for Morisot. But the artist made the woman's identity inconsequential to the painting by handling her features summarily, brushing them in with a few telling strokes. Rather than working toward realistic portraiture or articulated narrative, Morisot focused her attention on the play of light as it illuminated the foliage and two figures in the garden. Bright sunlight reflects off their straw hats and pale complexions. The ground to the left of the central figure gleams under direct rays, while more light flickers through the diamond pattern of the leaf-covered fence at the back of the space. For a woman of Morisot's generation and social class, the private city garden was a sheltered environment where she could enjoy the pleasures of the outdoors in undisturbed contentment.

Pierre Auguste Renoir
French; 1841–1919

Two Sisters (On the Terrace), 1881
Oil on canvas
100.5 x 81 cm (39 9/16 x 31 7/8 in.)
Mr. and Mrs. Lewis Larned Coburn Memorial
Collection, 1933.455

Pierre Auguste Renoir concluded his fifteen-year exploration of the theme of bourgeois leisure with this superb painting of 1881. The setting is a terrace of the Restaurant Fournaise, an establishment in the village of Chatou, on the Seine, where Renoir had previously executed *The Rowers' Lunch* (p. 45), among other works.

A celebration of the beauty of spring and the promise of youth, *Two Sisters (On the Terrace)* is a technical and compositional tour de force, a virtuoso display of vibrant color and variegated brushwork. The almost life-sized figures (who were not sisters, as indicated by the work's original title, but unrelated models) occupy a shallow space in front of a terrace railing; behind them quivers a lively, leafy landscape that brings their sharply delineated forms into vivid focus. The two girls' faces are extraordinarily refined—revealing Renoir's new emphasis on draftsmanship—and their porcelain complexions are uncompromised by reflections or shadows. The young child's irises are an almost startlingly clear, translucent blue, suggestive of the artist's desire to help us see the world afresh, through innocent eyes.

As always Renoir transformed what he saw, infusing nature with the artifice necessary to create harmony. For example the foliage behind the figures cannot rival the artificial flowers that adorn the little girl's hat. The balls of yarn in the basket, somewhat out of context in this outdoor setting, also refer to the artist's palette and his skill in deploying it. Shown in 1882 at the seventh Impressionist exhibition, *Two Sisters* signaled Renoir's impending departure from Impressionism's preoccupation with rendering transient effects of light by means of flickering brushwork, while summarizing his dedication to the subjects and themes he had presented so buoyantly.

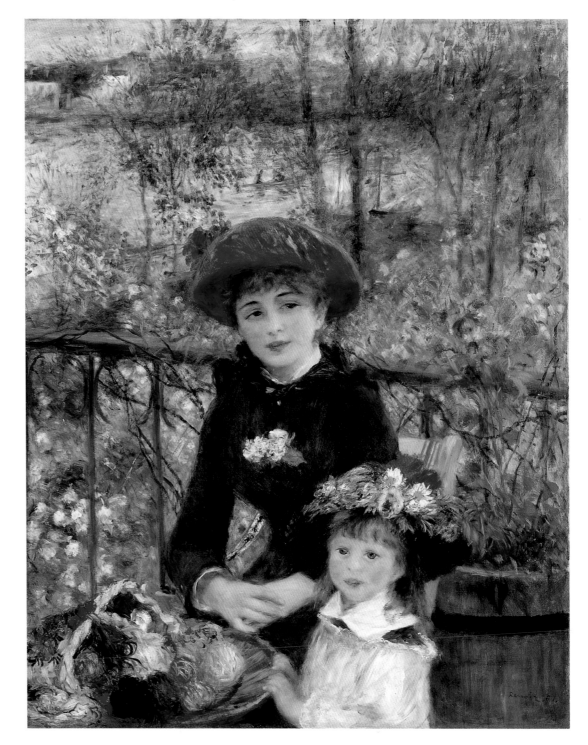

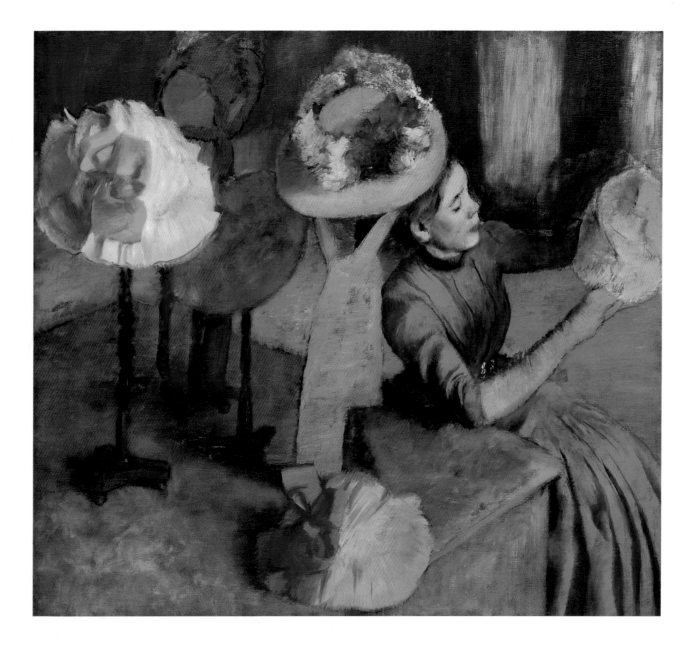

Hilaire Germain Edgar Degas
French; 1834–1917

The Millinery Shop, 1884/90
Oil on canvas
100 x 110.7 cm (39³⁄₈ x 43⁹⁄₁₆ in.)
Mr. and Mrs. Lewis Larned Coburn Memorial
Collection, 1933.428

Edgar Degas was interested in all forms of modern display, including fashion. In many drawings, pastels, prints, and paintings, he studied the construction and social significance of women's clothing. In particular, hats—which were very fanciful during the late nineteenth century—allowed the artist to indulge in rich colors and experiment with a range of textures. Here, we see a still-life arrangement of hats in various stages of completion. Behind the hats sits a young milliner, her mouth pursed around a pin as she shapes her next creation. Degas matched the level of painterly detail to the degree of finish in the hats themselves: the central, completed hat, adorned with a green ribbon and displayed on a tall stand, appears three dimensional and richly textured; while the unfinished form in the girl's hand is flat and monochromatic, and reveals the artist's repeated scraping and repainting.

Without a doubt, Degas considered this young woman's concentrated activity to be artistic in nature. Furthermore, he realized that her occupation as a private milliner was rapidly becoming obsolete: increasingly, consumer goods were manufactured more quickly, more cheaply, and in greater numbers by factories and sold in the new department stores. Degas's choice of composition reveals his intention to comment on this situation; examination of the canvas and preliminary drawings shows that he originally planned to depict a customer trying on a finished hat. During the course of executing the image, however, he became more interested in the act of production, and he scraped off the client and replaced her with the milliner. Although this young woman cannot own the fashionable items she creates, by making a visual contribution to modern society, she takes a place in history.

Hilaire Germain Edgar Degas
French; 1834–1917

Mary Cassatt in the Painting Gallery of the Louvre, 1879/80
Etching, aquatint, drypoint, and *crayon électrique* on grayish-ivory wove paper
Plate: 30.5 x 12.6 cm (12 x 5 in.);
sheet: 34 x 17.5 cm (13⅜ x 6⅞ in.)
Gift of Walter S. Brewster, 1951.323

Mary Cassatt in the Painting Gallery of the Louvre, 1885
Pastel over etching, aquatint, drypoint, and *crayon électrique* on tan wove paper
Plate: 30.5 x 12.6 cm (12 x 5 in.);
sheet: 31.3 x 13.7 cm (12⁵⁄₁₆ x 5⅜ in.)
Bequest of Kate L. Brewster, 1949.515

This image of the American artist Mary Cassatt (see p. 58) with her sister at the Musée du Louvre, Paris, is one of Edgar Degas's most technically complex prints. It evolved over the course of at least twenty states, two of which are shown here. Cassatt and Degas were close friends and associates, and both were inventive printmakers; their personal and professional ties may explain in part why Degas took his habitual perfectionism to a new level for this project.

Degas showed Cassatt here with her back turned, capturing her characteristically confident, distinguished, even challenging stance. She seems not to be intimidated by the great masterpieces before her, or by the elegant setting. Degas emphasized Cassatt's upright posture by designing a composition with an unusually narrow, vertical format similar to that of Japanese "pillar" prints, which both artists greatly admired.

Degas worked carefully on every aspect of this image, using a variety of tools and techniques to achieve a balance of line and tone. Even in monochrome, he established vivid distinctions in texture between the parquet floor, the marble doorjamb, the womens' silk dresses, the fabric-covered wall, the gilt frames, and the painted canvases. In 1885, six years after he made the first state of *Mary Cassatt in the Painting Gallery of the Louvre*, Degas felt compelled to modify it once more. It was not uncommon for him to explore the painterly potential of a black-and-white print by adding color, and in this instance he covered an impression (probably of an intermediary stage between the twelfth and thirteenth states) with pastel. Developing this image with ingenuity and skill, Degas demonstrated his thorough mastery of graphic media and created a tribute to a colleague who was most likely to appreciate the achievement.

Claude Monet
French; 1840–1926

Cliff Walk at Pourville, 1882
Oil on canvas
66.5 x 82.3 cm (26⅛ x 32⁷⁄₁₆ in.)
Mr. and Mrs. Lewis Larned Coburn Memorial
Collection, 1933.443

In February 1882, Claude Monet went to Normandy to paint, one of many such expeditions that he made in the 1880s. This was also a retreat from certain personal and professional pressures. His wife, Camille, had died three years earlier, and Monet had entered into a domestic arrangement with Alice Hoschedé, the wife of a former patron, Ernest Hoschedé (Monet and Alice Hoschedé would marry in 1892, after Ernest Hoschedé's death). France was in the midst of a lengthy economic recession that affected Monet's sales. In addition the artist was unenthusiastic about the upcoming seventh Impressionist exhibition—divisions within the group had become pronounced by this time—and he delegated the responsibility for his contribution to his dealer, Paul Durand-Ruel.

Uninspired by the area around the harbor city of Dieppe, which he found too urban, Monet settled in Pourville and remained in this fishing village until mid-April. He became increasingly enamored of his surroundings, writing to Alice Hoschedé and her children: "How beautiful the countryside is becoming, and what joy it would be for me to show you all its delightful nooks and crannies!" He was able to do so in June, when the Monet-Hoschedé family rented a house in Pourville.

The two young women taking a stroll in *Cliff Walk at Pourville* are probably Marthe and Blanche, the eldest Hoschedé daughters. In this work, Monet addressed the problem of inserting figures into a landscape without disrupting the unity of his painterly surface. He also integrated natural elements with one another through texture and color. The grass, composed of short, brisk, curved brush strokes, appears to quiver in the breeze, and subtly modified versions of the same strokes and hues convey the undulation of the sea. The composition sings with wind and sparkles with sunlight, reflecting Monet's increasing freedom from the metropolitan world.

Claude Monet

French; 1840–1926

Bordighera, 1884
Oil on canvas
64.8 x 81.3 cm (25½ x 32 in.)
Potter Palmer Collection, 1922.426

Having spent much of 1882 and 1883 scouring the cliffs of the Normandy coast for motifs (see p. 74), Claude Monet passed the winter and early spring of 1884 in the south of France, on the Mediterranean. In December of the previous year, he had discovered the area while traveling with Pierre Auguste Renoir; but he returned alone, determined "to do some astounding things."

Monet remained dedicated to Impressionism at the very moment that his colleagues, Renoir among them, were turning away from its aim of capturing transitory natural effects. Thus, in Bordighera, a resort town just over the Italian border, he responded immediately to the warm and constant southern light, so different from that of northern regions. Searching for painterly equivalents to this new environment, Monet covered canvases such as this one with a riot of intense greens and blues that at first glance seem to struggle with each other, but ultimately coalesce into a vibrant composition. Through a foreground choked with olive trees, we glimpse a sun-bleached town, beyond which the sea forms an expansive horizon.

Absorbed in the unique features of Bordighera, Monet worried that people would think his renderings false or exaggerated. He disregarded the picturesque conventions of guidebook illustrations to reveal the almost overpowering brilliance of the Mediterranean. Monet did not seek to contain or control the twisted tree trunks, bent by centuries of strong coastal winds; nor did he modify the gemlike azure of the water. Using what he described as a "palette of diamonds and precious stones," he moved beyond naturalism and emphasized the decorative aspects of his work, thus taking an early step along the road to his own version of Post-Impressionism.

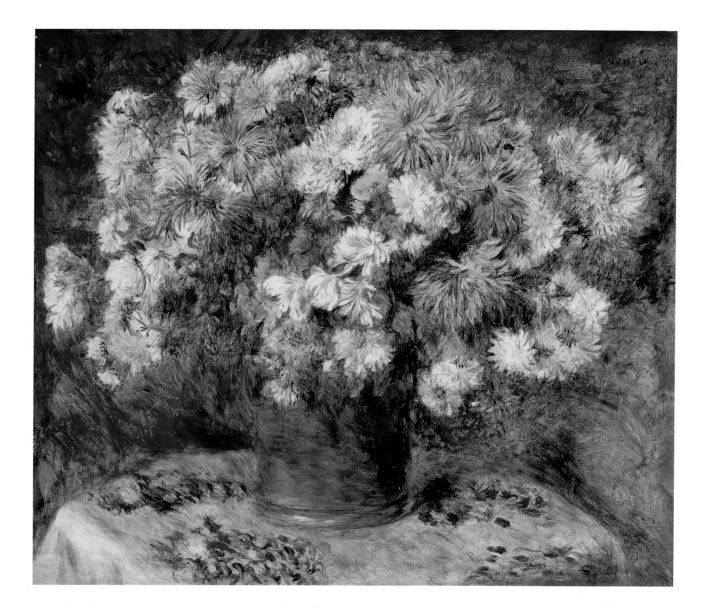

Pierre Auguste Renoir
French; 1841–1919

Chrysanthemums, 1881/82
Oil on canvas
54.7 x 65.9 cm (21½ x 26 in.)
Mr. and Mrs. Martin A. Ryerson Collection,
1933.1173

Pierre Auguste Renoir devoted the early 1880s to artistic exploration. In his masterpiece of 1881, *Two Sisters (On the Terrace)* (p. 71), he began to modify the loose handling and light-bleached palette of Impressionism, instead adopting tighter draftsmanship and bolder, more saturated colors. Thereafter, Renoir's search for greater rigor and solidity in his art prompted him to reevaluate his materials and methods.

During these years, Renoir supported himself by executing marketable works, such as portraits and floral still lifes. While some sitters disliked his "new" style, which they felt was unflattering, the genre of still life posed no such problems and thus facilitated experimentation. As Renoir later explained: "I just let my brain rest when I paint flowers. I don't experience the same tension as I do when confronted by the model. . . . I establish the tones, I study the values carefully without worrying about losing the picture. I don't dare do this with a figure piece for fear of ruining it."

For *Chrysanthemums* Renoir adopted a challenging, labor-intensive technique. First, taking a canvas with a white, commercially prepared ground, he used a palette knife to lay down another ground of lead white paint. This second layer obscured the weave of the canvas and resulted in a smoother, more reflective surface. While it was still wet, Renoir quickly brushed in thin layers of washlike paint, achieving a remarkable transparency and fluidity, particularly in the petals of the yellow-orange blossoms and in the background. Producing effects comparable to those of watercolor, Renoir's wet-on-wet technique may also be likened to overglaze porcelain painting—a craft that, in his youth, he had learned as an apprentice. Perhaps past experiences helped him to find a way forward in his art.

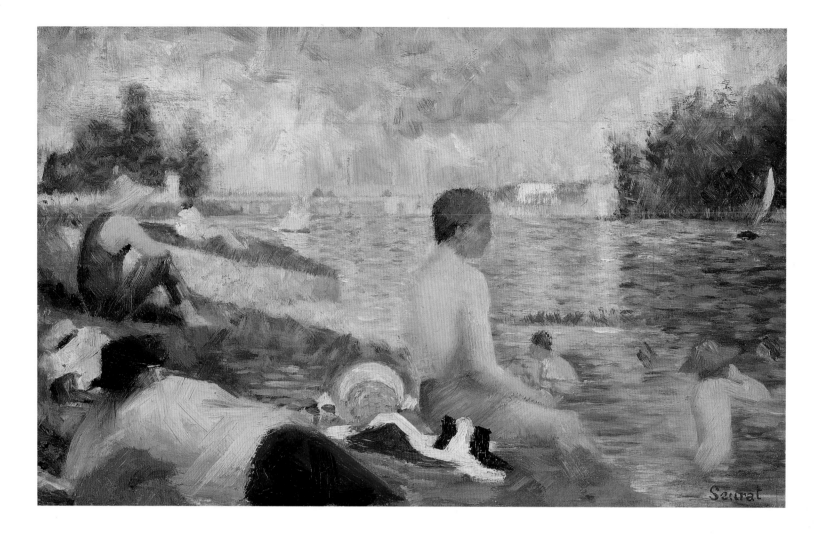

Georges Pierre Seurat

French; 1859–1891

Final Study for "Bathers at Asnières," 1883
Oil on panel
15.8 x 25.1 cm (6¼ x 9⅞ in.)
Gift of Adele R. Levy Fund, 1962.578

By the early 1880s, a number of artists began to express dissatisfaction with the Impressionist aim of rendering transient effects. Among them was the young Georges Seurat, who, after a brief stint at the Ecole des beaux-arts, Paris, set himself the daunting task of reconciling rigorous idealism with recent developments in contemporary art, including Impressionism.

Seurat's first important canvas, *Bathers at Asnières* (London, National Gallery), exhibited in Paris at the Salon des indépendants in 1884, shows men and boys from the artisanal and working classes lounging by the Seine just west of the capital. Although the work is quasi-Impressionist in color and handling, its matte surface, serene rhythms, and large scale align it with mural painting, especially as exemplified by the work of Pierre Puvis de Chavannes (see p. 120).

Seurat studied Eugène Delacroix's way of intermingling different shades of a single color to create a "woven" effect. Yet, as the Art Institute's oil study demonstrates, he modified the Romantic painter's technique by adding vivid, contrasting colors: for example he used occasional touches of pale orange and cream, in addition to three tints of green, to render the grassy bank. The varied size and direction of the brush strokes give this small panel a vitality absent from the ten-foot-high, final canvas, which is hauntingly stilled.

Seurat's decision to portray laborers and craftsmen on a monumental scale was a response to the depictions of bourgeois leisure produced in the 1870s by artists such as Claude Monet (see p. 33) and Pierre Auguste Renoir (see p. 45). But if there is any element of social critique in *Bathers at Asnières*, it is oblique, as it would be in Seurat's *Sunday on La Grande Jatte—1884* (p. 79), an image of a more decorous, largely middle-class pleasure spot just off to the right of the site depicted here, toward which the boy in the red hat calls.

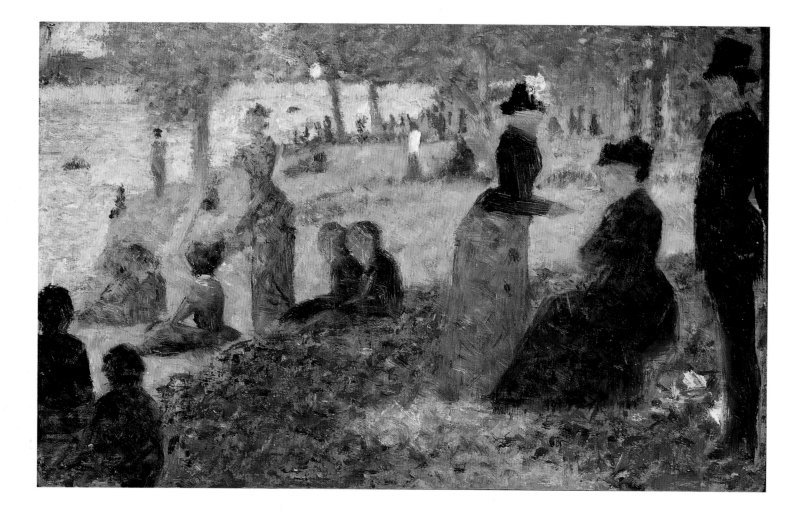

Georges Pierre Seurat

French; 1859–1891

Oil Sketch for "La Grande Jatte," 1884
Oil on panel
15.5 x 24.3 cm (6⅛ x 9⁹⁄₁₆ in.)
Gift of Mary and Leigh Block, 1981.15

A Sunday on La Grande Jatte—1884, 1884–86
Oil on canvas
207.6 x 308 cm (81¾ x 121¼ in.)
Helen Birch Bartlett Memorial Collection,
1926.224

In *A Sunday on La Grande Jatte—1884*, Georges Seurat recast Impressionism, using as his guides both optical theory and idealist aesthetics. When first shown in 1886, at the eighth and final Impressionist exhibition, this impressive painting of middle-class Parisians relaxing on an island in the Seine just west of the city attracted considerable attention, and no wonder. Although many artists had portrayed similar subjects in recent years, none had used so rigorous and schematic a style. The hieratic figures, shown mostly in profile or straight-on, recall ancient Egyptian reliefs, and the deliberate compositional rhythms amount to a pointed critique of Impressionist ephemerality. As if to dispel any lingering doubts on this point,

Seurat also rejected free, sketchy handling, choosing instead to render the entire scene with meticulous, dotlike touches of paint, which, viewed from a certain distance, resemble nothing so much as tapestry stitching.

Seurat conceived these little "dots" and dashes to exploit scientific theories of optical mixture, according to which discrete applications of certain colors, if immediately juxtaposed, will blend in perception to form new ones. The result was meant to be brilliantly luminous; one critic described a "vibration of light, a richness of color, [and] a sweet and poetic harmony."

Seurat arrived at *A Sunday on La Grande Jatte—1884* by way of a prolonged trial-and-error

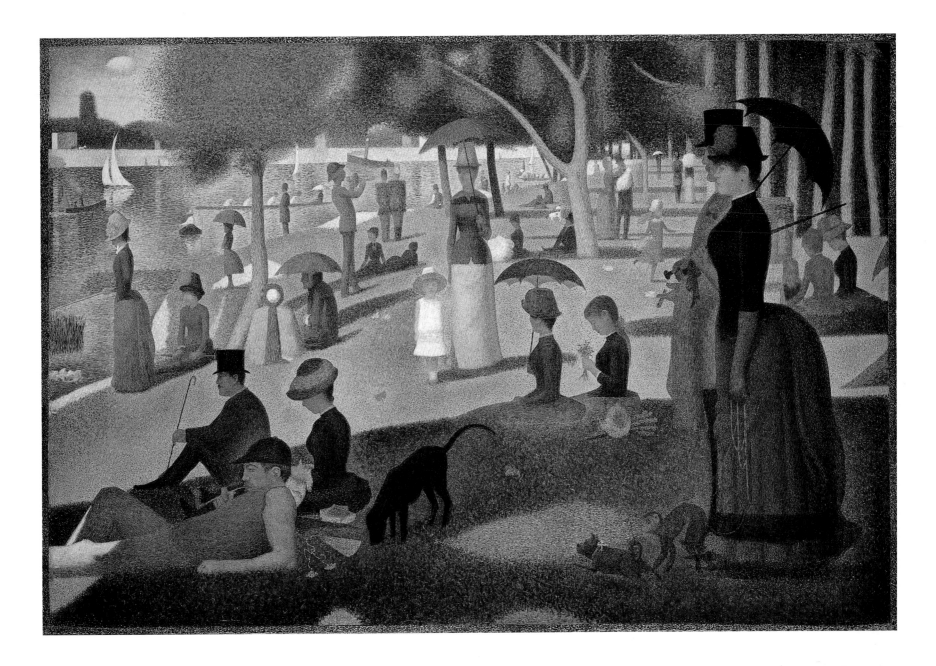

process, during which he produced many drawings (see p. 80) and oil studies such as the one shown here. By the time he executed the Art Institute's panel, he had already settled on the disposition of the landscape elements but was still experimenting with the figures, whose placement remains somewhat awkward. With its faceted handling and brilliantly orchestrated greens, blues, and yellows, the study has a charming immediacy. In the final canvas, however, the artist's grave stylization and playful irony are more prominent, and the resulting tone is complex. The distancing quality of Seurat's novel technique made it a fine vehicle for his dry wit, evident in the occasional visual pun—note the wafts of

cigar smoke that morph into a white dog—as well as in remarkable gallery of contemporary social types, from the brooding rower reclining at the lower left to the gawky standing man playing a French horn in the middle distance. But the pervasive self-absorption of the figures seems at odds with the integrative harmonies of the composition as a whole. The painting is rich in such enigmatic tensions, which are perhaps the secret of its enduring fascination.

The *Grande Jatte* brought Seurat fame and made him the leader of an artistic school; many painters, notably Camille Pissarro (see p. 142) and Paul Signac (see p. 122), chose to adopt Neo-Impressionism, as Seurat's manner came to be

known (it is also referred to as Pointillism or Divisionism). Although short-lived as a movement (largely due to Seurat's untimely death, at age thirty-one), the style is historically important for its introduction into avant-garde painting of new elements—such as the simplification of form, a classical mode of spatial organization, and a sophisticated sense of decorative unity. Basing his works on abstract schemes rather than pure sensation, Seurat opened wholly unforeseen possibilities for the development of modern art.

Georges Pierre Seurat
French; 1859–1891

Seated Woman with Parasol, 1884
Black conté crayon on ivory laid paper
48 x 31.4 cm (18⁷⁄₈ x 12⅛ in.)
Bequest of Abby Aldrich Rockefeller, 1999.7v

Landscape with Trees, 1884
Black conté crayon on off-white laid paper, laid down on cream board
62 x 47.5 cm (24⁷⁄₁₆ x 18¹¹⁄₁₆ in.)
Restricted gift of the Joseph and Helen Regenstein Foundation, 1966.184

Between 1881 and 1884, Georges Seurat perfected a personal style of draftsmanship that, while boldly schematic, was magically sensitive to the play of light and shade. Avoiding delineation in favor of a more tonal articulation of forms, he exploited the specific qualities of conté crayon, a drawing material similar to chalk or pastel. When applied to textured paper with varying degrees of pressure, it can leave marks ranging from hazy to opaque. In Seurat's hands, this medium yielded quietly mysterious images that sometimes resemble emanations from a world of shadows.

Seurat's twenty surviving drawn studies for *A Sunday on La Grande Jatte—1884* (p. 79)—there is at least one for every major figure or group in the painting—exemplify the elegance and remoteness of his draftsmanship. In *Seated Woman with Parasol*, he subtly gradated the woman's silhouette to distinguish light skin from dark clothing and to suggest illumination from the left, leaving the rest of the page blank to evoke ambient sunlight. The curious patch of dark hovering near the woman's chest corresponds to a shadow cast by a mother and child in the center of the final painting, indicating that this sheet dates from a rather late stage in its compositional elaboration.

Landscape with Trees, also a study for the *Grande Jatte*, is one of only three pure landscape studies Seurat is known to have executed in conté crayon. The trunk in the foreground is vaguely anthropomorphic; twisting dramatically, its tensile forms appear to strain toward an implied light. The web of criss-crossing marks used to describe the foliage—a remarkable graphic equivalent to the artist's closely knit brush strokes— seems to tremble with life. The spacing of vertical forms across the field typifies Seurat's mastery of the judiciously gauged interval, so crucial to the elusive poetry of the final painting.

Impressionism outside France

An International Style from the 1880s on

Impressionism is often associated with France, and with Paris in particular—the parks, rivers, boulevards, cafés, and other attractions of the first great modern metropolis and its environs are vividly portrayed in many works by Impressionist masters such as Edgar Degas, Claude Monet, and Pierre Auguste Renoir. However, in the 1880s, these painters and their colleagues began to look beyond Paris, exploring the potential of Impressionist technique to portray different subjects. At the same moment, their innovations were adopted—and adapted—by other artists, many of them North Americans who continued to practice the style well into the twentieth century. In this way, the boundaries of Impressionism were greatly expanded, together with its audience.

In an era of prosperity memorably described by the expatriate American novelist Henry James, hundreds of middle- and upper-class travelers made pilgrimages from the United States to Europe, in search of culture and artistic tradition. Among these tourists were many serious artists, such as Mary Cassatt, Childe Hassam, Theodore Robinson, John Singer Sargent, John Henry Twachtman, and James McNeill Whistler. In addition to studying the incomparable wealth of Old Master paintings available to them in European capitals, they also witnessed the Impressionist revolution and, in some cases, became closely associated with the French painters in the group (Cassatt for example participated in four of the eight Impressionist

exhibitions). Numerous aspiring artists enrolled at the Académie Julian, the largest private art school in Paris, which—unlike the state-sponsored Ecole des beaux-arts—admitted women and foreigners with no entry examinations. While providing a solid technical education to its students, the Académie Julian also encouraged freedom and diversity.

From this profitable and prestigious institution emerged many of the artists responsible for disseminating the signature elements of Impressionism—flickering brushwork and a commitment to *plein-air* painting—in their native countries. Twachtman is one example of this process. Studying art in Munich and then at the Académie Julian, he returned to the United States in 1889, settling in rural Connecticut. Using the lessons he had learned in Paris, he depicted the landscape surrounding his home in all seasons, building up the forms of snowbanks with dense paint layers in *Icebound* (p. 92), while adopting a light, feathery stroke for the spring foliage in *The White Bridge* (p. 94). Twachtman and other artists, such as Hassam and Robinson, thus set an example for the practice of Impressionism outside France by approaching local subjects with the concentration on light, atmosphere, color, and sensation that had come to characterize the movement.

John Singer Sargent
American; 1856–1925

Thistles, 1885/89
Oil on canvas
55.9 x 71.8 cm (22 x 28¼ in.)
Gift of Brooks McCormick, 1996.446

In 1884 John Singer Sargent unwittingly shocked the sophisticated Parisian public with a revealing portrait of the "professional beauty" Madame Pierre Gautreau, identified only as *Madame X* (New York, The Metropolitan Museum of Art). However, just when hostile criticism threatened Sargent's nascent career as a portraitist in France, several important commissions from British clients prompted him to move to England. There,

he joined a small but stimulating group of like-minded American expatriates, including painters Edwin Austin Abbey and Francis David Millet, and the writer Henry James. His new circle of friends had established an artists' colony in the village of Broadway in Worcestershire, and Sargent regularly joined them to spend the summers between 1885 and 1889. During that time, his interests shifted from portraiture to landscape, and he executed a number of fresh, natural studies in the open air, including *Thistles*.

Sargent had worked *en plein air* during sketching trips to Brittany in the late 1870s. Claude Monet's daring optical studies of light and color, which Sargent encountered in Paris, so deeply impressed him that he later declared to a friend that

the French artist's achievements "bowled me over." In the countryside around Broadway, Sargent made his own observations, often looking so closely at his subject that the result is almost an abstraction of the natural world. In *Thistles* he rendered pale stalks and delicate grasses in a tracerylike pattern against a sienna-brown earth. Although Sargent also painted the leisure activities of the Broadway community—including boating parties and sketching trips—in his landscapes and nature studies, he gave his visual impressions primacy over subject matter. Through this shift of emphasis, Sargent enriched his palette and gained the bravura command that was to characterize his mature portrait work.

Theodore Robinson
American; 1852–1896

The Valley of Arconville, c. 1887
Oil on canvas
45.8 x 55.7 cm (18 x 21⅞ in.)
Friends of American Art Collection, 1941.11

Theodore Robinson was among the first of many American artists to paint in the French village of Giverny, where Claude Monet had rented property beginning in 1883. Although Robinson was trained in the academic tradition in New York City and at the Ecole des beaux-arts, Paris, he had already begun to experiment with more diffuse, *plein-air* painting techniques in the artists'

colonies at Grez and Barbizon before going to Giverny in the late 1880s. Dividing his time between the United States and France for the next several years, Robinson became a student and close friend of Monet, under whose influence he learned to observe and render the effects of light and weather on the bucolic landscape of the area, employing layered, broken brushwork and adopting a pastel-hued palette.

Robinson painted *The Valley of Arconville* during a trip to France's Champagne region. This was around the time he met Monet, and the canvas shows his transition to the Impressionist style. Adopting an elevated viewpoint, Robinson depicted a female figure on a hillside overlooking a

village and the surrounding landscape. He used loose, sketchy brushwork to lead the viewer's eye down the grassy slope in the painting's foreground, and also to establish the hazy atmosphere of the distant horizon. Robinson's spontaneous, active handling in these areas is balanced by the more deliberately placed, flat patches of color that convey the solidity of the houses in the valley below.

The Valley of Arconville was one of several paintings by Robinson in the 1889 Society of American Artists exhibition, held in New York City; recognized by critics as belonging to "the new school," it helped disseminate the lessons of Impressionism to artists in the United States.

James Ensor
Belgian; 1860–1949

Portrait of the Artist's Sister, Marie, 1881
Charcoal on ivory wove paper
73.7 x 57.2 cm (29 x 22½ in.)
Margaret Day Blake Collection, 1970.42

Born in the coastal resort town of Ostend, Belgian painter James Ensor went to Brussels to study at the Académie royale des beaux-arts in 1877. When he returned home three years later, he rejected both the academic techniques he had learned at school and the avant-garde styles he had seen in the capital, instead inventing his own peculiar vocabulary of religious motifs, bold and intense color schemes, and a carnivalesque coterie of characters, all of which placed him decidedly outside any unified artistic movement. Setting up his studio in the family home, Ensor prepared figure drawings in a wide variety of media, including graphite, red chalk, and charcoal. Between 1880 and 1885, he frequently depicted members of his immediate circle engaged in mundane, domestic activities. The artist's sister, Marie, often served as his sitter, appearing as a melancholic figure in several images of oppressive, bourgeois interiors.

As the inscription at the lower left indicates, Marie is the subject of this tender portrait. She is deeply absorbed in a book, her head propped up with one hand. Ensor outlined her figure with a series of rapid charcoal strokes, providing more detail in her hair, face, and the folds of her skirt. The deep shadows beneath the ornate table, on which an elegant tea set rests, create a hint of pictorial depth. The artist left untouched the open pages of the book at the center of the composition, as if to suggest that the luminous, white space is a realm of imagination and fantasy.

Antonio Mancini
Italian; 1852–1930

Resting, c. 1887
Oil on canvas
60 x 100 cm (23⅝ x 39⅜ in.)
Gift of Charles Deering McCormick, Brooks
McCormick, and Roger McCormick, 1962.960

A portrait painter who worked primarily in Rome after 1883, Antonio Mancini developed an interest in the rich palettes and dark, tonal contrasts of Italian Baroque painting. Over the course of several trips to Paris, he also acquired a taste for contemporary stylistic developments, and met Edouard Manet and Edgar Degas during one such visit in 1875. Two years later, after being introduced to early Impressionist paintings by his Parisian dealer, Alphonse Goupil, Mancini revealed the depth of his interest in the French avant-garde by pursuing the group's concern with the materiality of the canvas. Applying his oils with reckless and ecstatic abandon, he went so far as to incorporate bits of colored glass and foil into the surfaces he built up.

With its dramatic impasto, particularly in the bedsheets that surround the ruddy-cheeked, soporific young woman, *Resting* demonstrates the bold, almost sculptural quality of Mancini's work from this period. The array of reflective decanters near the subject's bed suggests that she is a convalescent, perhaps recovering from an illness, given her flushed complexion. Nevertheless, her sensuous appearance conveys as much erotic allure as it does innocent vulnerability. She looks wistfully off to the side, refusing to meet the viewer's gaze, her barely parted lips and slightly tilted head contributing to her dreamy demeanor. The lyrical atmosphere of this intimate—and intimately scaled—image seems intensified by the curve of the model's abundant, black hair flowing across the length of the large, white pillow behind her; the red roses she clutches in her hand; and the manner in which she coyly pulls down the sheet to reveal her breast and shoulder.

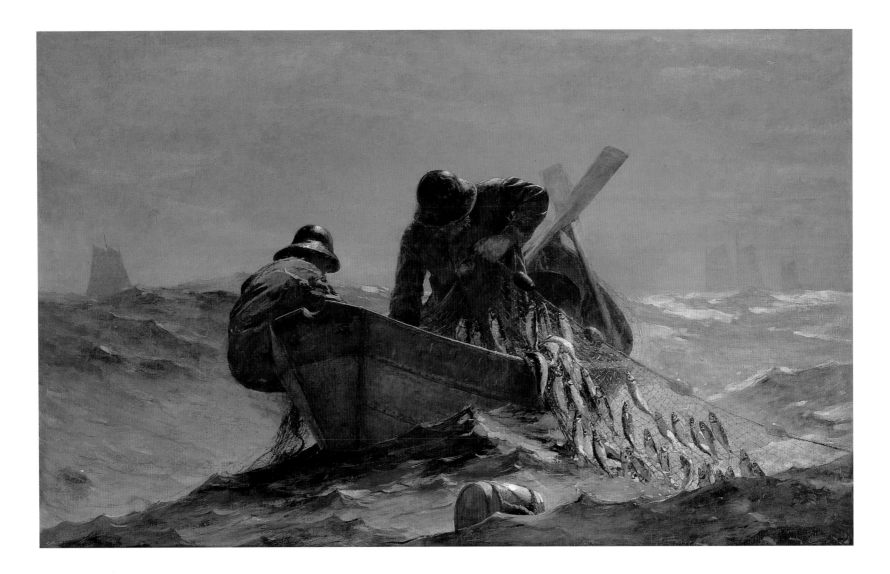

Winslow Homer
American; 1836–1910

The Herring Net, 1885
Oil on canvas
76.5 x 122.9 cm (30⅛ x 48⅜ in.)
Mr. and Mrs. Martin A. Ryerson Collection,
1937.1039

In the summer of 1883, Winslow Homer moved to Prout's Neck, a secluded fishing village on the coast of Maine, where he resided for the remainder of his life. Essentially a rocky promontory jutting out into the Atlantic, Prout's Neck features looming cliffs that offer spectacular views of the ocean. There, in a bleak, rugged setting where humanity battled with an adversarial sea for its livelihood, Homer found the epic inspiration for his mature marine paintings, such as *The Herring Net*.

Homer first painted seacoast life in 1873 and 1880 in Gloucester, Massachusetts, and then in 1881–82 in Cullercoats, on the Northumberland shore of England. *The Herring Net* strikes a new, heroicizing note in this ongoing series of works based on firsthand observation. An unusually large school of herring appeared off the shore at

Prout's Neck in the fall of 1884; hiring a local boy to man his rowboat, Homer went out with the fishing fleet so that he could make preliminary sketches of the action. Once back in the studio, Homer depicted the figures of the fishermen— clad in cumbersome gear, struggling to haul their catch into a wave-tossed dory—with sculptural monumentality. His dark palette, dominated by the sheen of steely gray, conveys the threat of a harsh and unpredictable environment. But the strong structure of the composition, with its horizontal bands of sky and water bolstering the fishermen's stark silhouettes, establishes a formal stability. Recording his subjects' alert response to the elements, Homer conveyed in *The Herring Net* the resilience and courage that they needed to ply their trade.

Winslow Homer
American; 1836–1910

For to Be a Farmer's Boy, 1887
Watercolor with touches of scraping over graphite
on cream wove paper
35.5 x 50.9 cm (13 15/16 x 20 1/16 in.)
Gift of Mrs. George T. Langhorne in memory of
Edward Carson Waller, 1963.760

The richly descriptive surface of *For to Be a Farmer's Boy* demonstrates Winslow Homer's unparalleled virtuosity as a watercolorist. Rendered in strong, blunt strokes and a restricted range of blue and brown, the central figure has weight and presence. In contrast Homer worked the foreground in a variety of tones and textures: broadly applied greens and yellows represent foliage; scraped, rose-gray pigment suggests hardened, bare earth at the end of the season; trailing stems are scratched like fine lines into the surface. By dampening the paper and blotting the color, Homer attained a subtle, atmospheric quality in the distant, blue-green hills and pale, cloud-streaked sky. Despite the anecdotal nature of the title, *For to Be a Farmer's Boy* is devoid of narrative or sentiment. It is a study in frank observation, translated into a challenging medium with spontaneity and mastery.

Homer became intrigued with watercolor in 1873, after viewing an exhibition of English works in the medium at the National Academy of Design, in New York City. As he had with oil painting, Homer learned the technique on his own, through trial, error, and experiment. By 1883 he developed an unmatched boldness in handling. In addition to working confidently with the brush, he incised and sanded the painted surface to expose pigment or paper beneath the wash; allowed color to flow and pool, using blotting to control the effect; and layered transparent tones for depth and brilliance. In *For to Be a Farmer's Boy*, Homer revealed a sophisticated command of his materials, prompting one critic to declare: "Mr. Homer goes as far as anyone has ever done in demonstrating the value of watercolors . . . and does it wholly in his own way."

William Merritt Chase

American; 1849–1916

A City Park, c. 1887
Oil on canvas
34.6 x 49.9 cm (13⅝ x 19⅝ in.)
Bequest of Dr. John J. Ireland, 1968.88

William Merritt Chase figured prominently in the American art world, both as a painter and teacher. His career began with an extended educational trip to Europe in the 1870s, but unlike expatriates Mary Cassatt, John Singer Sargent, and James McNeill Whistler, Chase chose to establish his studio in New York. There, he applied lessons learned abroad to the American scene, painting portraits, landscapes, still lifes, and genre subjects.

A City Park is one of a group of works from the mid-1880s in which Chase explored the green spaces of New York City. In this case, the setting is most likely Tompkins Park, in Brooklyn. Dominating the composition is one of the park's wide, straight paths, along which women and children promenade. Chase probably executed this scene *en plein air*. As he described his process, "When I have found a spot I like, I set up my easel, and paint the picture on the spot." The spontaneity of the artist's approach is demonstrated here by the placement of the stylishly dressed woman in the foreground. She turns toward the viewer, as though she has just encountered someone she knows walking down the path. This emphasis on capturing the moment, as well

as the choice of subject, aligned Chase with the French Impressionists, whose work he saw in Paris and again in New York City, at a large exhibition organized by dealer Paul Durand-Ruel in 1886. Chase shared the Impressionists' interest in representing the leisure activities that took place in city parks, and in addition infused his scenes with a distinctively American aura of pastoral gentility compatible with the aims of Frederick Law Olmsted and Calvert Vaux, the accomplished landscape architects who designed Tompkins Park.

Childe Hassam

American; 1859–1935

The Little Pond, Appledore, c. 1890
Oil on canvas
40.6 x 55.8 cm (16 x 22 in.)
Through prior acquisition of the Friends of
American Art and the Walter H. Schulze
Memorial collections, 1986.421

Childe Hassam, a prominent practitioner of
Impressionism in the United States, adapted the
French style into a uniquely American idiom by
imbuing his images with an identifiable sense of
place. Favoring scenes he considered to be partic-
ularly "American," Hassam produced paintings of

the streets of New York City, simple New England
villages and churches, and tourist attractions such
as Nantucket and Gloucester, Massachusetts.
These works capture not only the appearance of
these subjects but also the associations connected
to them.

After returning from an extended stay in
Paris in the late 1880s, Hassam often painted
Appledore Island, off the coast of New
Hampshire, where celebrated poet Celia Thaxter
presided over an informal colony of writers and
artists. This summer retreat offered a proliferation
of wildflowers and a varied topography that al-
lowed Hassam to fuse his burgeoning interests in
Impressionist technique and American subjects.

The Little Pond, Appledore features an identifiable
location on the island, one with specific meaning
for Hassam and other visitors. It is a site that was
touched by tragedy: artist William Morris Hunt
had drowned in the pond in 1879. Perhaps for this
reason, Hassam set aside the vivid reds and blues
he generally used to depict Appledore's gardens,
instead employing a more subdued, pastel palette.
Sheltered from the ocean, which appears as a thin
line of blue on the horizon, the pond is hugged
by low-lying rocks and tall grasses painted in var-
iegated tones. The scene is imbued with a sense of
elegy, a silent and contemplative quality distinct
from Hassam's other work (see p. 95).

John Henry Twachtman
American; 1853–1902

Icebound, c. 1889
Oil on canvas
64.3 x 76.6 cm (25 ¼ x 30 ⅛ in.)
Friends of American Art Collection, 1917.200

John Henry Twachtman was a prominent member of a group of painters who incorporated the techniques of French Impressionism into a distinctively American landscape tradition. Like many of his contemporaries, Twachtman traveled to Europe for his artistic education; he went first to Munich, in the mid-1870s, and then enrolled at

the Académie Julian, Paris, in 1883. Upon his return to the United States, in 1889, Twachtman purchased a farm in Cos Cob, Connecticut, near Greenwich. This town had attracted a number of American Impressionists, whom the painter Childe Hassam nicknamed the "Cos Cob Clapboard School," a tongue-in-cheek reference to their interest in rural subjects of a characteristically American nature.

Like Claude Monet, Twachtman was fascinated by the way seasonal and climatic changes affected his surroundings, and he painted the same scenes repeatedly under various conditions. In this way, he hoped both to record the different

effects of light and to capture the essence of a place. Over time Twachtman depicted Horseneck Brook, the subject of *Icebound*, in summer, spring (see p. 94), and fall, but he seemed to favor the view in winter, when tourists departed and a blanket of snow created a hushed solitude. With a limited palette of blues and whites touched by a hint of yellow, the artist captured the ambience of a frigid, New England winter day and evoked the virtues of country life. For Twachtman this setting was not only picturesque but imbued with cherished national values. *Icebound* celebrates both the aesthetic and moral beauty of its landscape subject.

George Inness

American; 1825–1894

The Home of the Heron, 1893
Oil on canvas
76.2 x 115.2 cm (30 x 45 in.)
Edward B. Butler Collection, 1911.31

Throughout his career, George Inness painted intimate landscapes that are a distinct departure from the grandiose, topographical views of the Hudson River School, which represented the established American landscape tradition. A regular visitor to Europe, Inness admired the formal experiments of James Mallord William Turner, the Barbizon School painters, and James McNeill Whistler, and he may have seen works by the

Impressionists in Paris in 1874, the year of their first group exhibition. He adopted the practice of making quick sketches outdoors and then translating them into finished oil paintings in his studio. However, Inness denied the influence of modern French trends, preferring to explain his works in spiritual rather than optical terms. Like many artists and writers of the period, Inness subscribed to the tenets of philosopher Emmanuel Swedenborg and believed that harmony in nature reflects a divine presence. In his evocative paintings, he attempted to communicate his mystical vision of landscape.

Inness painted *The Home of the Heron* near the end of his life, during a summer stay in Tarpon Springs, Florida. There, he confronted an exotic

landscape of marshes and mist—quite different from that of his rural New England home—which he depicted in an increasingly muted, abstract style. The trees that dominate this canvas have become flattened patterns, balanced against a light ground. Inness blurred the boundaries between the ground cover and the canopy of branches both in the foreground and along the horizon, symbolically suggesting the unity of all of God's handiwork. The gravity and stillness of this image, with the last rays of sun bathing the lone figure of a heron in golden light, perhaps hint at the artist's sensitivity to nature's cyclical rhythms of day and night, and of life and death.

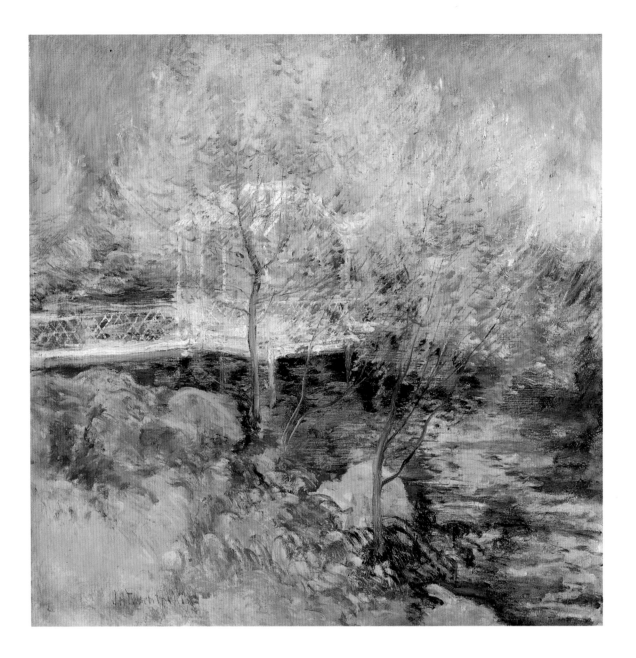

John Henry Twachtman

American; 1853–1902

The White Bridge, after 1895
Oil on canvas
75 x 75 cm (29½ x 29½ in.)
Mr. and Mrs. Martin A. Ryerson Collection,
1937.1042

For John Henry Twachtman, Cos Cobs, Connecticut, was a source of never-ending artistic inspiration. He purchased property there in 1889, and, over the following decade, made improvements to his house and surrounding land. In 1895 he added a trellised, white footbridge, which spanned Horseneck Brook. Twachtman carefully selected the proportions and color of the structure to enhance the site's inherent aesthetic qualities. He then made at least five paintings of the bridge from different vantage points, exploring its relationship to both the man-made and natural world. These works are contemporaneous with Claude Monet's pictures of the Japanese bridge over his water-lily pond at Giverny (see p. 159); although Twachtman was less methodical (and less prolific) than Monet, he worked with a similarly palpable love of place.

The Art Institute's *White Bridge* is a vivid, joyous image of springtime that complements *Icebound* (p. 92), Twachtman's rendition of the same brook in winter. Delineated with bright, white paint, the bridge crosses over the reflective surface of the water and stands out sharply through transparent trees in the foreground. The light, feathery strokes that compose the bridge echo those used to trace the limbs and branches of the surrounding hemlocks. The artist thus used brushwork to unify forms on the surface of the canvas, as he had made an effort to integrate the bridge itself into the Cos Cob setting. Twachtman's desire to show human construction in harmony with nature indicates his concern—widespread at the turn of the twentieth century—about the effects of urban and industrial growth. A witness to (and participant in) the suburbanization of rural Connecticut, Twachtman lamented the threat posed to the pastoral landscape he loved.

94

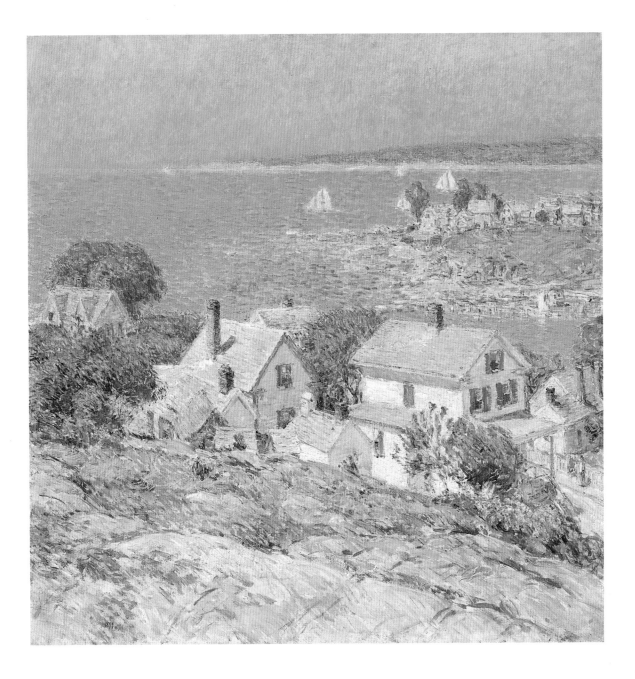

Childe Hassam

American; 1859–1935

New England Headlands, 1899
Oil on canvas
68.9 x 68.9 cm (27 1/8 x 27 1/8 in.)
Walter H. Schulze Memorial Collection, 1930.349

Born in New England, painter Childe Hassam frequently chose to depict his native landscape. He was doubtless influenced by his exposure to the work of the French Impressionists, who applied their bold, new techniques to the exploration of familiar rural scenes. Hassam's interest in images of New England also reflects contemporary concerns about the future of American culture.

Unsettled by the effects of increased immigration and rapid urbanization on national values and folkways, a number of Americans dedicated themselves to preserving the character of early Anglo-Saxon settlements. These nativists looked to "olde" New England as a paradigm, celebrating it in literature, art, decorative arts, pageantry, and garden design.

In *New England Headlands*, Hassam used the bright, sunlit palette and the broad brush strokes of Impressionism to depict the coastline at Gloucester, Massachusetts. Despite its up-to-date technique, this work exemplifies certain aspects of the colonial revival that swept the United States at the turn of the twentieth century. Gloucester,

which dates back to the 1600s, was considered the quintessential New England fishing village, and it provided Hassam with highly appropriate imagery to attach to his geographically vague but emotionally evocative title. He erased signs of industrialization, framing the picture so that it features simple colonial-era homes and sailboats, rather than the fish-packing factories and tourists that had come to dominate the landscape. Hassam thus presented a nostalgic, idealized view of a site that symbolized the Yankee spirit which he and others believed was essential to the future success of the American experiment.

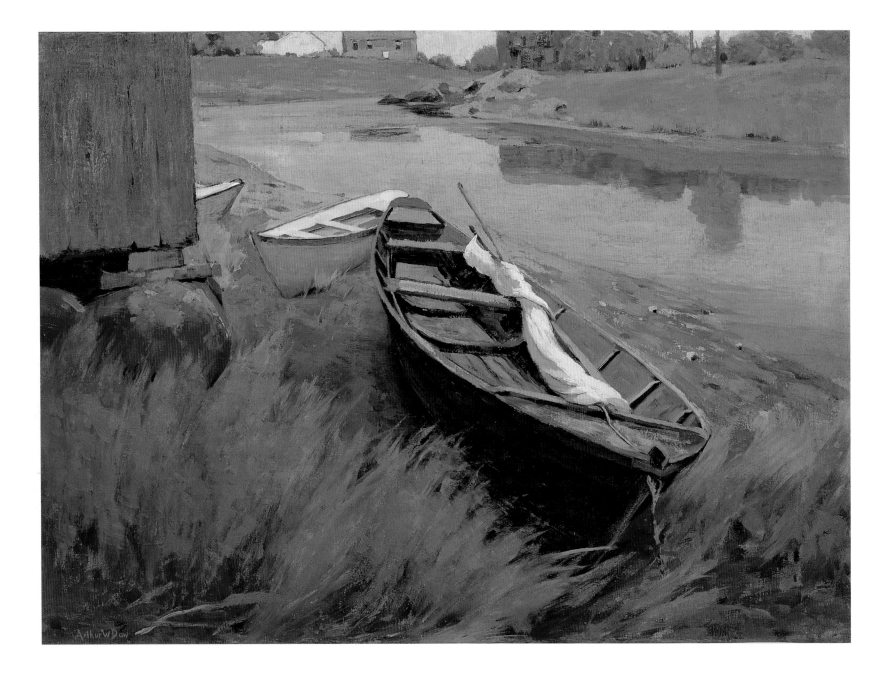

Arthur Wesley Dow

American; 1857–1922

Boats at Rest, c. 1895
Oil on canvas
66 x 91.4 cm (26 x 36 in.)
Through prior acquisition of the Charles H. and
Mary F. S. Worcester Collection, 1990.394

Arthur Wesley Dow studied at the Académie
Julian in Paris from 1884 to 1889, spending the
summers painting in Pont Aven. Although Paul
Gauguin worked in the immediate area for some
of that time, there is scant evidence that the two
artists ever met. *Boats at Rest*, painted after Dow's
return to Ipswich, Massachusetts, reveals the

heightened sensitivity he had acquired in Brittany
to local landscape, but its dynamic palette marks
a significant shift from the atmospheric and tonal
quality of the *plein-air* technique he had practiced
in France. While the strong hues—almost jarring
in their vibrant contrasts—suggest Gauguin's free
exploration of color, they derive from another
influence: the Japanese prints that Dow, like
many artists of his time, came to appreciate.

Dow pursued his interest in Japanese art by
studying the notable collection of *ukiyo-e* (the
floating world) prints in the Museum of Fine
Arts, Boston; his instinctive understanding of
these works prompted curator Ernest Fenollosa
to hire him as his assistant. As Dow wrote to his

fiancée, "One evening with Hokusai gave me
more light on composition and decorative effect
than years of study of pictures." Three basic ele-
ments that Dow discerned in the Japanese aes-
thetic—line, color, and *notan* (harmony)—
provided the core of the artistic theory he articu-
lated in *Composition*, an instruction manual he
published in 1899. The clear tones, daring diago-
nals, and boldly flattened forms used in *Boats at
Rest* demonstrate Dow's application of Japanese
artistic principles to his own work. In his career as
a teacher, Dow imparted these elements to a wide
range of students, including Georgia O'Keeffe
and Max Weber, thus influencing the course of
American modernism.

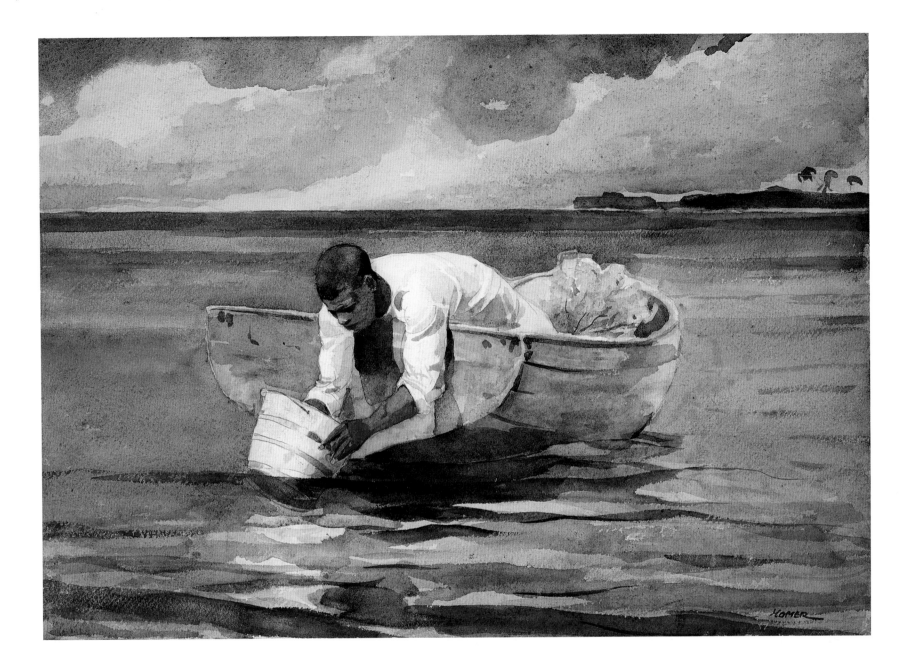

Winslow Homer
American; 1836–1910

The Water Fan, 1898/99
Watercolor with graphite on off-white wove paper
37.4 x 53.4 cm (14 11/16 x 21 1/16 in.)
Gift of Dorothy A., John A., Jr., and Christopher
Holabird in memory of William and Mary
Holabird, 1972.190

In *The Water Fan*, Winslow Homer captured the brilliant reflection of the tropical sun on the warm waters of the Caribbean. He achieved this effect with an economy of means—a simple composition and a limited palette—but his expert handling of watercolor gives the image subtlety and strength. To convey the glassy depths of the water, Homer exploited the natural translucence of his medium, layering thin washes of blue. He added tints of gray, highlights of white, and saturated strokes of pure, bright pigment over the delicate wash. He used the same range of hues in the sky, incorporating the off-white of the bare paper into his color scheme. The dazzling white of the fisherman's shirt provides a stunning contrast to the rest of the composition's tranquil blue tonality, while a more subtle note is struck by the pale piece of coral in the prow of the boat, the "water fan" that gives the image its name.

Homer first visited the Bahamas in the winter of 1884–85, stopping in Nassau and Cuba, where the luminous skies and turquoise seas added a new dimension to his work in watercolor. He returned to Nassau in December 1898 and, during a two-month sojourn, painted many of the subjects that immediately intrigued him: lush vegetation, seaside vistas, and fishermen working along the shore. In terms of color and light, Homer's later Bahamian watercolors suggest a sensuous departure from the hard realism of the marine scenes he produced at home in Prout's Neck, Maine (see p. 88). But the monumentality of the figure in *The Water Fan*—strong, solid, and purposeful—reveals that Homer discerned the same epic sensibility in Caribbean fishermen that he respected in the men who fished the North Atlantic.

Georges Lemmen
Belgian; 1865–1916

Portrait of the Artist's Sister, 1891
Oil on canvas
62 x 51 cm (24⁷/₁₆ x 20¹/₁₆ in.)
A. A. McKay Fund, 1961.42

A painter with limited formal training and an interest in the decorative arts, Belgian Georges Lemmen quickly made his mark after 1888, when he joined the Brussels-based avant-garde group Les Vingt (The Twenty; see p. 99). It was almost certainly while exhibiting with this organization (whose membership was international) that Lemmen was exposed to Georges Seurat's Neo-Impressionist technique, a carefully orchestrated system of contrasting and complementary paint dots devised by the French artist to create an optically based, decorative field of color. Shortly after Seurat's *Sunday on La Grande Jatte—1884* (p. 79) appeared in Les Vingt's 1887 exhibition, Lemmen emerged as one of the leading adherents of Belgian Neo-Impressionism.

In this staid but psychologically penetrating portrait of his sister, Julie, Lemmen applied the style to his own interpretive ends, focusing not only on the composition as a chromatically unified whole but on the sitter's personality as well. Thirteen years Lemmen's elder and unmarried, Julie lived in her brother's household and cared for his children. Here, the artist conveyed her chaste, determined character, tinged with a hint of melancholy, through her prim posture, simple hairstyle, and austere attire, which is brightened only by the triangular gold brooch below her neck. Indeed, even the setting is devoid of any extraneous ornamentation, containing only a plain, armless chair and a modest curtain backdrop. Lemmen applied different-sized dots throughout the composition, reserving the smallest to model his sitter's fine features. In accordance with Neo-Impressionist color theory, he outlined her head with a halo of contrasting blue and orange dots, and followed Seurat's example by painting a "frame" in black and violet hues that complement those of the main image.

James Ensor

Belgian; 1860–1949

Still Life with Fish and Shells, 1898
Oil on canvas
81 x 100.5 cm (31⅞ x 39½ in.)
Gift of Mary and Leigh Block, 1978.96

James Ensor helped to found the avant-garde group Les Vingt (The Twenty) in Brussels in 1883. Working outside traditional institutional systems of academies and Salons, Les Vingt also engaged in a critical dialogue with other progressive artistic movements. Shortly after leaving the group, Ensor took up still-life painting, perhaps seeking to reconnect with art-historical traditions through this time-honored genre.

In this work, he made clear references to seventeenth-century Flemish examples, dutifully including objects that project over the edge of the table into the viewer's space, such as the oyster at the left, a device Baroque painters commonly used to convey their illusionistic skill. However, while traditional marine still lifes feature bountiful market arrangements of fresh, often still-alive catches from the ocean, in Ensor's interpretation, the fish and crustaceans lie dead, evenly spaced, and surrounded by empty shells. Furthermore, the artist imposed an intense, unnatural, red illumination, offset only by white, impastoed highlights and a few pieces of colorful earthenware. This tonality creates a somewhat unappetizing mood, at odds not only with the works of Ensor's

Baroque predecessors but also with those of his fellow nineteenth-century practitioners of the genre, such as Paul Cézanne, Claude Monet, and Pierre Auguste Renoir (see pp. 62, 64, 65). These artists typically made little effort to conceal the studio setting of their still-life arrangements, while Ensor placed his objects in a more ambiguous space suggestive of a merchant's stall or a kitchen. (The actual location may very well have been his mother's Ostend curiosity shop, where he could have encountered many of the exotic shells that populate this canvas.) Ensor's still lifes—enigmatic in content and painterly in style—would attract the German Expressionists in the early decades of the twentieth century.

Cecilia Beaux
American; 1855–1942

Dorothea and Francesca, 1898
Oil on canvas
203.5 x 116.8 cm (80⅛ x 46 in.)
A. A. Munger Collection, 1921.109

In the dual portrait *Dorothea and Francesca*, Cecilia Beaux painted the eldest daughters of her friend Richard Watson Gilder with fond familiarity. Beaux had met Gilder, a poet and the editor of *Century Magazine*, and his wife, Helena, in Paris in 1896. Their friendship deepened after Beaux returned to the United States and moved from her native Philadelphia to New York City, where the Gilders regularly hosted events for the arts community in their apartment on Fifteenth Street, which was nicknamed "The Studio." The Gilders became a second family to Beaux, and in the fall of 1898, while visiting them at their farm in Tyringham, Massachusetts, she painted this affectionate portrait of sixteen-year-old Dorothea patiently teaching her little sister Francesca a dance.

The subject's thoroughly spontaneous appearance resulted from the artist's careful control of her composition and her models. Beaux set up a studio in a converted tobacco barn on the farm's grounds, building a platform on the bare earth floor to facilitate the girls' natural movements. Several preparatory sketches preceded Beaux's work on the large-scale canvas, and she regularly had the sisters pose separately, using a wooden brace to position accurately the hand that would be held by the absent figure in the final image. The sumptuous sheen of the girls' dresses—warm white tinged with a shimmer of rosy pink—sets off their delicate complexions against their dark hair and the deeply shadowed background. Like John Singer Sargent (see p. 101), Beaux employed tonal contrasts and bravura brushwork to attain in her fashionable portraits a confident but casual elegance, prompting William Merritt Chase in 1899 to praise her as "not only the greatest living woman painter but the best that has ever lived."

John Singer Sargent

American; 1856–1925

The Fountain, Villa Torlonia, Frascati, Italy, 1907
Oil on canvas
71.4 x 56.5 cm (28⅛ x 22¼ in.)
Friends of American Art Collection, 1914.57

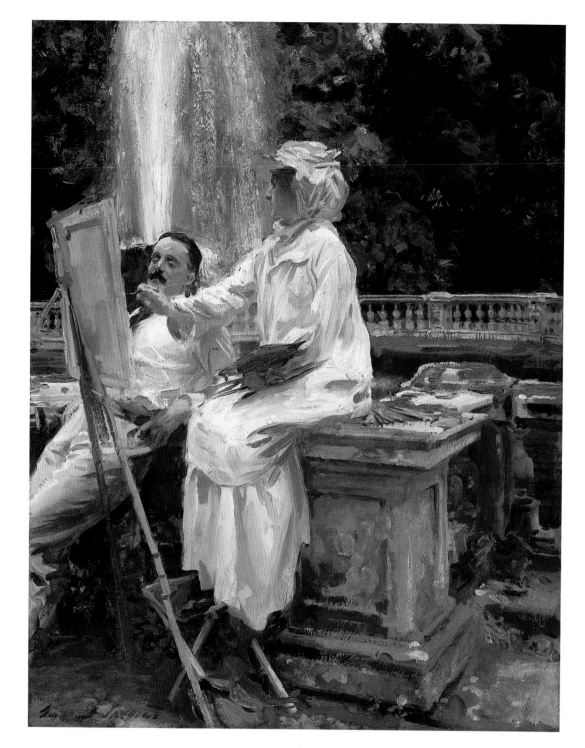

In 1907 John Singer Sargent and a party of friends shared an autumn holiday in Frascati, the famous wine region located roughly fifteen miles southeast of Rome. Sargent used the picturesque location as a point of departure for his painting expeditions. On several occasions, he was joined by the young American expatriates and painters Jane and Wilfrid von Glehn; Sargent had taken a mentor's interest in Wilfrid's career in portraiture. One of their destinations was the Villa Torlonia, an old estate built against the Frascati hillside. Known for its gardens and fountains, the landscaped grounds featured a tall spray of water spouting from a large pool near the summit of the hill. This romantic setting provides the background for *The Fountain, Villa Torlonia, Frascati, Italy,* an informal portrait of Jane von Glehn painting *en plein air,* while her husband relaxes at her side.

Jane, who happily described the portrait as "the very 'spit' of me," is comfortably perched on the corner of a balustrade, with her feet resting on a folding canvas stool. Wearing a smock to protect her fashionable summer gown, she turns to look at her subject, the sparkling plume of water shooting high into the air. Sargent seized the opportunity to display his well-known virtuosity with white paint, varying its undertones and textures with astonishing subtlety.

In previous paintings, Sargent had depicted male artists accompanied by their wives, but here he reversed that mode, portraying Jane actively engaged in her work with Wilfrid idly keeping her company. *The Fountain* marks the year that Sargent suspended his career as a portraitist (see p. 103), but he continued to paint intimate likenesses of friends such as the von Glehns.

Maurice Brazil Prendergast
American; 1859–1924

The Terrace Bridge, Central Park, 1901
Watercolor over graphite on ivory wove paper
38.8 x 56.9 cm (15 5/16 x 22 7/16 in.)
Olivia Shaler Swan Memorial Collection, 1939.431

Decorative color is the key feature in Maurice Prendergast's distinctive application of the Impressionist sensibility to American urban scenes. In the watercolor *The Terrace Bridge, Central Park*, Prendergast created a mosaic of delicate tones, evoking the pleasant experience of a stroll in the park on a balmy day. The pale tints of the women's dresses—predominantly white and rose—make the surface of the painting shimmer with an airy luminosity. Bright parasols of red and orange provide a vital accent. A gentle breeze swirls the diaphanous skirts of the promenaders, adding a deft touch of sensuous delight and energy. The neutral tone of the bridge, rendered in subtle gray-green wash and lightly defined details, grounds the delicate image with a sense of a specific place. In the distance, a dense stand of trees, its blue-green foliage swaying against a cloud-strewn sky, suggests the lush, vast park that provides a haven for the residents of New York City in the summer's heat.

Born in St. John's, Newfoundland, Prendergast was raised in Boston. In 1891 he traveled to Paris, where he remained until the winter of 1894, studying art at the Académie Julian. He had little patience for the demands of the drawing studio and preferred to sketch in public gardens and along the boulevards. After his return to United States, Prendergast worked for a decade almost exclusively in watercolor, finding the translucent and spontaneous effects of the medium ideal for his favorite subject: the world of fashionable leisure seen in the parks and squares of Boston and New York. As *The Terrace Bridge* demonstrates, he portrayed the ever-changing pageant of contemporary life with grace, wit, and sophistication.

John Singer Sargent
American; 1856–1925

Workmen at Carrara, c. 1911
Watercolor over graphite heightened with white
gouache on ivory wove paper
40.3 x 53.4 cm (15⅞ x 21⁷/₁₆ in.)
Olivia Shaler Swan Memorial Collection, 1933.507

Although John Singer Sargent worked in water-
color from childhood, his concentrated interest in
the medium occurred late in his career. In 1907 he
decided to retire from his lucrative but demand-
ing work as a society portraitist. Freedom from
regular commissions allowed him to indulge even
more frequently in his passion for travel. Born in
Italy to American parents who continually moved
from city to city in Europe, Sargent was a veteran
traveler, fluent in four languages and able to
adapt to new situations with ease. Once released
from his professional obligations, he embarked on
an annual schedule of painting expeditions: sum-
mer in the Alps, September in Venice, and a so-
journ in a favorite Italian resort area. Watercolor
proved to be the perfect medium for the touring
artist. Not only was it portable—requiring little
more than a palette, a block of paper, and box of
paints—but it also allowed Sargent to compose
quickly in color, working rapidly in response to
his subject.

Workmen at Carrara displays Sargent's mature
technique. Using a limited palette—silver gray,
with washes of mauve and rose-brown, accents of
cobalt blue, and a single dash of red—Sargent
created a friezelike procession. There is nothing
extraneous in his composition, and the figures
have the monumental presence of an ancient re-
lief sculpture. Indeed, the site is associated with
the art of carving: Carrara, on the northwest coast
of Italy, is Europe's most renowned marble quarry
and the source of the blocks used by sculptors
such as Michelangelo. In *Workmen at Carrara*,
Sargent presented the dignity of the quarrymens'
labor, perhaps suggesting a parallel between their
work and that of the artist or artisan.

Joaquín Sorolla y Bastida
Spanish; 1863–1923

Two Sisters, Valencia, 1909
Oil on canvas
176.2 x 112.1 cm (69⅜ x 44⅛ in.)
Gift of Mrs. William Stanley North in memory
of William Stanley North, 1911.28

As an art student in his native Valencia, Joaquín
Sorolla y Bastida was inspired by the painterly
techniques of seventeenth-century Spanish masters.
In 1885 he expanded his horizons, traveling on a
study grant to Rome, where he came in contact
with members of the Macchiaoli, a small group of
progressive artists noted for the naturalistic effects
they achieved with patches of color, or *macchie.*
After an extended stay in Paris, Sorolla returned
to Spain in 1889, establishing a studio in Madrid
while continuing to travel widely. The influence
of the Macchiaoli, who were regarded as the
Italian response to the Impressionist movement,
coupled with the daring color experiments of the
Post-Impressionist work he saw in Paris, shaped
Sorolla's artistic vision. Whenever possible, he
painted out-of-doors, earning an international
reputation for his seaside subjects. As seen in *Two
Sisters, Valencia,* Sorolla purged his palette of the
traditional, dark tonalities of Spanish art and con-
centrated almost exclusively on the brilliant
effects of natural light.

In 1909 Sorolla had a successful debut in the
United States, his one-person exhibition at the
Hispanic Society in New York City attracting
unprecedented crowds. This attention led to a
commission to paint a portrait of President
William Howard Taft (1909; Taft Museum,
Cincinnati, Ohio). Around this time, Sorolla pur-
chased a beach house in Valencia, on the
Mediterranean shore, where he painted *Two
Sisters.* Employing the spontaneous approach he
used for his *apuntes* (small oil sketches), Sorolla
depicted his lively, young models with an air of
intimacy and informality that belies the work's
large scale. Yet the subject of the painting is also
light, which dazzles both girls' eyes and sparkles
on the waves behind them.

Edward Henry Potthast
American; 1857–1927

A Holiday, c. 1915
Oil on canvas
77.5 x 102.9 cm (30½ x 40½ in.)
Friends of American Art Collection, 1915.560

In *A Holiday*, Edward Henry Potthast used a luminous palette to capture the sun-drenched sensations of a day at the seashore. Light gleams on the bathing dresses of the group of girls in the foreground, while their reflections sparkle on the water swirling at their feet. Beyond the sandbar, waves break into foaming white crests, and deep water darkens into rich shades of blue under a cloudless, aqua sky.

Potthast became an advocate of *plein-air* painting during a trip to France in 1887. After leaving his native Cincinnati for New York City in 1896, he experimented with urban genre scenes. He discovered his signature subject in 1909, when he attended an exhibition of works by the Spanish painter Joaquín Sorolla y Bastida at the Hispanic Society. Inspired by Sorolla's images of the Mediterranean shore (see p. 104), Potthast began to sketch in oil at Coney Island and Rockaway Beach, recording his own impressions of light glistening on the surfaces of sand and water.

At the turn of the twentieth century, an expanding workforce and a rising economy allowed Americans more time for leisure. During the summer, they flocked to private resorts and public beaches. In response, artists ranging from Impressionist William Merrit Chase to urban Realists Robert Henri and John Sloan added scenes of seaside recreation to their repertories. Unlike many of his contemporaries who vividly portrayed class distinctions and entertaining anecdotes, Potthast focused on the formal challenge of describing bright, summer light. The figures in Potthast's beach scenes, such as *A Holiday*, are incidental, merely elements that add color and movement to his studies of the brilliant effects of the sun.

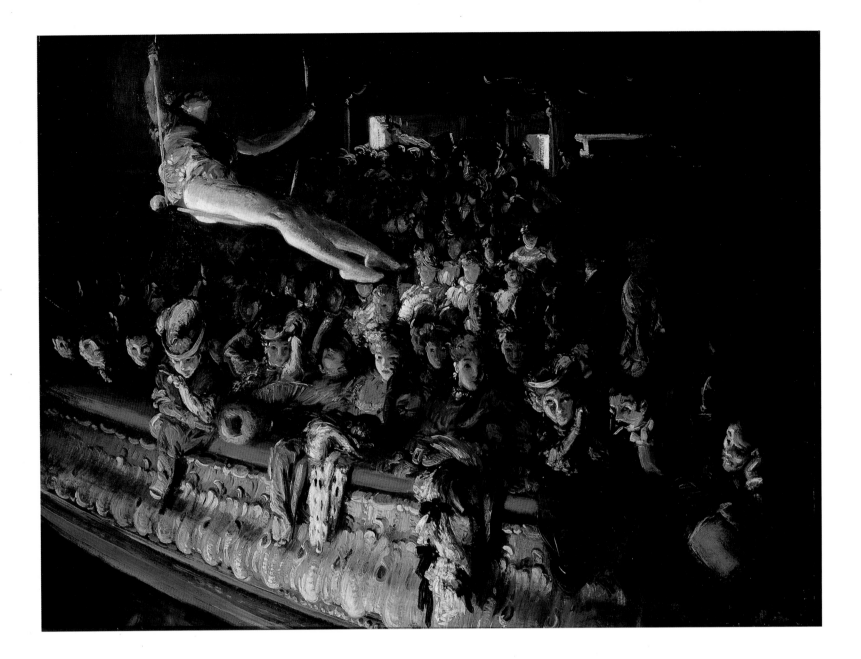

Everett Shinn
American; 1876–1953

The Hippodrome, London, 1902
Oil on canvas
66.9 x 89.3 cm (26⁵⁄₁₆ x 35³⁄₁₆ in.)
Friends of American Art Collection; the
Goodman Fund, 1928.197

Throughout his career as an illustrator, painter, and stage designer, Everett Shinn was captivated by popular entertainments, including vaudeville, the theater, and the circus. These subjects appealed as well to his colleagues, such as William Glackens and John Sloan, who like Shinn began their careers as commercial draftsmen and be-

longed to the group of painters known as The Eight (see p. 107). Although Shinn had already illustrated such scenes for publication in various popular magazines, *The Hippodrome, London* was one of his first works in oil devoted to this theme.

Shinn must have visited the Hippodrome, a popular circus venue, during his trip to London and Paris in 1900. Exposure to the works of Edgar Degas and Henri de Toulouse-Lautrec at this time seems to have reinforced his interest in scenes of urban spectacle. Contemporary critics compared Shinn's unusual use of perspective to that of the French painters. Here, in a bizarre spatial juxtaposition, a lithe trapeze artist balances carefully on a swing, which hangs without visible means of sup-

port over a crowded balcony. Lighting from the stage illuminates the performer's white tights and colorful costume, as well as a group of figures that stands out from the otherwise undefined audience in the dark background. Shinn defined the fashionably dressed onlookers seated along the lip of the gilded balcony with broad, bold strokes of rich pigment. Strangely, the presence of the performer in their midst draws the attention of only a few individuals; the others, seemingly immune to the thrills of the flying trapeze, focus on the patrons below. The dynamic interplay of spectatorship in *The Hippodrome, London* reveals Shinn as a keen observer of the urban scene.

William Glackens

American; 1870–1938

At Mouquin's, 1905
Oil on canvas
121.9 x 99.1 cm (48 x 39 in.)
Friends of American Art Collection, 1925.295

William Glackens—a member of an association of artists called The Eight, as well as the loosely affiliated group known as the Ashcan School— was at the center of avant-garde American painting at the turn of the twentieth century. Rejecting the academic standards that ruled the displays at the influential National Academy of Design, New York, The Eight sought alternative exhibition spaces that would allow them to show work influenced by the latest European styles. Ashcan School artists, a subset of The Eight, became known for their realistic urban subjects, including street scenes and leisure activities. Thus, *At Mouquin's,* with its technical inventiveness and its focus on the social conditions of modern life, combines interests of both groups.

After a trip to Paris with fellow painter Robert Henri in 1895–96, Glackens began to focus on the depiction of metropolitan settings such as Mouquin's, a fashionable New York restaurant he and his friends frequented. Doubtless influenced by Edouard Manet's *Bar at the Folies-Bergère* (1881–82; London, Courtauld Institute of Art), Glackens chose to place his two elegant diners before a mirror that reflects the image of the restaurant's other occupants. The mirror; the still life of glasses, bottles, and a vase of flowers; and the sheen of the woman's blue dress and gray cloak all indicate the artist's fascination with the play of light on reflective surfaces. Another link to the work of Manet, and that of his colleague Edgar Degas, is the melancholy, abstracted gaze of the woman, who seems to have withdrawn from the convivial gathering. Perhaps Glackens intended to make a social commentary; many contemporary writers maintained that anomie was one of the psychological consequences of rapid change in European and American cities.

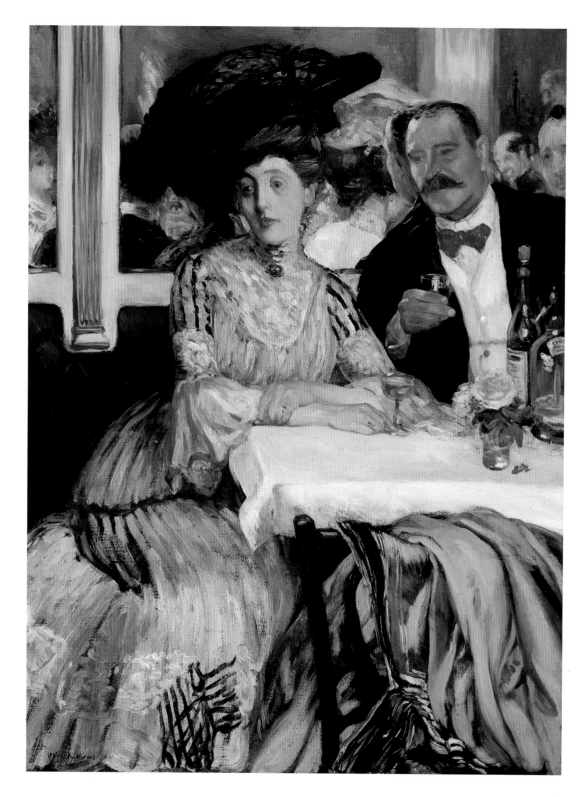

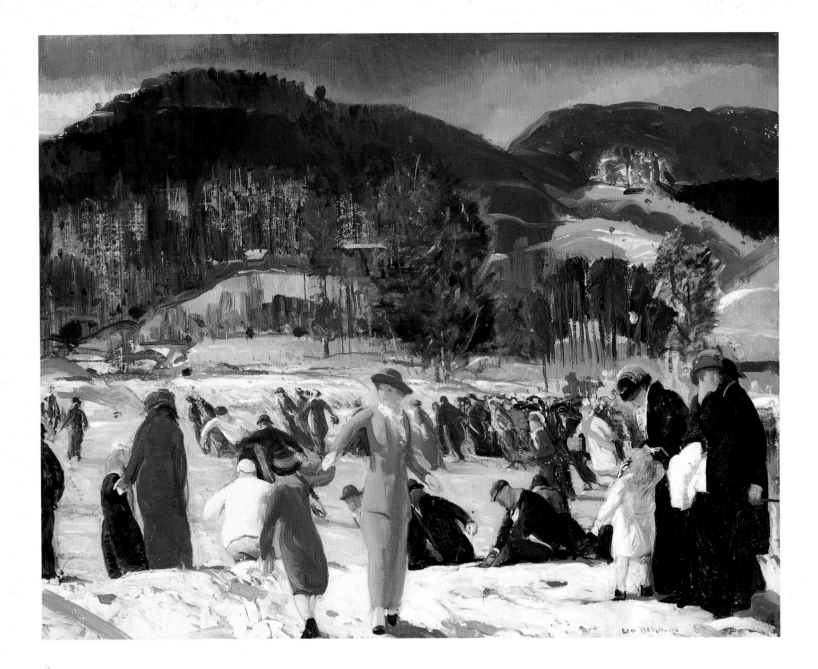

George Bellows
American; 1882–1925

Love of Winter, 1914
Oil on canvas
82.6 x 102.9 cm (32½ x 40½ in.)
Friends of American Art Collection, 1914.1018

In January 1914, George Bellows lamented in a letter, "There has been none of my favorite snow. I must always paint the snow at least once a year." Since 1907 Bellows had regularly executed winter scenes. These works, which earned him critical recognition, reflect the deep pleasure he took in the brisk temperatures and bright light of the season. On February 13, when a blizzard blanketed New York City with fresh, white snow, Bellows eagerly got to work, painting *Love of Winter*, a rollicking depiction of skaters defying the cold with their energetic activity.

In *Love of Winter*, Bellows celebrated his favorite time of year with closely observed vignettes: a mother takes her daughter's hand, boys race across the ice, a man laces on his skates. The work's fresh appeal derives from the artist's bold palette. Bellows's interest in the effects of color, as well as his dedication to Realism, was first sparked in 1904, when he attended the New York School of Art. Like many American artists around the turn of the twentieth century, Bellows practiced Tonalism, a method pioneered by George Inness and James McNeill Whistler in which a single tone dictates the chromatic range throughout a composition. In his winter paintings, Bellows took a daring, new direction, introducing sharp contrasts that convey bright light gleaming on frozen surfaces. He based his experiments on a system developed by the paint manufacturer Hardesty Maratta, who marketed a set of twelve colors, assigning each a musical note to suggest combinations based on harmonious chord structures. Bellows applied Maratta's rules liberally, for the jarring contrasts in *Love of Winter*—the strong yellows and oranges that flick across the dominant icy blues—add as much vitality as harmony to this lively scene.

Post-Impressionism

Expanding the Boundaries of Impressionism after 1886

"Post-Impressionism" is a catch-all term, coined in 1910 by the English critic Roger Fry to describe the diverse art produced after Impressionism. The simple chronological designation is still useful, because the individuals included under the label did derive certain essential elements from the Impressionists; yet their works are too different in appearance to be contained adequately within a single, more descriptive category.

The Post-Impressionists understood from their predecessors that modern art should represent the natural world, "as seen by a temperament," to use the phrase of novelist Emile Zola. However, they extended the range of nature to include inner vision as well as external sensation. They emphasized the expressive over the representational function of art, pushing the basic artistic elements of color, line, and composition into new, uncharted psychological and formal territories.

Included among the Post-Impressionists are many of the Impressionists themselves. No longer working or consistently exhibiting together in Paris, major figures such as Edgar Degas, Claude Monet, and Camille Pissarro pursued individual goals: Degas remained in the city but concentrated on nude studies in various media in his studio, Monet settled at Giverny and embarked upon his extended series of renderings of his water-lily garden, and Pissarro experimented with Georges Seurat's divisionist (or Neo-Impressionist) technique for a time. One of their original colleagues,

Paul Cézanne, took a notably dramatic path away from Impressionism, faithful to the ethos of sensation but increasing his concern for solidity and spatial organization.

Vincent van Gogh's *Self-Portrait* (p. 113), painted in Paris in 1886, reflects the influence on the Dutch artist of Seurat's masterpiece, *A Sunday on La Grande Jatte—1884* (p. 79), shown at the final Impressionist exhibition. With its powerful emotional content and its decorative, patterned surface, van Gogh's image of himself—sensitively attuned to both pain and beauty—introduces the central concerns that link the disparate artists who are presented under the rubric of Post-Impressionism.

Monet's *Iris* (p. 166), a nearly abstract, highly gestural canvas painted in the mid-1920s, represents the culmination of Impressionism and Post-Impressionism. In a matter of decades, the artists featured in this book had shattered centuries-old traditions of academic subject matter and technique, liberating color and line from purely descriptive roles, emphasizing the canvas's dual identity as a two-dimensional surface and a means of three-dimensional representation, and foregrounding the artist's personal vision. Reminding us constantly of the reciprocity—as well as the difference—between nature and art, these works of modern art perform commentaries on modern life.

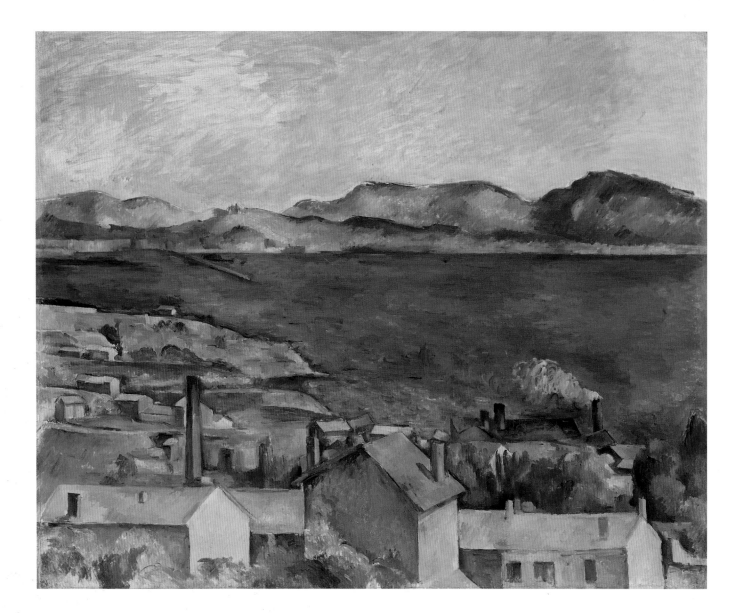

Paul Cézanne
French; 1839–1906

The Bay of Marseilles, Seen from L'Estaque,
c. 1885
Oil on canvas
80.2 x 100.6 cm (31⁹⁄₁₆ x 39⁹⁄₁₆ in.)
Mr. and Mrs. Martin A. Ryerson Collection,
1933.1116

Between 1876 and 1885, Paul Cézanne made several visits to the seaside town of L'Estaque, in the south of France, producing a dozen canvases of the setting incorporating views of the Mediterranean. As a group, these works chart his gradual jettisoning of Impressionism, with its dissolution of form and local color, in search of greater solidity and structural integrity.

The Art Institute's *Bay of Marseilles, Seen from L'Estaque*, the largest and probably the culminating canvas of the series, is built around calculated formal contrasts. The viewer looks down on the town from an adjacent hill, which affords an unobstructed view of water, distant hills, and sky. The composition is anchored by the buildings arrayed across its bottom register. Many of the rooflines are horizontal, resonating with the bay's opposite shore, while chimneys and a large central building surge upward, their verticality countered by an implied diagonal linking a puff of smoke with a distant jetty. The more organic contours of the treetops, near shoreline, and mountain range soften this geometric compositional armature. Natural and man-made forms alike seem timeworn, and they do not so much

interlock with one another as engage in a peaceable dialogue.

The whole surface is alive, Cézanne being ever wary of schematic description and alert to felicitous effects of rhythm and handling. The varied tans, ochers, and oranges in the foreground deftly evoke sun-baked surfaces. The water is a richly modulated field of blues and greens; the same pigments are repeated in the hills, where the artist applied them more lightly and complemented them with enlivening touches of mauve, yellow, gray, and brown. Capped by a loosely scumbled sky, *The Bay of Marseilles* has a calm majesty suggestive of dry, Mediterranean days.

Vincent van Gogh
Dutch; 1853–1890

Self-Portrait, 1886/87
Oil on artist's board, mounted on panel
41 x 32.5 cm (16⅛ x 13¼ in.)
Joseph Winterbotham Collection, 1954.326

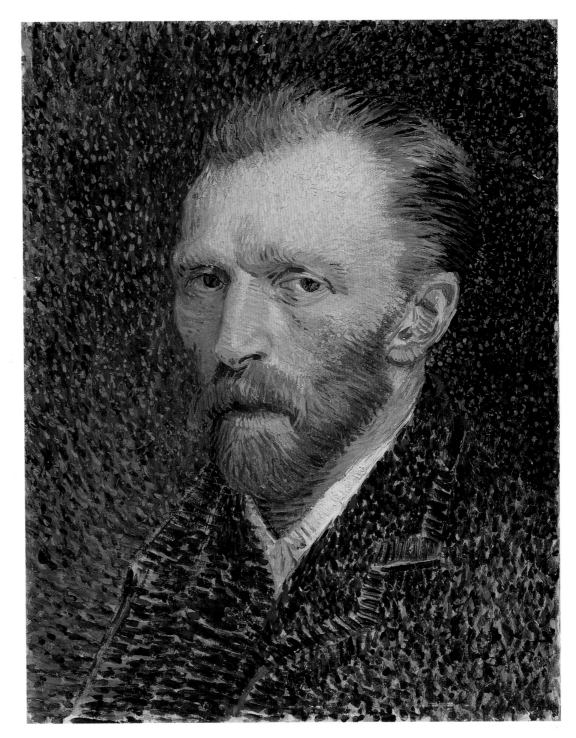

Prior to leaving the Netherlands for Paris in February 1886, Vincent van Gogh had rendered the harsh beauty of peasant life in images such as *The Potato Eaters* (1885; Amsterdam, Van Gogh Museum), the great work of his early Realist phase. However, sudden exposure to French avant-garde painting prompted him to rethink his artistic means. Rejecting the bleak palette and crude forms he had employed in his previous paintings, van Gogh set about assimilating the art of the Impressionists, notably their broken brushwork and vibrant use of color. Simultaneously, he came to terms with the quasi-scientific method of Georges Seurat, whose *Sunday on La Grande Jatte—1884* (p. 79) he discovered at the final Impressionist exhibition, which opened a few months after his arrival in the capital. In 1888 van Gogh went to Arles (see p. 116), where he devised a highly personal style characterized by decorative clarity, expressive drawing, and violent chromatic contrasts. But it was during his two-year Paris sojourn that he laid the foundation for the achievement of his final years.

In this transitional period, van Gogh—who had never before executed a self-portrait—produced at least twenty-four images of himself, in which we can measure his adaptation of new ideas to his own expressive ends. The format of the Art Institute's example evokes traditional conventions of the genre, but the technique is thoroughly modern. The face is rendered in brusque strokes of bright color, and the coat and background are a vibrating flux of dots and dashes. Juxtaposing complementary colors, for example red and green (in the beard, as well as the background), van Gogh demonstrated his awareness of Neo-Impressionist practice. He would soon abandon Pointillist handling, but Seurat's poetic notion of a "harmony of contrasts" would continue to haunt his imagination.

Henri Marie Raymond de Toulouse-Lautrec

French; 1864–1901

Equestrienne (At the Cirque Fernando), 1887–88
Oil on canvas
100.3 x 161.3 cm (39 1/2 x 63 1/2 in.)
Joseph Winterbotham Collection, 1925.523

Henri de Toulouse-Lautrec was of aristocratic ancestry, but he opted to become an artist. Sickly from childhood and dwarfish in stature, he was a fixture of the bawdy nightlife of Montmartre, rendering its stars and denizens with an honesty that was sometimes cruel. Influenced by Edgar Degas as well as by artists in Paul Gauguin's circle, Toulouse-Lautrec staked out an aesthetic terrain between illustration and high art, producing a body of work that consolidated the reputation of bohemian Paris as a center of sexual outlawry and adventurism.

Equestrienne (At the Cirque Fernando), a depiction of a performance at a permanent circus in Montmartre (see also p. 57), was Toulouse-Lautrec's first important painting. He probably executed it in haste for the fifth exhibition of Les Vingt (The Twenty; see p. 99), held in Brussels in February 1888. The work's skewed perspective and cropped figures derive from the art of Degas and from Japanese prints, while the limited palette, spare composition, and linear economy anticipate Toulouse-Lautrec's well-known lithographic posters of the 1890s. But it is the painting's psychosexual candor that makes it potent.

The ringmaster—piscine of profile, imbued with menace by his whip and confident stride—glares at the female rider, who throws him a tense, ambiguous smile. Seated precariously on a muscular horse lumbering toward the paper hoop through which she will soon jump, the performer is on display, her tulle skirt blown back to reveal her thighs and hips. This spectacle of implicit sadistic cruelty is observed by an audience whose sparsity and impassivity suggest dream imagery, as does the incongruous splayed strut of the clown at the left. This dark but exhilarating work is one of Toulouse-Lautrec's most concentrated evocations of the moral ambiguity central to the lure of the Paris underworld.

Paul Gauguin
French; 1848–1903

The Faun, 1886
Unglazed stoneware with touches of gold
47 x 29.9 x 27.3 cm (18½ x 11¾ x 10¾ in.)
Estate of Suzette Morton Davidson; Major
Acquisitions Centennial Endowment, 1997.88

Paul Gauguin was a key figure in the late nine-teenth-century shift from the optically based aes-thetic of Impressionism toward greater stylization. He participated in five of the Impressionist group exhibitions, but beginning in the late 1880s, he increasingly favored simplified forms and fields of unmodulated color, allied in his mind with an in-nocence that had been lost in modern metropoli-tan culture.

Although best known for his paintings, Gauguin also produced a considerable body of sculpture, most notably wood carvings and stoneware. As a ceramist, he was a sophisticated primitivist, delighting in the accidents of firing and drawing upon an eclectic array of models in hopes of tapping primal spiritual sources. *The Faun*, perhaps one of Gauguin's earliest ceramics, occupies a special place in this output. Although the form of the base derives from Chinese bronzes, the figure is a distant cousin of the satyrs produced by renowned late eighteenth-century French sculptor Claude Michel Clodion. The faun or satyr—half man, half goat—traditionally signifies lasciviousness. Here, however, erotic vigor has given way to wistful despondency; what-ever sexual energies this creature once possessed seem now to have deserted him.

The piece is probably an oblique self-portrait. Gauguin often depicted himself with an exaggerated beak nose, and he deemed his own satyrlike lusts to be inextricable from his creative wellsprings. But at this particular moment, Gauguin was troubled by a sense of failure. In 1884 he and his family had moved from France to Denmark, where his wife had relatives who offered support; two years later, he returned to Paris alone. *The Faun* reflects Gauguin's growing certainty that this separation from his family was permanent, a sacrifice necessarily en-tailed by his devotion to art. An affecting evoca-tion of Gauguin's crisis of virility, *The Faun* can also be seen as a tentative early instance of his pen-chant for artistic self-dramatization.

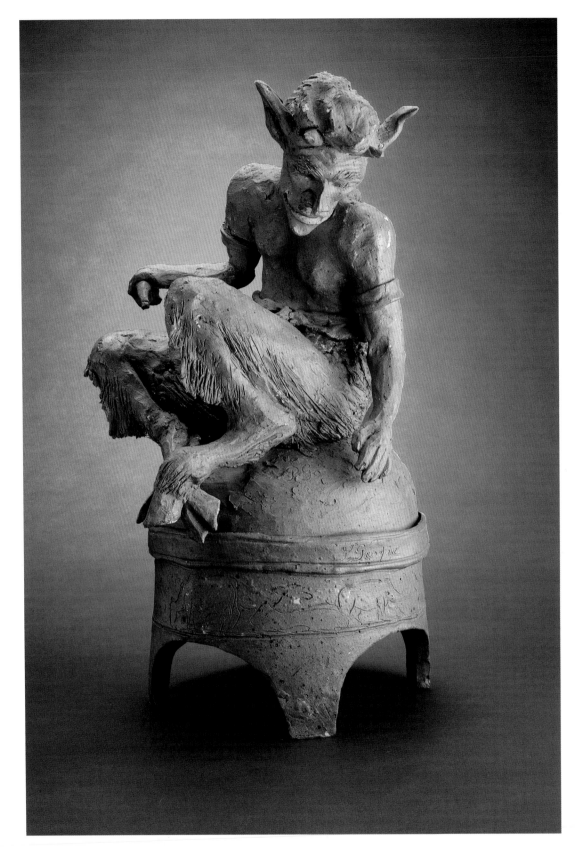

Vincent van Gogh

Dutch; 1853–1890

The Poet's Garden, 1888
Oil on canvas
73 x 92.1 cm (28¾ x 36¼ in.)
Mr. and Mrs. Lewis Larned Coburn Memorial
Collection, 1933.433

In February 1888, Vincent van Gogh left Paris for Arles, in southern France, hoping that the warm climate would renew his art. Installed in a small residence known as the Yellow House, van Gogh soon began to envision "The Studio of the South," an artists' cooperative whose presiding genius would be Paul Gauguin, whom he had met the previous November. Gauguin did go to Arles

that October—supported by Vincent's brother Theo, an art dealer—but the high-strung temperaments of both artists made prolonged cohabitation difficult. After nine weeks, van Gogh suffered a breakdown and mutilated his own left ear, prompting Gauguin's return to Paris.

In anticipation of Gauguin's arrival in Arles, van Gogh embarked on a number of paintings intended for Gauguin's bedroom. Four of these works depict the Poet's Garden, a small, enclosed public park directly in front of the Yellow House. "I have tried to distill in the decoration . . . the immutable character of this country," van Gogh wrote to Gauguin, noting further that he had sought to picture the motif "in such a way that one is put in mind of the old poet from these

parts (or rather from Avignon), Petrarch, and of the new poet from these parts—Paul Gauguin."

The view is unprepossessing, but van Gogh infused the park's unkempt grass and trees with great vitality by means of repetitive brush strokes and thick impasto, especially in the chrome-yellow sky and scraggly foliage. Prominent in this teeming, autumnal tapestry are a compact, round bush and a "weeping" tree (van Gogh's own characterization); their contrasting forms evoke the psychological tension between resolve and release. At the left, we glimpse the purplish tower of the church of St. Trophime, the only reminder of the bustling town beyond the garden walls.

Paul Gauguin

French; 1848–1903

The Arlesiennes (Mistral), 1888
Oil on canvas
73 x 92 cm (28¾ x 36³⁄₁₆ in.)
Mr. and Mrs. Lewis Larned Coburn Memorial
Collection, 1934.391

After weaning himself away from the Impressionism that he practiced until the mid-1880s, Paul Gauguin began to maintain that "art is abstraction." He shared this theory with Vincent van Gogh during their brief sojourn together in Arles in late 1888, urging the Dutch artist to paint not from nature but entirely from his imagination. Gauguin apparently conceived *The Arlesiennes*

(Mistral), one of seventeen paintings he produced in Arles, in part as a pedagogic demonstration piece for van Gogh's benefit. Like some of the latter's works (see p. 116), it pictures the Poet's Garden, a public park in front of the Yellow House, but in a completely different, radically simplified style. We readily make out a path, fountain, bush, fence, and the figures of four women in distinctive local costume, two of whom seem to protect themselves against the mistral, the violent wind that often sweeps the region. But Gauguin arranged these elements with an eye primarily to decorative effect, paying scant attention to conventional notions of perspectival coherence or realistic detail. A sense of enigma pervades the scene, epitomized by the curious

yellow cones on the right, which in fact represent packed hay used to protect plants from harsh weather. Some have been tempted to read a face in the bush, but scientific study of the paint layers offers no evidence that the artist intended to create such an effect.

Initially, van Gogh was receptive to the approach exemplified in *The Arlesiennes*, writing in mid-November to his brother Theo that Gauguin had given him the "courage to imagine things." Ultimately, however, van Gogh required a dialogue between the material and the imaginary. Disagreement over this question exacerbated the tensions between the two men, fostering the crisis that scuttled van Gogh's dream of a "Studio of the South."

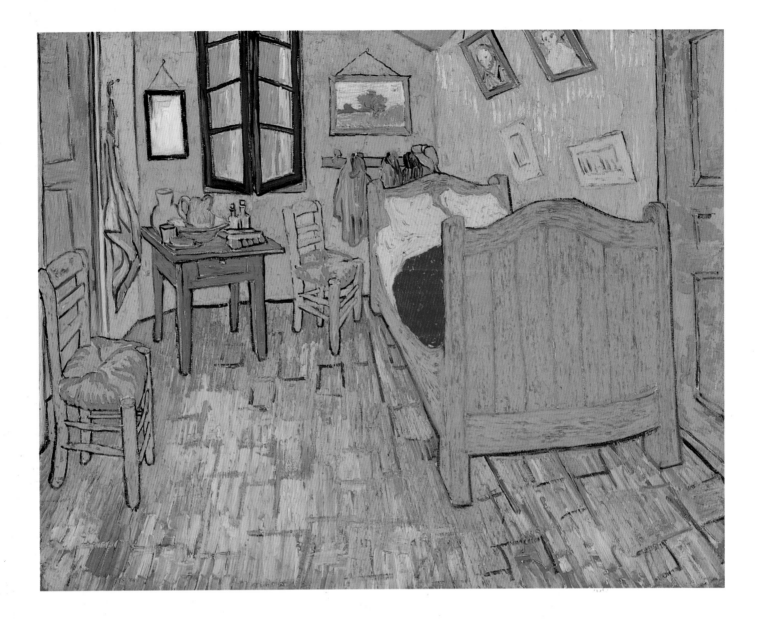

Vincent van Gogh

Dutch; 1853–1890

The Bedroom, 1889
Oil on canvas
73.6 x 92.3 cm (29 x 36⅝ in.)
Helen Birch Bartlett Memorial Collection,
1926.417

On October 11, 1888, when Vincent van Gogh was in Arles, painting feverishly in anticipation of Paul Gauguin's arrival there, he wrote to his brother Theo: "Instead of trying to reproduce exactly what I see before me, I make more arbitrary use of color to express myself more forcefully." A few days later, he completed his first version of *The Bedroom* (Amsterdam, Van Gogh Museum), an image that exemplifies this approach, reconciling decorative and expressive elements to novel effect.

The Art Institute's canvas, executed by the artist in September 1889, is the second version of the composition (a third is in the Musée d'Orsay, Paris). It features a different set of paintings on the walls than does the original; and its tile floor, muted red with green interstices in the Amsterdam canvas, consists of patches of aquamarine with black-brown outlines over gray underpainting. Van Gogh's repetition of the motif indicates that it remained profoundly significant for him after Gauguin's departure from Arles in December 1888.

A depiction of the bedroom van Gogh furnished for himself in the Yellow House (see p. 116), the work has a graphic clarity reminiscent of the Japanese woodblock prints that the artist collected; shadows are banished and forms are radically simplified. Van Gogh claimed he wanted the work to express "absolute restfulness." Apparently, he

thought that the inclusion of all six complementary colors would result in a chromatic equilibrium, thus communicating calm. However, to our eyes, the palette of orange, aquamarine, lime green, blood red, and chrome yellow seems to throb with intensity. This nervous energy is heightened by the floor, which plunges precipitously, thrusting the foot of the bed toward the viewer. The chairs seem like surrogates for absent human beings, creating an air of expectation perhaps related to van Gogh's high hopes for a "Studio of the South."

Vincent van Gogh
Dutch; 1853–1890

Madame Roulin Rocking the Cradle (La Berceuse),
1889
Oil on canvas
92.7 x 73.8 cm (36½ x 29½ in.)
Helen Birch Bartlett Memorial Collection,
1926.200

In December 1888, shortly before suffering the breakdown that precipitated Paul Gauguin's departure from Arles (see p. 116), Vincent van Gogh began a portrait of Madame Roulin, the wife of a "Socratic" local postman—the artist's own characterization—with whom he had become friends. Van Gogh completed the first of an eventual five versions of the portrait in January 1889, during his recuperation (the Art Institute's painting is the second in the series). His letters reveal that by then the work had acquired multiple connotations for him. He told one correspondent that he had named it *La Berceuse*, which means both "lullaby" and "woman rocking a cradle," wondering playfully whether the color did not sing a lullaby of its own. He suggested to Gauguin that its visual music would comfort lonely Icelandic fishermen at sea, and noted how wonderful it would be "to achieve in painting what the music of Berlioz and Wagner has already done." And he advised his brother Theo to place it between two of his sunflower paintings to form a kind of triptych, a "decoration" suitable "for the end wall of a ship's cabin."

Analogies between color and music, common since the Romantic period, assumed a new importance in the late 1880s thanks to the Symbolists (see p. 144), who valued subjective expression, poetic association, and formalist ingenuity over mimetic literalism. Here, van Gogh merged divergent aesthetic currents. He began *Madame Roulin Rocking the Cradle (La Berceuse)* as a portrait rooted in the Realist tradition. But the extraordinary flowered wallpaper, whose forms teem with a vitalist energy, and the addition of a cradle rope—clearly an afterthought—transform the work into something richer and more allusive, an arresting paean to motherhood, the life force, and the mysterious power of color.

Pierre Cécile Puvis de Chavannes
French; 1824–1898

The Sacred Grove, Beloved of the Arts and Muses,
1884–89
Oil on canvas
93 x 231 cm (36⅞ x 90¹⁵/₁₆ in.)
Potter Palmer Collection, 1922.445

In 1883 the famed muralist Pierre Puvis de Chavannes received a commission from his native city of Lyons for a suite of murals for its Musée des beaux-arts. Since Puvis regarded decoration as essential to the aesthetic experience of architecture, he intended the first work in the series, *The Sacred Grove, Beloved of the Arts and Muses*, "to welcome the visitor to the threshold of the Museum, as a baptistry to the threshold of a Church." The image portrays a gathering of the muses in a tranquil, sylvan setting, reminding the visitor that the contemporary term museum had its origin in the Greek word *mouseion*, or home of the muses. Puvis situated the nine patron goddesses of the arts in a carefully regulated space, their postures evoking an aura of perfect equilibrium. With a pale, whitened palette, the artist emulated the quality of fresco, although he actually worked in oil.

In 1884, before the mural was installed in Lyons, Puvis showed it at the Salon. He painted the Art Institute's version of *The Sacred Grove* after the exhibition closed, in accord with his regular studio practice. He conceived of it as a reduction,

rather than as a replica, making adjustments in the proportions of the figures and recalibrating their spatial relations on the smaller canvas while fully preserving the spirit of the mural's serene, arcadian world. Despite its traditional mode and historicized iconography, Puvis's art was widely admired for its lyrical simplification by contemporary painters such as Mary Cassatt, Paul Gauguin, and Georges Seurat (who began work on his magisterial *Sunday on La Grande Jatte—1884* [p. 79] the year *The Sacred Grove* was displayed in Paris). At Puvis's death, Paul Signac lamented, "Who is now going to decorate the walls?"

Maurice Denis

French; 1870–1943

Easter Mystery, 1891
Oil on canvas
104 x 102 cm (41 x 40⅛ in.)
Through prior acquisition of William Wood
Prince, 1994.431

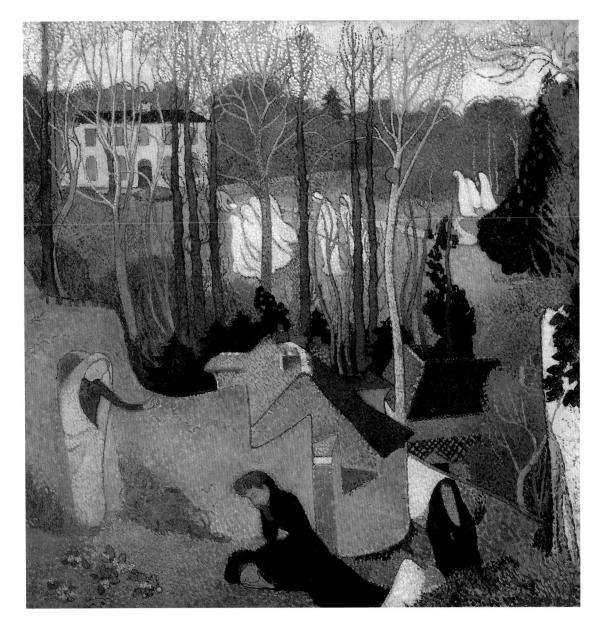

In 1890 several art students at the Académie Julian in Paris—notably Pierre Bonnard, Maurice Denis, and Edouard Vuillard (see p. 158)—joined forces to form a vanguard group called the Nabis. As suggested by their name (Hebrew for "prophet"), they rejected Impressionism's reliance on sensory data, opting instead for stylized forms imbued with mystery. The Nabis delighted in pure line and unmodulated color, and they greatly admired Japanese woodblock prints and the art of Paul Gauguin.

That same year, Denis famously defined painting as "essentially a flat surface covered with colors arranged in a certain order," a statement often said to characterize the formalist tendencies of the entire group. Denis himself, however, was an ardent Catholic for whom the process of decorative abstraction was redolent of spiritual purification. Believing art to be "the sanctification of nature," he sought to emulate the fifteenth-century Italian master Fra Angelico, using the vocabulary of avant-garde painting to devise modern "icons."

Denis set *Easter Mystery*, a gentle fantasia on the Resurrection as narrated in the Gospel of Saint Mark, in the rolling landscape near his home in St.-Germain-en-Laye, just west of Paris. In the foreground, the two Maries and Salome encounter the angel of the Good News at the tomb of the risen Christ. A disembodied hand of God bearing the Eucharist emerges from a screen of trees, beyond which mysterious, white-robed figures advance across a lawn in a procession evocative of a First Communion ceremony. All of nature seems to hum with imminent rebirth.

Easter Mystery reveals the impact on Denis of Georges Seurat's Neo-Impressionist "dot" technique (see pp. 78–79), as well as the influence of Gauguin and the so-called Italian primitives. But its eclectic iconography, delicate color harmonies, and sinuous arabesques give it a sweet visual poetry that is Denis's alone.

Paul Signac
French; 1863–1935

Les Andelys, Côte d'Aval, 1886
Oil on canvas
60 x 92 cm (23⅝ x 36¼ in.)
Through prior gift of William Wood Prince,
1993.208

Paul Signac dabbled with Impressionism early in his career, but in 1884 he saw the work of Georges Seurat at the first Salon des indépendants (an exhibition forum that Signac had cofounded as an alternative to the official Salon). That year Seurat exhibited *Bathers at Asnières* (1884; London, National Gallery; see p. 77), a painting that reveals the beginnings of his "scientific" technique, according to which colors are divided from one another in order to enhance their optical effect. Signac's encounter with Neo-Impressionism proved decisive for his subsequent career; he soon adopted Seurat's method, and a mutually rewarding exchange ensued between the two artists.

The largest and most technically refined of a series of landscapes that Signac painted in the summer of 1886, *Les Andelys, Côte d'Aval* depicts a placid, sun-drenched village nestled along the winding bank of the Seine, near Rouen. Seurat's work provided a model for the innovative spatial recession seen here: Signac established insistent connections between compositional elements such as a cropped boat in the lower-left corner; its anchor, which leads the viewer's eye to the middle ground; and the unpopulated, toylike village in the distance, dominated by a church steeple at the right. Signac's abbreviated, discrete strokes also seem to echo those of his colleague, for example in the patchwork hillside. But in the sky, he began with a more broadly brushed underlayer, suggesting that he had not fully relinquished the intuitive approach to color and handling so central to Impressionism.

Signac published an important and influential tract on Neo-Impressionism in 1891 and is widely regarded as the central disseminator of the group's aesthetic theories. Among the artists whom he persuaded to experiment with the style were Camille Pissarro (see p. 142) and Vincent van Gogh (see p. 113).

Henri Edmond Cross

French; 1856–1910

Beach at Cabasson, 1891–92
Oil on canvas
95.3 x 92.3 cm (37½ x 36⅜ in.)
The L. L. and A. S. Coburn, and Bette and
Neison Harris Funds; Charles H. and Mary F. S.
Worcester Collection; through prior acquisition of
the Kate L. Brewster Collection, 1983.513

Like Paul Signac (see p. 122), Henri Edmond
Cross encountered Neo-Impressionism through
his involvement with the Société des artistes in-
dépendants, which he helped to found in 1884.
However, Cross's "conversion" to the style was
more gradual than Signac's. He had established a
name for himself at the Salon in the early 1880s,
showing Realist portraits and still lifes; in subse-
quent years, he began to lighten his palette and
paint *en plein air*, influenced by the work of
Claude Monet and Camille Pissarro.

Cross—who anglicized his surname, Dela-
croix, to avoid association with the celebrated
Romantic painter—adopted the Neo-Impressionist
technique, with its dot brush strokes and decorative
surfaces, in 1891. That same year, he moved to the
south of France. There, along the Riviera, he com-
pleted *Beach at Cabasson*, selecting a palette of
bleached browns, ivories, and blues in response to
the bright Mediterranean light, and arranging the
landscape's features into regular, horizontal bands.

Cross' affinity with Neo-Impressionism was
not only stylistic but also political: he shared with
Signac (who settled nearby in 1892) and Pissarro
an anarchist vision of a classless, utopian society.
Indeed, *Beach at Cabasson* seems to represent an
idyllic realm: the dots of paint are impeccably
aligned, the water is perfectly calm, sailboats float
in an orderly row along the horizon, the branch
at the upper right is unruffled by wind, the boys
in the foreground are happy and warmed by the
sun. Yet perhaps the three boys are a single boy,
represented in successive postures. In this way,
Cross introduced the element of time into the
arcadian scene.

Hilaire Germain Edgar Degas

French; 1834–1917

The Morning Bath, 1890/96
Pastel on cream wove paper
66.8 x 45 cm (26⁵/₁₆ x 17¹¹/₁₆ in.)
Potter Palmer Collection, 1922.422

At the eighth and last Impressionist exhibition, in 1886, Edgar Degas showed a group of fifteen pastels, described in the catalogue as a "suite of nude women bathing, washing themselves, drying themselves, dressing themselves, or being dressed." These drawings marked a major shift in Degas's work. For the rest of his life, he remained preoccupied with depicting the apparently mundane aspects of the female toilette, experimenting with eccentric compositions, glowing colors, and the representation of the figure in motion.

Although the nude in this pastel (created some years after the 1886 exhibition) moves with natural ease, her pose has an extensive pedigree in the history of art, ranging from works by the Old Masters to Degas's own sculptures. Moreover, Degas's frequent use of pastel links him to a French tradition of virtuosic, aristocratic portraiture. Yet he moved far beyond the conventions established by the eighteenth-century practitioners of the medium, fully exploiting its aesthetic and expressive potential as no artist had done before. First sketching the woman's outline in charcoal in the center of the composition, Degas went on to cover the entire surface of the sheet with rich pastel layers. In some areas, he applied the colors directly; in others he dissolved the chalky pigments in liquid and used a brush. He also scraped fine lines into the built-up surface with knives and needles.

Degas infused the bather's luminous skin with the work's entire palette: her breast and stomach reflect the blue of the curtain, her pink skin is dappled with spots of the greens of the wallpaper, and her dark hair picks up the reddish-brown shadows beside the tub. The subject became a pretext for the artist's dazzling examination of iridescence.

Hilaire Germain Edgar Degas
French; 1834–1917

The Tub, 1889
Bronze
21.6 x 41.9 x 45.7 cm (8½ x 16½ x 18 in.)
Wirt D. Walker Fund, 1950.114

In the last phase of his career, Edgar Degas treated the theme of the female bather in all media, including sculpture. This charming work, cast in bronze after Degas's death, is a particularly appealing, even playful, variation on that subject. In a round basin partially filled with water, a young woman relaxes and absently plays with the toes of her left foot.

Degas's original wax version of *The Tub* (now in the National Gallery of Art, Washington, D.C.) is one of his greatest, most original technical achievements. He molded the figure out of red-brown beeswax, placed it in an ordinary metal basin, surrounded it with "water" made of plaster-soaked rags, and placed a real sponge in its left hand. X-rays have revealed that the work's ingredients also include cork, wood, wire, and a lead-alloy strip.

The Tub is innovative in another, more subtle way. The female nude is of course a central subject in the history of Western art, associated with many conventions and traditions. However, unlike so many of his predecessors and more conservative contemporaries, Degas did not depict his adolescent bather in the guise of a nymph or goddess, nor did he imbue her features and gestures with eroticism. Instead, she is self-absorbed, modest, and engaged in a mundane activity. In this small piece—it measures only some twenty inches across—Degas explored a state of privacy, intimacy, and even vulnerability.

Henri Marie Raymond de Toulouse-Lautrec

French; 1864–1901

Moulin de la Galette, 1889
Oil on canvas
88.5 x 101.3 cm (34 13/16 x 39 7/8 in.)
Mr. and Mrs. Lewis Larned Coburn Memorial
Collection, 1933.458

With *Moulin de la Galette*, Henri de Toulouse-Lautrec continued his large-scale explorations of raucous Parisian nightlife (see also p. 114). The pictured venue, situated at the top of the Montmartre hill, was also represented by Pierre Auguste Renoir in one of his most famous paintings (1876; Paris, Musée d'Orsay). Compositional parallels suggest that Toulouse-Lautrec may have had Renoir's *Ball at the Moulin de la Galette* in mind when executing his own version of the theme. In mood, however, the two works are antithetical; indeed Toulouse-Lautrec may even have set out here to produce a dark corrective to the Renoir. Rather than a sun-dappled gathering place for wide-eyed, innocently hedonistic youths in their Sunday best, Toulouse-Lautrec portrayed a gloomy dance hall with a dowdy, lower-class clientele. While the animated figures arrayed friezelike across the top of the canvas suggest the pleasurable buzz of social interaction, they also possess a tawdry aspect. Even without the inclusion of a uniformed member of the *garde républicaine* at the upper right, we would sense the presence of troubling energies. Isolated in the foreground, seated on either side of an oblique barrier, are three impassive women and a man whose predatory demeanor suggests he is their pimp. Spatially proximate but psychologically remote from one another, their joyless expressions indicate that they are all business.

Toulouse-Lautrec here applied a somber palette in a deliberately approximate manner, apart from the faces in the foreground, which he delineated with cold precision. Much of the paint seems more stained than brushed onto the canvas. Apparently arbitrary vertical streaks and drips, together with the sickly green tonality, create a subaqueous, unsavory atmosphere. The work's combination of hardened physiognomies and smeary handling left its mark on the young Pablo Picasso, whose forlorn bohemians and sad clowns are spiritual descendants of Toulouse-Lautrec's dispirited pleasure-seekers.

Pierre Bonnard
French; 1867–1947

France—Champagne, 1889–91
Color lithograph on buff newsprint poster paper
Image: 77.4 x 57.8 cm (30 7/16 x 22 3/4 in.);
sheet: 80.6 x 60.5 cm (31 11/16 x 23 13/16 in.)
Restricted gift of Dr. and Mrs. Martin L. Gecht,
1991.218

Pierre Bonnard, like many artists of the mid-to-late nineteenth century, was an enthusiast of Japanese art. In the spring of 1890, he saw a display of over seven hundred Japanese woodcuts at the Ecole des beaux-arts, Paris (see p. 128), which he later recalled as a revelation: "I realized that color could express everything, as it did in this exhibition, with no need for relief or texture. I understood it was possible to translate light, shape, and character by color alone, without the need for values." While the Impressionists had been interested primarily in the unconventionally cropped compositions found in such prints, Bonnard was intrigued as well by their symbolic use of color.

In his subsequent work—which includes paintings, prints, furniture, decorated pottery and ceramics, screens, and fans—Bonnard applied the lessons he had learned from Asian art, working with flat tints, black accents, distinct contours, and monochromatic backgrounds. All of these formal innovations are evident in the striking lithograph *France—Champagne*, an advertisement notable for its restricted color scheme and graphic virtuosity. Bonnard echoed the curving outline of the female figure in the main title's hand-drawn lettering. This dynamic, exuberant line, together with the golden hue and bubble pattern, effectively conjure the effervescence of the sparkling wine the woman offers.

Bonnard's friend Henri de Toulouse-Lautrec was so impressed with this poster that he also took up color lithography and became famous for his skill in the medium. Bonnard, meanwhile, did not continue to produce posters, but the one hundred francs that he received for *France—Champagne* convinced him to abandon the law career his father had urged him toward and dedicate himself instead to his artistic calling.

Mary Cassatt
American; 1844–1926

The Bath, 1890–91
Drypoint, aquatint, and soft-ground etching on ivory laid paper
Plate: 36.8 x 26.3 cm (14 ½ x 10 ⅜ in.)
Mr. and Mrs. Martin A. Ryerson Collection, 1932.1281

In the spring of 1890, shortly after visiting an extensive exhibition of Japanese prints at the Ecole des beaux-arts, Paris, Mary Cassatt wrote a note to Berthe Morisot: "You who want to make color prints wouldn't dream of anything more beautiful. . . . You must see the Japanese—come as soon as you can." Woodblock images by late eighteenth- and early nineteenth-century masters such as Kitagawa Utamaro and Katsushika Hokusai had intrigued artists and collectors since the 1850s, when Japan became open to Western trade. The 1890 exhibition, organized by art dealer Siegfried Bing, included over seven hundred objects and provided an unprecedented view of the tradition of Japanese printmaking known as *ukiyo-e* (the floating world). Cassatt, like many other artists (see p. 127), made several visits to the display. Her admiration of the linear delicacy, tonal variety, and compositional strength of the works she saw there inspired her to take her own printmaking in a highly innovative direction.

The Bath is one of a series of ten remarkable color prints *à la japonaise* that Cassatt made between 1890 and 1891. Her technique was her own invention. She chose not to employ the woodblock process, instead refining her expertise in etching, drypoint, and aquatint to attain the desired visual effects of precise lines and subtle color harmonies. Cassatt's response to Japanese precedent was more than merely technical; as demonstrated by *The Bath*, she made bold compositional choices—flattening forms and perspective, contrasting decorative patterns and broad planes of color—based on her deep appreciation of traditional Japanese aesthetics. Even the private nature of Cassatt's subject reflects the intimacy of *ukiyo-e* images, many of which portray famous courtesans absorbed in personal and solitary activity.

Mary Cassatt
American; 1844–1926

Interior of a Tramway Passing a Bridge, 1890–91
Drypoint and aquatint on ivory laid paper
Plate: 36.7 x 26.8 cm (14⁵⁄₁₆ x 10⁹⁄₁₆ in.)
Mr. and Mrs. Martin A. Ryerson Collection,
1932.1289

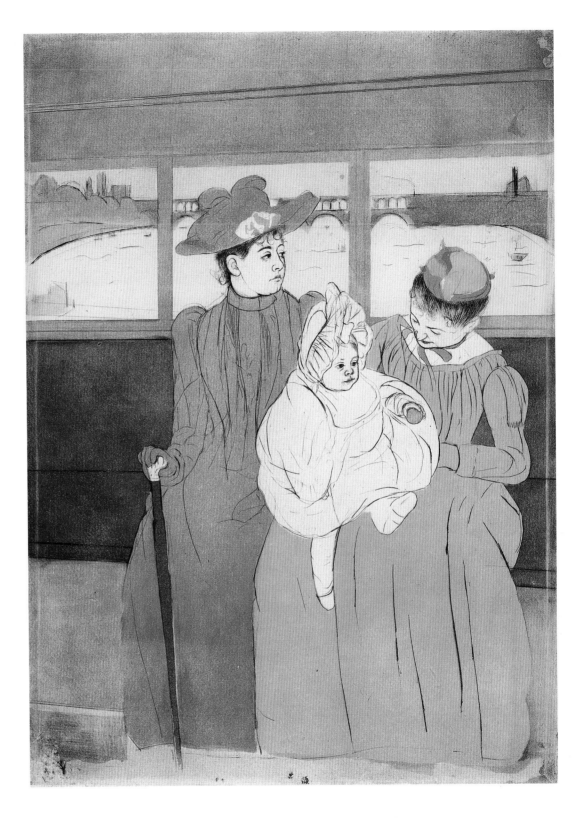

The subject of Mary Cassatt's color print *Interior of a Tramway Passing a Bridge* offers a glimpse of life in modern Paris. An elegant, young mother, with her extravagantly dressed child and a nursemaid, rides in a tramway car, glancing out the window as the train rumbles across a bridge over the Seine. In the original drawing for this print (Washington, D.C., National Gallery of Art), Cassatt depicted a man seated to the mother's left, but she eliminated his figure in the final design, establishing a private realm for her figures in a very public space. While the subject is fully contemporary, Cassatt's inspiration was traditional: *Interior of a Tramway* is one of ten color prints *à la japonaise* that she included in her first solo exhibition, held in April 1891 at Durand-Ruel's Paris gallery.

Cassatt used familiar techniques of drypoint and aquatint to emulate the subtle aesthetic of Japanese woodblock printing. Beginning with a pencil drawing, she executed her design in drypoint on a copper plate. Working with expert printer Auguste Clot, she prepared two more identical plates, to which she added areas of aquatint to print tone and color. Finally, Cassatt and Clot printed the plates in sequence, using the first to establish the black contour lines and registering the additional plates—inked by hand (*à la poupée*: with "dolls" made of rags)—to add color. Painstaking and labor-intensive, Cassatt's technique attained a tonal nuance characteristic of work by the Japanese masters of the *ukiyo-e* (the floating world) tradition. Camille Pissarro, who also experimented with color printing (see p. 59), called these works "rare and exquisite." He marveled that they were "as beautiful as Japanese work, and it's done with printer's ink."

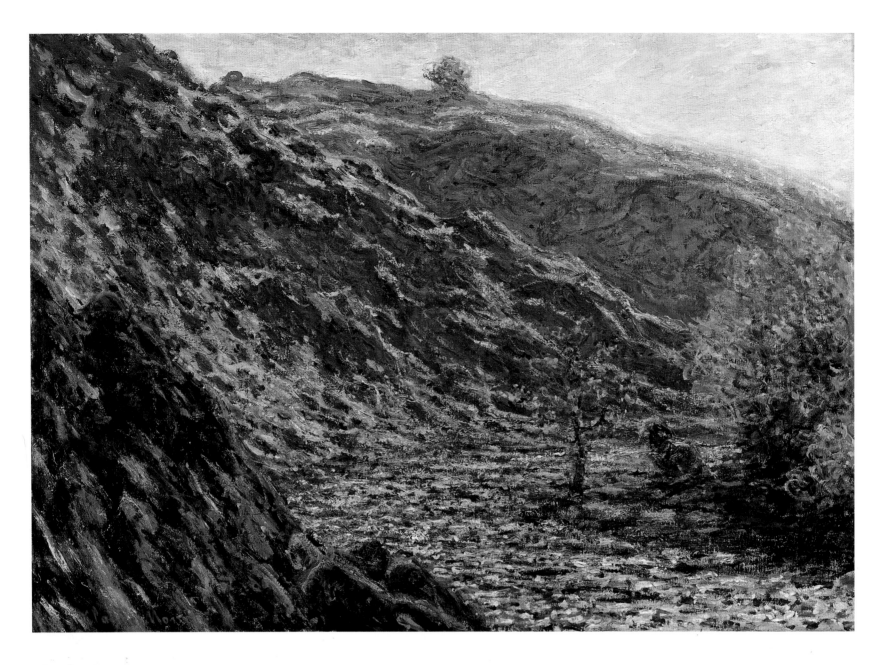

Claude Monet
French; 1840–1926

The Petite Creuse River, 1889
Oil on canvas
65.9 x 93.1 cm (25¹⁵/₁₆ x 36⅝ in.)
Potter Palmer Collection, 1922.432

Claude Monet undertook one of his most arduous painting campaigns in the spring of 1889, spending three months working near the remote village of Fresselines, in central France, where the Grande Creuse and the Petite Creuse rivers converge. The area is rugged and rocky, with deep valleys and steep hillsides; the climate is harsh, windy, rainy, and cold.

Monet completed twenty-four canvases at Fresselines, each one a struggle against the elements and against his own growing sense of physical vulnerability. He simplified the forms that he observed day after day, rendering the hills monumental, almost primeval. At the same time, he allowed strong, brooding colors to express not only what he observed but also something of the complex feelings of exhilaration and frustration that this challenging site aroused in him. Although the sky in the Art Institute's painting is a cold white, strokes of bright blue, yellow-green, and even lavender animate the craggy slopes; only the outcropping in the left foreground consists of conventional browns and mossy greens. Even the

trees seem overwhelmed by the strong shapes and colors of this landscape.

The Creuse campaign was a turning point for Monet. He had a goal—to create a series of works representing a scene at different times of day—but when he returned to the spot to resume work on a composition, he found the motif transformed by factors beyond his control, such as the river's changing levels and the trees' sprouting of leaves. Realizing that he had to find a place to pursue his aims more efficiently, the artist turned his attention homeward, to the environment of Giverny.

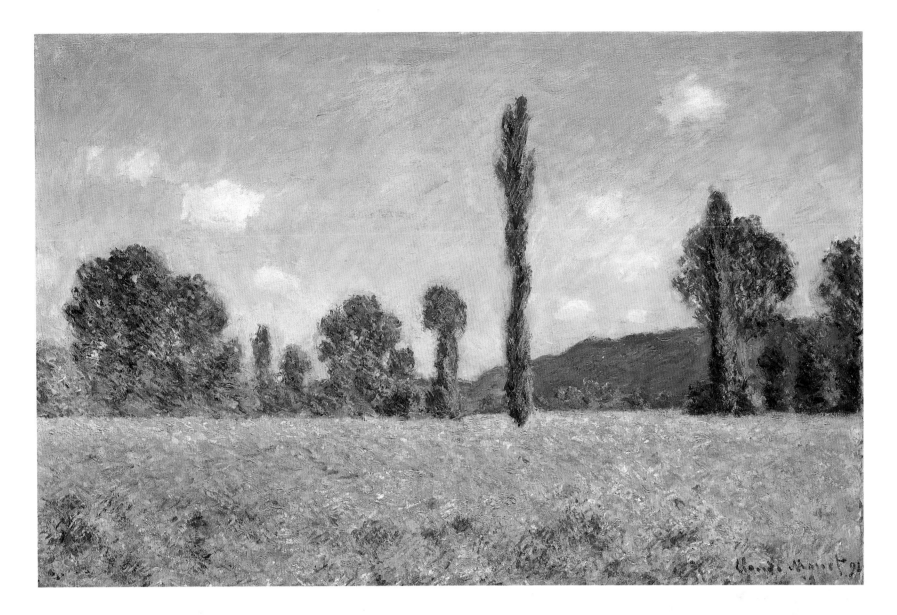

Claude Monet

French; 1840–1926

Poppy Field (Giverny), 1890–91
Oil on canvas
61.2 x 93.1 cm (24 1/16 x 36 5/8 in.)
Mr. and Mrs. W. W. Kimball Collection, 1922.4465

Claude Monet rented property in Giverny, a village fifty miles northwest of Paris, in 1883. Traveling almost continuously during the 1880s, he did not truly settle there until 1890, when he was approaching fifty years of age. Dissatisfied with his achievements, beginning to suffer from physical complaints such as rheumatism, and irritated by the pressure to prepare for exhibitions, Monet found himself suddenly revitalized by his immediate surroundings.

He must have observed many times the common sight of wild poppies growing in the grain fields of northern France. Now he became so fascinated with it that he produced not only this canvas but three other, identically sized versions, each from the same vantage point but under slightly different conditions of light and atmosphere. Clearly, this group of works predicts the paintings of stacks of wheat that Monet would begin a few months later (see pp. 132–35); in both series, each canvas is unique, created in response to specific natural circumstances rather than in conformity to its companion pieces.

Using short, hatching brush strokes, Monet built up a densely layered composition that can be read both as an abstract arrangement of bands or stripes, and as an illusionistic expanse toward a hilly horizon. As the eye moves up (or back) through the field, the marks that represent poppies change from bright red to red-orange to gold; interspersed among the flowers are touches of the blue that outlines the trees, forms the hills, and ultimately constitutes the sky. The sense of color, light, and space in the picture is breathtaking. Facing a transition in his life, Monet sought to prove that this humble field in Giverny was as loaded with pictorial potential as the brutal Creuse Valley (see p. 130) or the exotic Mediterranean coast (see p. 75). He continued to prove this for more than thirty years.

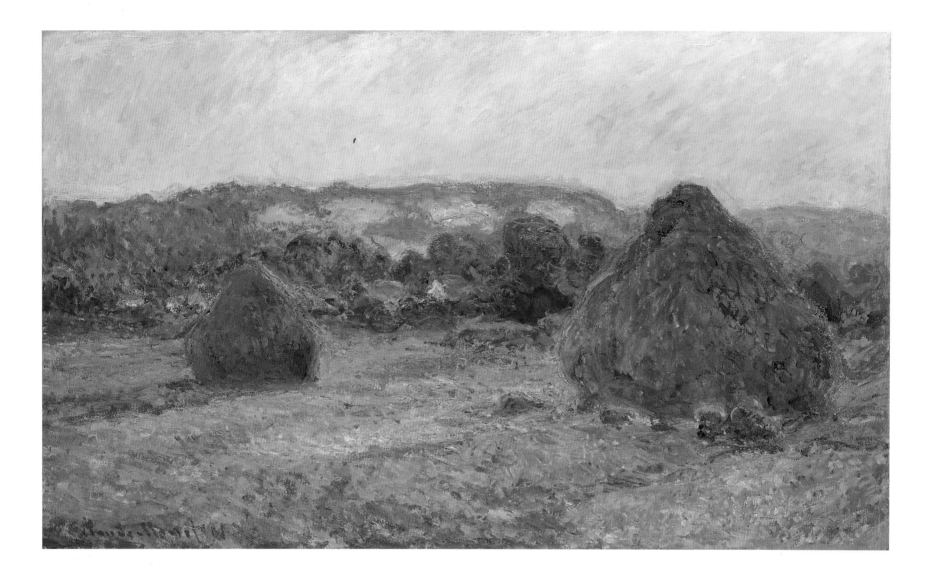

Claude Monet
French; 1840–1926

Stacks of Wheat (End of Summer), 1890–91
Oil on canvas
60 x 100 cm (23⅝ x 39⅜ in.)
Gift of Arthur M. Wood in Memory of Pauline
Palmer Wood, 1985.1103

Stack of Wheat (Snow Effect, Overcast Day),
1890–91
Oil on canvas
66 x 93 cm (26 x 36⅝ in.)
Mr. and Mrs. Martin A. Ryerson Collection,
1933.1155

Toward the end of the summer of 1890, Claude
Monet embarked on one of the most significant
projects of his career: his series of paintings of the
stacks of wheat that stood in a field adjacent to
his property at Giverny. In these works, he ex-
plored the boundaries of Impressionism as a real-
istic, empirical mode of representation, while
considering the influence of memory and intu-
ition on perception.

　　After reaping a harvest, farmers built fifteen-
to twenty-foot-high stacks of grain that remained
outdoors for some months before being threshed.
These forms, which appear somewhat mysterious
in Monet's paintings, were ordinary elements of
northern France's agricultural landscape, and car-
ried certain symbolic associations with sustenance
and abundance. What renders them enigmatic is

the extraordinary atmosphere surrounding
them—the "envelope," as the artist described it,
of pulsating, colored light that both defines and
alters forms.

　　Stacks of Wheat (End of Summer) must have
been one of the first paintings in the series. This
becomes apparent through the season that it rep-
resents—the raking light emanating from a low
sun, its warm yellow tempered by crisp blue, is
unmistakably autumnal. Moreover, its composi-
tional structure is relatively illusionistic, with a
logical sequence of planes receding into the dis-
tance: shadows, stacks, trees marking the field's
border, distant hills, and finally sky. Some
months later, having become more familiar with
the topography, Monet devised a more abstract
spatial configuration in *Stack of Wheat (Snow*

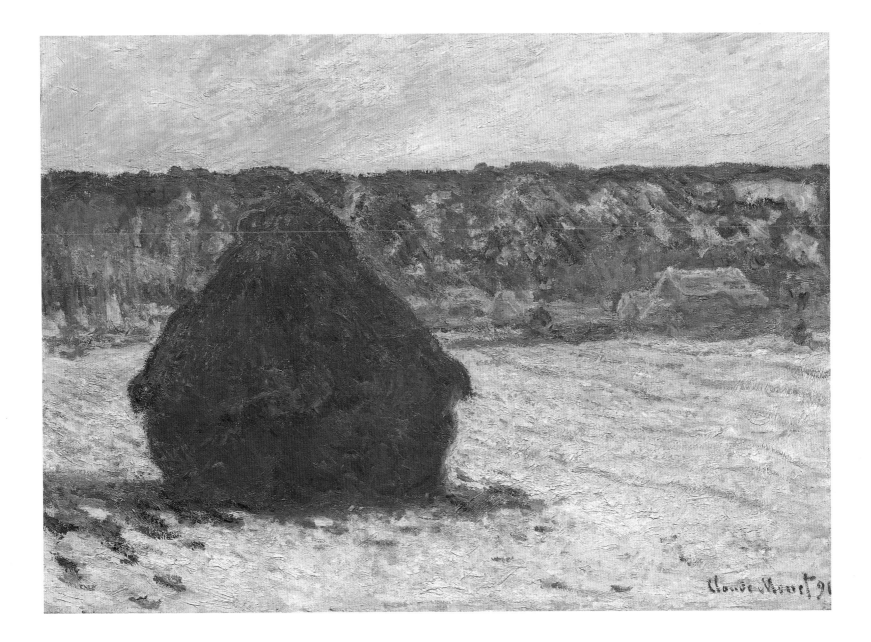

Effect, Overcast Day). Here, under a bleak, white, winter sky, a single stack casts a stunted shadow on the snow-covered ground. A band of blue, flecked with more white, serves as background; trees and hills have merged. Against this pattern, Monet introduced a farmhouse with a peaked roof that echoes the crown of the stack; the building balances the arrangement and represents shelter from the evident cold.

Monet planned the schedule of his entire household around his painting activities. According to one account, he even paid a local farmer to delay dismantling some of the stacks so that he could complete his works. He set up several easels outdoors, moving from one to another as the light changed. At certain points during the day, Blanche Hoschedé (one of the daughters of

Monet's companion, Alice Hoschedé, who lived with him at Giverny) carried these canvases back to the studio and exchanged them for others. Ultimately, Monet's *Stacks of Wheat* series is a study not only of weather and light, but also of the passage of time, experienced by the painter himself and manifested in the inanimate stacks. As Monet's friend the critic Gustave Geffroy wrote: "These stacks . . . are a fulcrum for light and shadow; sun and shade circle about them at a steady pace; they reflect the final warmth, the last rays; they become enveloped in mist, sprinkled with rain, frozen in snow; they are in harmony with the distance, the earth, and the sun."

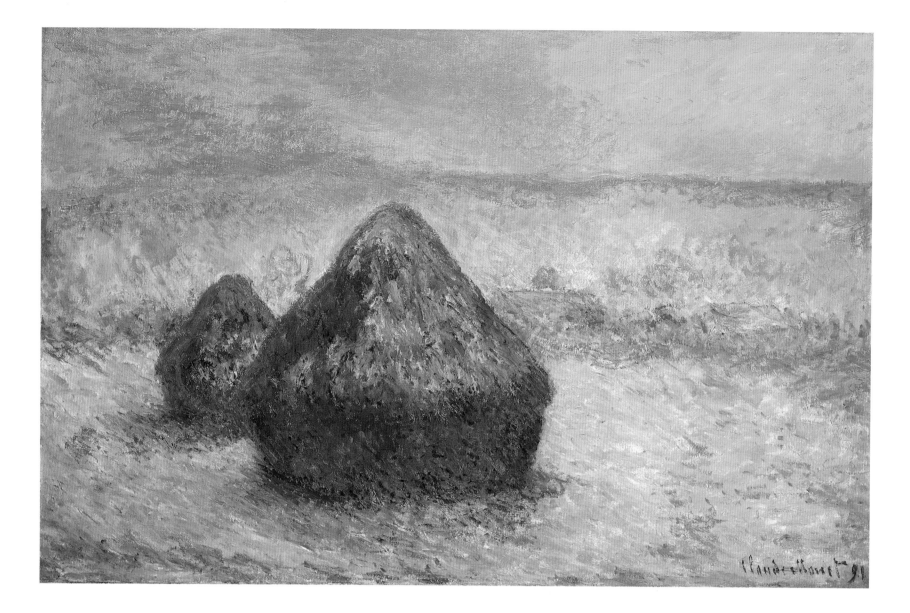

Claude Monet

French; 1840–1926

Stacks of Wheat (Sunset, Snow Effect), 1890–91
Oil on canvas
65.3 x 100.4 cm (25¹¹/₁₆ x 39⁹/₁₆ in.)
Potter Palmer Collection, 1922.431

Stack of Wheat (Thaw, Sunset), 1890–91
Oil on canvas
64.9 x 92.3 cm (25⁹/₁₆ x 36³/₈ in.)
Gift of Mr. and Mrs. Daniel C. Searle, 1983.166

Claude Monet made some thirty paintings of stacks of wheat in a field near his Giverny home in the fall and winter of 1890–91. Although the series proffers neither a narrative nor a straightforward allegorical message, it is rich with significance on a number of levels. These two scenes for example are redolent with quiet finality, winter being the end of the year and sunset the end of the day. At the same time, the artist asserted the cyclical essence of the seasons and of his own creative activity.

Monet was incredibly responsive to the nuances of nature. When the field and hills were covered in snow, he saw blue, lavender, and pink within the icy whiteness, making *Stacks of Wheat (Sunset, Snow Effect)* a dazzling, almost fiery, otherworldly scene. When the thaw came, he adjusted his palette and focus accordingly. The melting of the snow revealed the earth and the features of the background; the sun no longer glares angrily but glows gently. In *Stack of Wheat (Thaw, Sunset)*, the stack—with its deep, subtle, russet color, the result of months of mellowing—seems to loom larger than those in *Sunset, Snow Effect*, but their actual sizes are roughly equal.

Monet intended the *Stacks of Wheat* paintings to function both independently and as parts of a series. He realized that he would have to break up the group when he sold individual canvases, but, before they were dispersed, he wished to exhibit them together. In May 1891, he included fifteen of them in a display of recent works held at Paul Durand-Ruel's gallery in Paris. Collectors had already shown great interest in the *Stacks of Wheat*;

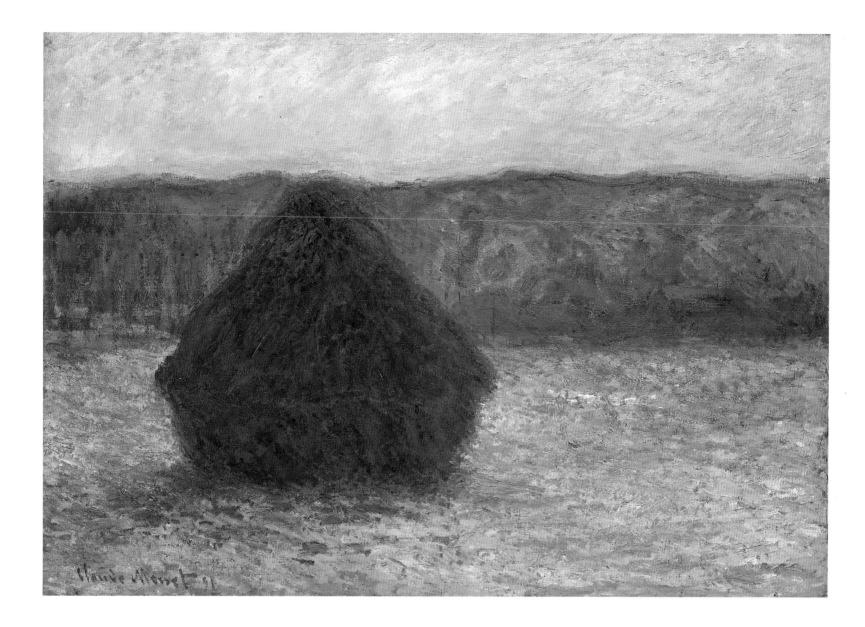

by the time the exhibition opened, all but five of the fifteen had been sold, many to Americans, including Chicagoan Bertha Honoré Palmer, who purchased nine versions of the subject. The Art Institute today has six works from the series, five of which appeared in the 1891 Durand-Ruel show, and thus provides a rare opportunity to appreciate their cumulative effect.

Critics and artists were equally dazzled by Monet's achievement. His longtime Impressionist colleague Camille Pissarro (see pp. 59, 142)—who, when he first heard about the series, had criticized Monet for repeating himself and for selling out to the market—changed his mind after seeing the exhibition. He wrote to his son Lucien: "That the effect is both luminous and masterly is uncontestable. The colors are at once attractive and strong. The drawing beautiful, but insubstantial, in the backgrounds as well. It is the work of a very great artist . . . the canvases seem to breathe contentedly."

Working in series allowed Monet to reconcile his determination to render instantaneously what he saw in front of him with the constant alterations that occur in nature. "For me," he explained, "a landscape hardly exists at all as a landscape, because its appearance is constantly changing; but it lives by virtue of its surroundings—the air and light—which vary continually." With his *Stacks of Wheat*, Monet redefined once again the genre of landscape painting.

Paul Cézanne
French; 1839–1906

Madame Cézanne in a Yellow Chair, 1888/90
Oil on canvas
80.9 x 64.9 cm (31¹³/₁₆ x 25⁹/₁₆ in.)
Wilson L. Mead Fund, 1948.54

Paul Cézanne painted Hortense Fiquet, his companion starting in 1869 and his wife from 1886, some twenty-four times. The present work is one of a related quartet of canvases in which she is shown wearing a distinctive carmine dress and seated in a yellow chair. The largest work in this group (New York; The Metropolitan Museum of Art) is one of the artist's most elaborate portraits, incorporating a curtain, fire tongs, and the edge of a mirrored mantelpiece. In the Art Institute's example, however, Cézanne aimed for something more austere.

Here, as in all four compositions, the unit formed by Madame Cézanne and the chair is oddly askew. The unconventional dynamism that results is accentuated by Cézanne's elision of the bend at her hip, which prompts doubt as to whether she is sitting or standing. A wine-red band above the wainscoting, noticeably wider on the left than on the right, acts as a visual prop, countering the tilt of figure and chair.

Although the sitter's features are recognizable, they are radically simplified in a way that evokes a primitive totem. Her hands are not fully articulated, their forms appearing to coalesce from blank canvas before our eyes. Cézanne's mastery of his materials is evident in the delicate color chords of the background, the opalescent face, and the vibrant dabs and strokes of the dress. Formal relationships are carefully gauged: cryptic shadows and upholstery motifs seem to converse animatedly with one another, while the elongated oval of the figure's head is echoed by the majestic curve of the arms. With its emphasis on process and contrivance, this is one of Cézanne's most concentrated essays on the dynamic nature of perception, and on the mysterious intractability of another's psychic life.

Paul Gauguin
French; 1848–1903

Portrait of a Woman in Front of a Still Life by Cézanne, 1890
Oil on canvas
65.3 x 54.9 cm (25 11/16 x 21 5/8 in.)
Joseph Winterbotham Collection, 1925.753

Before Paul Gauguin left behind a banking career to devote himself to art, he assembled a small but choice collection of contemporary French paintings. It included several canvases by Paul Cézanne, whose work Gauguin greatly admired. The regard was not reciprocal; distrustful of Gauguin, Cézanne referred disparagingly to his "Chinese images" and accused him of trying to steal his "little sensation" (see p. 62).

In the Art Institute's "portrait" (the sitter is unidentified), Gauguin explored the mystery of the older artist's technique. *Compote, Glass, and Apples* (1879/80; New York, private collection)—Gauguin's favorite among the Cézannes he owned—appears in the background. In copying this still life, Gauguin tried to duplicate the "constructive" handling that Cézanne had adopted around 1880 as a way of disciplining unruly Impressionist sketchiness; he also used a variant of this stroke for parts of the model's blouse, dress, and hands. The compacted juxtaposition of figure and still life recall Cézanne's unorthodox compositional strategies. X-rays reveal that the woman's hands were originally clasped, as is the case in a number of roughly contemporary portraits by Cézanne of his wife (see p. 136), which also seem to have provided Gauguin with a precedent for the female figure's monumentality and psychological opacity.

Significantly, at around the same time he created this homage to Cézanne, Gauguin executed a copy (1891; private collection) of Edouard Manet's *Olympia* (1863; Paris, Musée d'Orsay). Contemplating his future at a transitional moment in his career—he made his first journey to Tahiti in June 1891—Gauguin reassessed his position with regard to an older generation of artists. *Portrait of a Woman in Front of a Still Life by Cézanne* is thus a work of great interest, offering a unique glimpse of one great painter grappling with the achievement of another.

Paul Cézanne
French; 1839–1906

The Vase of Tulips, 1890/92
Oil on canvas
59.6 x 42.3 cm (23 ½ x 16 ⅝ in.)
Mr. and Mrs. Lewis Larned Coburn Memorial
Collection, 1933.423

Around 1850 renowned Romantic painter Eugène Delacroix produced several large floral still lifes that gave the previously lowly genre a new legitimacy. Gustave Courbet and Edouard Manet followed his lead in the 1860s, prompting many members of the Impressionist group to do likewise. Most of these paintings—by artists such as Pierre Auguste Renoir (see p. 76)—celebrate the abundance of nature with brilliant color harmonies and bravura handling. Paul Cézanne also executed variations on this theme, showing floral compositions in the 1877 Impressionist exhibition. But by the time he began the Art Institute's *Vase of Tulips*, his reservations about the Impressionist aesthetic had profoundly affected the tenor of his work.

In the present canvas, Cézanne depicted a casual arrangement, in a modest vase, of two red tulips—somewhat past their prime—and a scattering of smaller blossoms. Their petals and stems probe outward, set against a background brushed lightly with pale blue and green. The vase rests on a table whose surface is a rich patchwork of browns, olives, and purples. In addition to the vase, the table supports a pair of red apples and an isolated yellow-green one, their configuration oddly resonant of human affinities and tensions (see also p. 139). Throughout, the color harmonies are subtle, the formal contrasts considered, the brush strokes supple. The result has a quirky charm, but there is also a suggestion of incipient disorder held in abeyance that is unique to Cézanne.

The dealer Ambroise Vollard reported that Cézanne painted some of his flower pieces using artificial blossoms. This may be true, for their longevity would have facilitated the prolonged process of revision that was now central to his working method.

Paul Cézanne
French; 1839–1906

The Basket of Apples, c. 1893
Oil on canvas
65 x 80 cm (25⁷/₁₆ x 31½ in.)
Helen Birch Bartlett Memorial Collection,
1926.252

Many of Paul Cézanne's late still lifes depict complex arrangements whose artificial character underscores the artist's role as contriver. They are, however, very different from the seventeenth-century Dutch prototypes to which they are sometimes compared. Cézanne never aimed at illusionism, and his still-life compositions can be anthropomorphic, expressive of psychological tension, in ways never dreamt of by his Baroque predecessors. *The Basket of Apples* exemplifies this effect. The theatrical tilt of the basket implies that the apples on the tabletop have rolled out of it; yet the way they huddle and nestle in the crumpled napkin suggests that they possess independent minds. The biscuits on a plate are carefully stacked, but they too seem animate, as if straining to take in the drama unfolding before them. The bottle—slightly askew and off center, teasingly close to stabilizing union with the picture's upper edge—presides over the scene like a dark sentinel.

Poised between resolution and imbalance, sensation and ponderation, *The Basket of Apples* makes tangible the complex eye-mind interplay that determines visual experience. Cézanne's grave attentiveness to this dynamic gives his art a philosophical cast, but the pleasures afforded by his robust color chords, lively touch, and sure compositional instincts make it seductive. Here, his considered juxtapositions of autumnal hues, like the resolutely disjointed table edges and intentionally "unfinished" contours, draw attention to the deliberative nature of art-making.

Cézanne's determination to recognize the provisional nature of perception derives from Impressionism, but his stress on the tension between optical sensation and aesthetic transformation sets him apart. In his mature work, he found beauty of a new kind in the inherently charged dialogue between contingency and contemplation, thereby facilitating the more radical break with realistic representation effected by the Cubists and other modernists in the early twentieth century.

James McNeill Whistler
American; 1834–1903

Green and Blue: The Dancer, c. 1893
Watercolor and gouache over traces of black chalk
on brown wove paper
27.5 x 18.3 cm (10¹³⁄₁₆ x 7³⁄₁₆ in.)
Restricted gift of Dr. William D. Shorey; through
prior acquisitions of the Charles Deering
Collection; through prior bequest of Mrs. Gordon
Palmer, 1988.219

Throughout his career, James McNeill Whistler
was intrigued by the theme of the female form
clad in diaphanous drapery. Influenced by his
friend the Symbolist poet Stéphane Mallarmé,
Whistler sought to distill in his art the elusive, in-
tangible concepts of grace, transparency, and
movement, especially as expressed in contempo-
rary dance. Mallarmé, Whistler, and many other
artists of the day adored American dancer Loïe
Fuller's famous "butterfly dance," which she per-
formed with veils, and they tried to approximate
its effects in their verbal and visual imagery.

Whistler depicted draped models in draw-
ings, prints, pastels, oil paintings, and watercolors,
always displaying extreme sensitivity to the aes-
thetic and expressive potential of each medium.
Here, his choice of watercolor—and of rather
coarse, brown paper—is significant: the support
(which the artist consistently used for pastels) pro-
vided a palpable surface texture and muted the
colors, rendering the thin washes almost opaque.
The dancing figure seems to emerge from a hazy,
dreamlike realm.

Whistler clothed his models in garments and
accessories that he kept in the studio; both ker-
chief and fan appear in many studies, as does this
high-waisted, classical gown with a crossed
bodice. The artist greatly admired the ancient
Greek terracotta statuettes, discovered at Tanagra,
that were beginning to appear in European gal-
leries and museums in the second half of the
nineteenth century. In his famous 1888 "Ten
O'Clock" lecture, Whistler contrasted the
"Arcadian purity" of antique art with the "un-
gainly" productions of the present day. In mini-
mal, small-scale works such as *Green and Blue: The
Dancer*, he concentrated on the most basic
rhythms of the draped female form and sought to
create a modern symbol of classical refinement.

Hilaire Germain Edgar Degas
French; 1834–1917

Two Dancers, 1890/98
Pastel on cream wove paper
70.5 x 53.6 cm (27¾ x 21¹⁄₁₆ in.)
Amy McCormick Memorial Collection, 1942.458

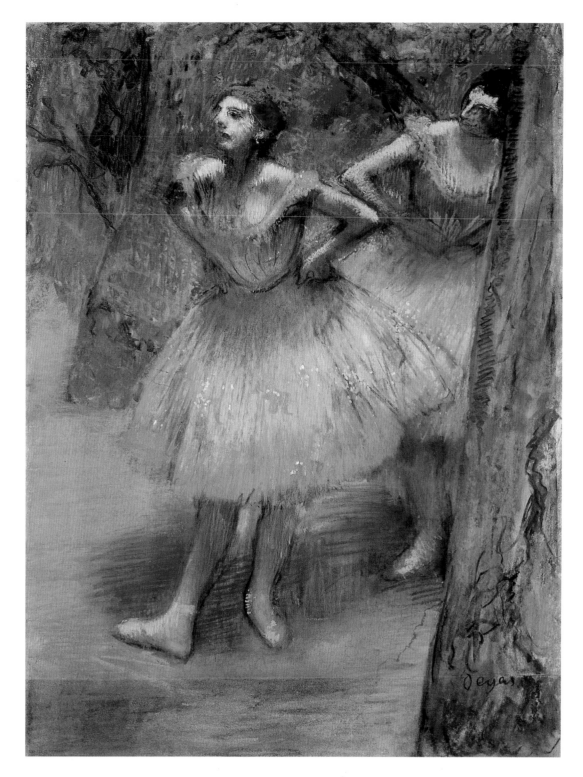

In *Two Dancers*, Edgar Degas captured the bored restlessness of a pair of performers waiting to go onstage. Such transitional moments fascinated the artist; in this pastel, he took the opportunity to study the contrast between the ballerinas' beautiful, formal costumes and their temporarily relaxed, somewhat ungainly attitudes. In the wings, Degas could also observe the point at which stage flats—here depicting a woodland setting—cease to function illusionistically and instead reveal their artifice.

Degas made many studies of dancers related to this work, some from models and others based upon his own sculptures. All feature a tall, angular figure wearing a long, pink-and-orange tutu. In the Art Institute's example, Degas first drew her outline in black charcoal, which is still visible in some areas, such as around her legs. Then, he applied color in short, delicate strokes of pastel, allowing the paper surface to show through in some places, as if to emphasize the "unfinished" nature of a backstage area. At some point after completing the main portion of the work, Degas added a horizontal strip along the bottom, increasing the expanse of empty foreground and putting more distance between the figures and the viewer.

Harsh, dappled stage lighting strikes the heads and torsos of both ballerinas, converting their faces into masks. Degas thus observed a fundamental aspect of the dancer's—or any performer's—life: the tenuousness of the boundaries between rest and performance, between private and public, and between reality and illusion.

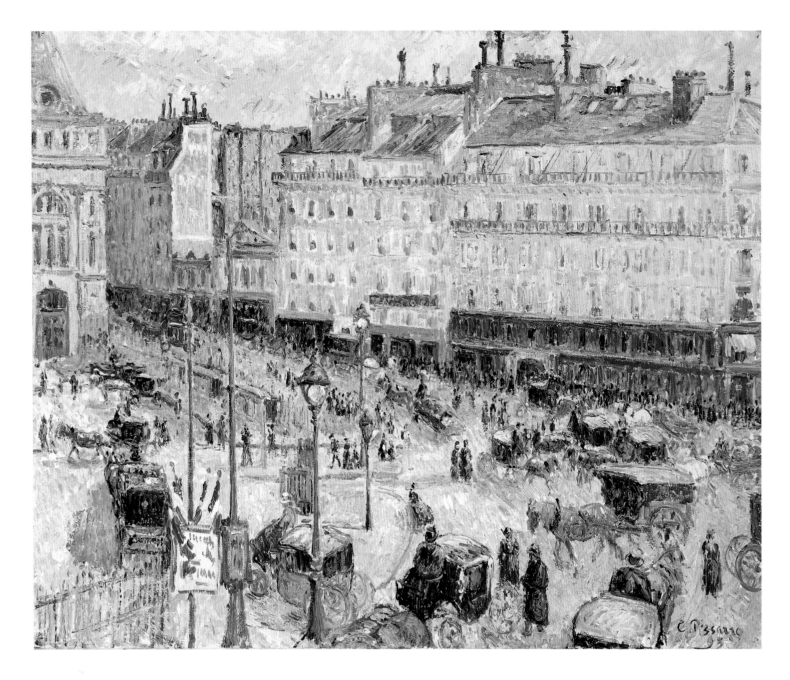

Camille Pissarro

French; 1830–1903

The Place du Havre, Paris, 1893
Oil on canvas
60.1 x 73.5 cm (23⅝ x 28¹³⁄₁₆ in.)
Potter Palmer Collection, 1922.434

In the 1890s, after experimenting briefly with the Neo-Impressionist style developed by Georges Seurat (see pp. 78–79), Camille Pissarro returned to the more gestural surface treatment associated with Impressionism. *The Place du Havre, Paris* is one of four canvases the artist painted in February 1893 from his room at the Hôtel Garnier, overlooking the rue St.-Lazare, during a temporary stay in Paris. Like several of his fellow Impressionists, most notably Gustave Caillebotte (see p. 55) and Claude Monet (see p. 54), Pissarro—the great painter of rural life—found himself drawn to the teeming activity of the capital's boulevards. Retaining the bright, primary hues of Neo-Impressionism for his representations of frenetic urban bustle, he applied them in an array of flickering, multidirectional brush strokes, an approach that epitomizes the Impressionist painting technique.

During this period, Pissarro began working in series, a practice initiated by Monet several years earlier and exemplified in his famous *Stacks of Wheat* (see pp. 132–35). Pissarro typically began such canvases on site, recording significant atmospheric effects, and then finished them in his studio. He depicted Paris several times throughout his career, rendering metropolitan activity in a full range of seasons and weather conditions, much as he had done for more rustic settings. *The Place du Havre* is among the largest of the Paris compositions, all of which feature a high vantage point. Pissarro wrote of this series in 1898: "Perhaps it is not really aesthetic, but I am delighted to be able to try to do these Paris streets which people usually call ugly, but which are so silvery, so luminous, and so vital. . . . This is so completely modern."

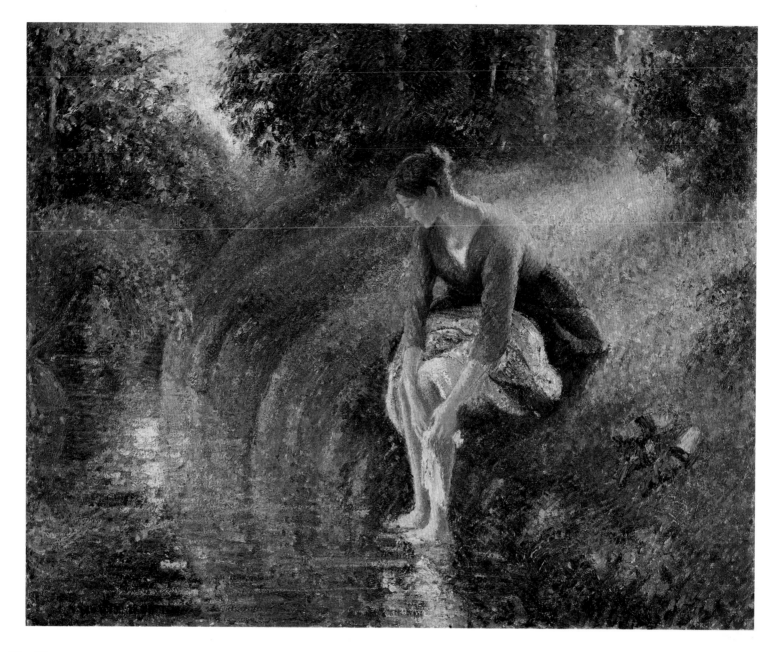

Camille Pissarro

French; 1830–1903

Woman Bathing Her Feet, 1895
Oil on canvas
73 x 92 cm (28½ x 36 in.)
A Millennium Gift of Sara Lee Corporation,
1999.364

Unlike the series of land- and cityscapes that comprise the bulk of Camille Pissarro's production after 1890 (see p. 142), this large canvas of a young woman in an idyllic, natural setting focuses on the human figure. Creating an atmosphere of graceful sensuality, Pissarro consciously referred to art-historical prototypes, most notably the work of François Boucher and other practi-

tioners of the Rococo, a highly decorative, eighteenth-century style that became newly fashionable in both the fine and applied arts at the turn of the twentieth century. Like many of Boucher's alluring bathers, Pissarro's model leans ever so slightly toward the viewer, apparently unaware that she is being observed.

With its thickly textured, iridescent brushwork, *Woman Bathing Her Feet* stands among Pissarro's most accomplished late works. He brilliantly rendered the play of light on the water's gently rippling surface, an effect that seems to capture the woman's eye, momentarily distracting her. Sun also strikes a patch of grass just behind the figure, where Pissarro created a shimmering spray of vibrant greens and radiant yellows. To

the right, a pair of temporarily discarded shoes with deftly sketched, cobalt-blue ribbons constitute a colorful, informal still life.

Pissarro probably never witnessed this scene, but rather concocted it with the help of a local farm girl as his model. The composition of *Woman Bathing Her Feet* developed over a long period, during which the artist produced numerous related drawings, prints, and smaller oil paintings before executing the large canvas, which itself reveals numerous *pentimenti* (or visible alterations), especially in the figure's pose. Ambitious in its scale and intricate in its surface, this work illuminates Pissarro's ever-evolving methods and goals.

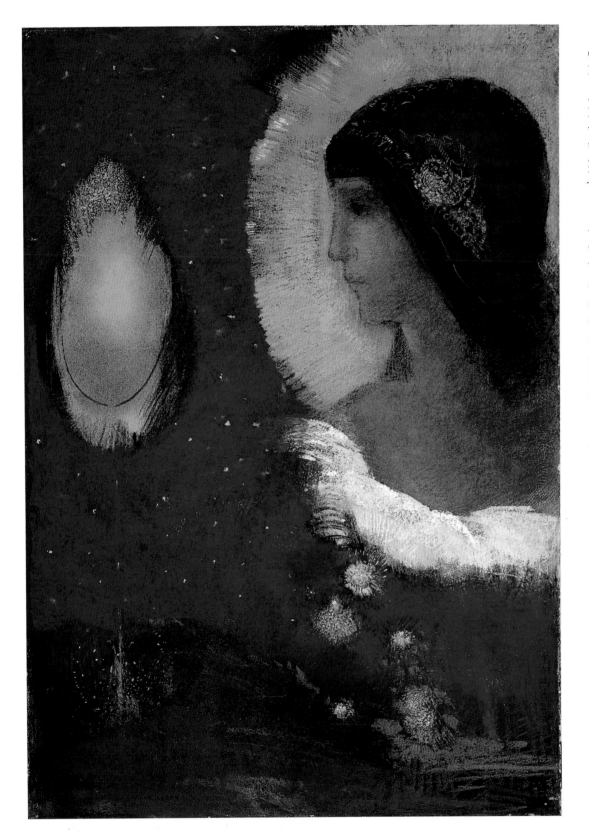

Odilon Redon
French; 1840–1916

Sita, c. 1893
Pastel with touches of black conté crayon over various charcoals on cream wove paper, altered to a golden tone
53.6 x 37.7 cm (21¹⁄₁₆ x 14¹³⁄₁₆ in.)
Joseph Winterbotham Collection, 1954.320

Although he participated in the last Impressionist exhibition, held in Paris in 1886, Odilon Redon was linked more closely with the poets, writers, and painters known as the Symbolists. These artists distinguished themselves from their Realist and Impressionist predecessors by seeking subjects in the realm of the imagination rather than in the physical world. Disillusioned by the materialism he saw in contemporary society, Redon experimented with a range of religious iconography in search of symbols that, as he put it, "still move the hearts of an innumerable part of mankind." The subject of this pastel for example is drawn from a Hindu tale. Sita is the devoted and beautiful wife of King Rama, hero of the Hindu epic *The Ramayana* and one of the myriad incarnations of the god Vishnu. In a fit of jealousy, Ravana, the lecherous ruler of Lanka, kidnaps Sita. While flying through the air in the course of her abduction, Sita manages to remove her dress and jewels, which she hurls down to earth to provide her husband with clues to her fate.

Sita is one of many *noirs*, or charcoal drawings, that Redon transformed through the addition of colored pastels. The original charcoal and aged paper are evident now only in the ovoid shape at the upper left, possibly a representation of the cosmic egg of Hiranyagarbha, from which, according to Hindu tradition, the universe was born. Redon wrote the following description of this work in his personal papers: "Her head in profile, surrounded by a golden-green radiance, against a blue sky, stardust falling, a shower of gold, a sort of undersea mountain below." These words—and the image itself—conflate air and water, ascent and descent, natural and artificial light, thus compelling the viewer to abandon objective reality and share in the artist's mysterious vision.

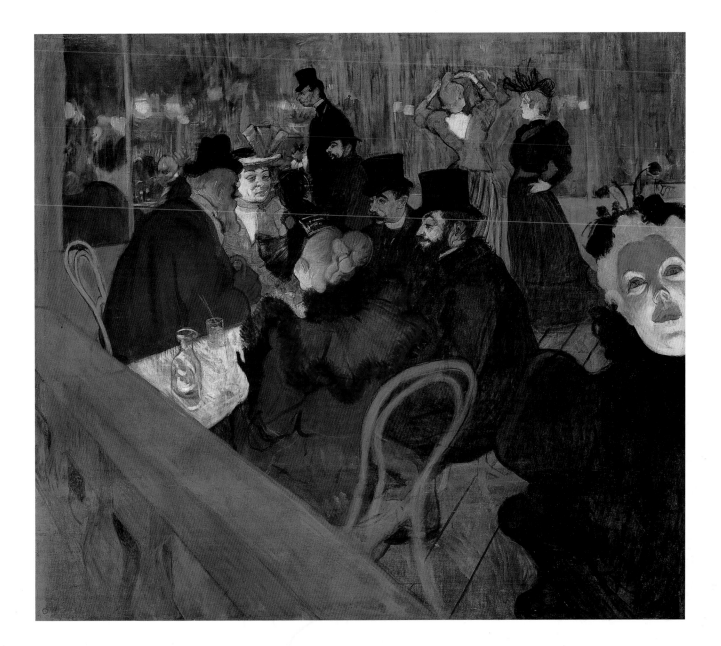

Henri Marie Raymond de Toulouse-Lautrec

French; 1864–1901

At the Moulin Rouge, 1892/95
Oil on canvas
123 x 141 cm (48⁷/₁₆ x 55½ in.)
Helen Birch Bartlett Memorial Collection, 1928.610

The dance hall known as the Moulin Rouge, which opened in 1889, was situated at the bottom of the Montmartre hill, in Paris. Larger and more accessible than the Moulin de la Galette (see p. 126), the Moulin Rouge attracted an adventurous, middle-class clientele, as well as members of the artistic avant-garde, all of whom relished its provocative performances and intoxicating sexual energy.

Henri de Toulouse-Lautrec early became as-sociated with the place. His *Equestrienne (At the Cirque Fernando)* (p. 114) hung above the bar in its foyer, and he produced promotional posters for it, in addition to many paintings featuring its per-formers and habitués. The Art Institute's canvas, one of Toulouse-Lautrec's most ambitious, is set on a balcony overlooking the dance floor. In the background, La Goulue, the Moulin Rouge's reigning dance star, adjusts her red hair, while the dwarfish Toulouse-Lautrec and his tall cousin, Gabriel Tapié de Céléyran, walk toward the left. Seated around a table is an oddly glum assem-blage: the writer Edouard Dujardin (disciple of Symbolist poet Stéphane Mallarmé), the enter-tainer La Macarona, the photographer Paul Sescau, the vintner Maurice Guibert, and another redhead, perhaps the entertainer Jane Avril.

At the Moulin Rouge was apparently cut down along the right and bottom after the artist's death, perhaps to moderate its radical composition. (It was restored sometime before 1924.) Edgar Degas's work provided precedents for Toulouse-Lautrec's eccentric point of view, with its oblique railing and "tilted" floor, and also for the bizarrely cropped figure at right, lit from below, who is probably another entertainer. Stylized, curving surface patterns suggest the influence of Paul Gauguin and the Nabis (see p. 121). But only Toulouse-Lautrec, with his acerbic line, acidic col-ors, and loose handling, could have conjured so vividly the mixture of disaffection and exhilaration typical of Montmartre's nightlife in this period.

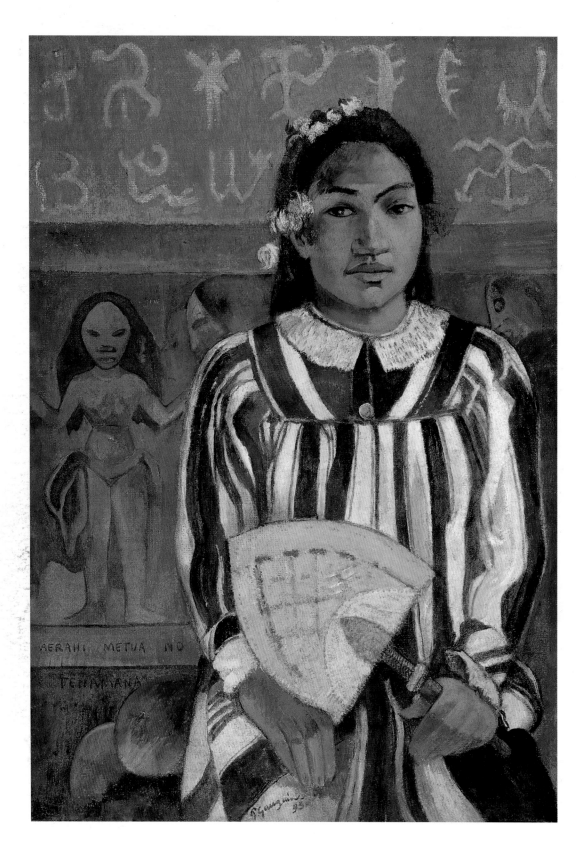

Paul Gauguin
French; 1848–1903

Ancestors of Tehamana (Merahi Metua No Tehamana), 1893
Oil on canvas
76.3 x 54.3 cm (30 1/16 x 21 3/8 in.)
Gift of Mr. and Mrs. Charles Deering McCormick, 1980.613

Paul Gauguin's restless search for a life of "ecstasy, calm, and art" took him twice to the French colony of Tahiti. During his first sojourn (June 1891–June 1893), he confronted the fact that the idyllic paradise he had imagined did not exist. Nevertheless, he searched for it in his art. The resulting works— based on the artist's quasi-ethnographic "documents," or drawings of local people and motifs, and on various books, prints, and photographs he had brought with him—are rich amalgams of European and Oceanic forms. Radiant portrayals of a tropical paradise, they are also poignant essays on the discrepancy, in an age of imperialism, between exoticist fantasy and indigenous reality.

 This portrait depicts Tehamana, Gauguin's young companion during much of this period, wearing a high-collared, "Mother Hubbard" dress of the sort imposed by missionaries on the local population. Her clothing is an obvious reference the pervasiveness of European influence, but her plaited fan, regal bearing, and elusive smile suggest Gauguin's desire for access to something more profound. Fascinated by Tahiti's mythic past but unable to find it in the present, Gauguin represented his sitter's "ancestry" with a variety of symbols. The painting's background consists of an assortment of enigmatic imagery, arrayed over three superimposed levels. At the bottom are two ripe mangoes, an allusion to the island's bounty and possibly to female fertility. In the middle section, the full-length figure of the local deity Hina, moon goddess and mother of the world, appears in a painted relief. The uppermost zone features two rows of yellow glyphs, inspired by tablets discovered in 1864 at Easter Island whose inscriptions—the only known traces of written language in Polynesia—remained undecipherable. Gauguin's analogous signs evoke both the richness and the ultimate inscrutability, to the European mind, of Tehamana's cultural heritage.

Henry Ossawa Tanner
American; 1859–1937

Two Disciples at the Tomb, c. 1905
Oil on canvas
129.5 x 106.4 cm (51 x 41⁷⁄₈ in.)
Robert A. Waller Fund, 1906.300

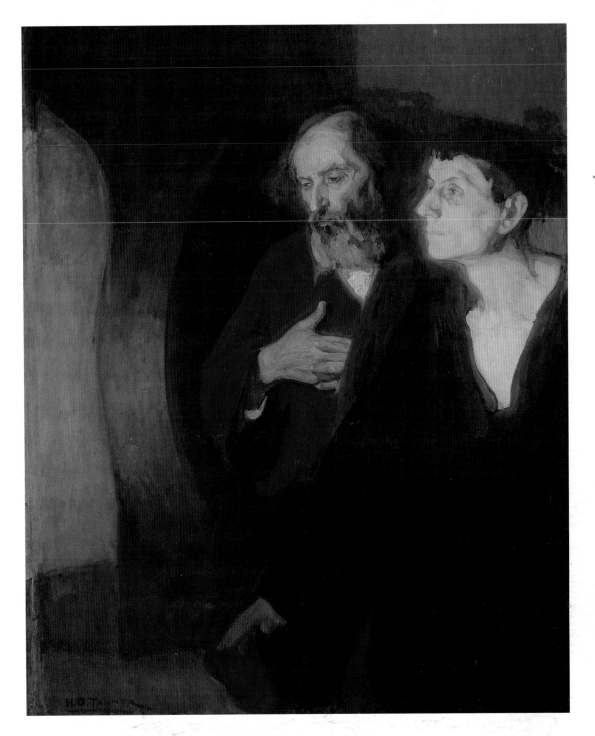

The reverent mood of Henry Ossawa Tanner's *Two Disciples at the Tomb* testifies to the painter's deeply held Christian beliefs. The son of a prominent minister of the African Methodist Episcopal Church, Tanner regarded his faith as central to his racial identity. Themes of salvation and resurrection held a particular poignancy for African Americans of Tanner's generation; while his father was a second-generation freedman, his mother had been born into slavery. Inspired by a passage from the Gospel of Saint John, *Two Disciples at the Tomb* depicts Peter and John as they view evidence of Christ's ascent into heaven: the empty tomb and a discarded linen shroud. By emphasizing the deeply personal nature of each man's response to the miraculous event, Tanner gave the religious subject a genuine human dimension, while at the same time presenting a reassuring allegory of promised redemption.

As a student at the Pennsylvania Academy of the Fine Arts, Philadelphia, in the 1880s, Tanner emulated the forceful Realism practiced by his teacher Thomas Eakins. His encounters with racial prejudice prompted him to leave the United States, and in 1891 he traveled to Paris to complete his education. There, Tanner's race proved to be less an obstacle to his success than it had been at home, and, although he never relinquished his American citizenship, he lived the rest of his life in France. By 1897, when he took a brief tour to Egypt and Palestine, Tanner had established an international reputation for his biblical imagery, prompting an American critic to hail him as the "Poet Painter of the Holy Land." Treating spiritual themes well into the twentieth century, Tanner responded increasingly to Symbolist currents, here using expressive brushwork and a restricted palette to establish an aura of mysticism.

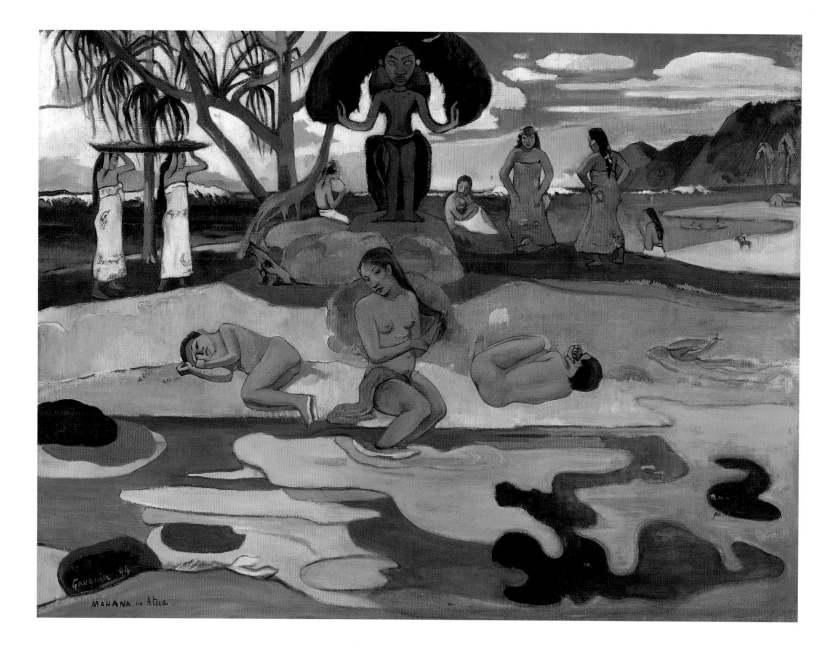

Paul Gauguin
French; 1848–1903

Day of the Gods (Mahana No Atua), 1894
Oil on canvas
68.3 x 91.5 cm (26⅞ x 36 in.)
Helen Birch Bartlett Memorial Collection,
1926.198

Paul Gauguin spent most of his final French so-journ (September 1893–August 1895) in Paris promoting his work. This fostered retrospection, and he set about writing and illustrating a fictionalized account of his Tahitian experiences, entitled *Noa Noa. Day of the Gods (Mahana No Atua)*, one of very few paintings completed during this period, is closely aligned with Gauguin's contemporane-ous literary projects. Intimate in scale but monu-mental in conception, it is his attempt to synthe-size all that he had learned and achieved in the South Seas. He also intended here to demonstrate that he could hold his own against Pierre Puvis de Chavannes's mural paintings (see p. 120), Georges Seurat's *Sunday on La Grande Jatte—1884* (p. 79), and recent work by the Nabis (see p. 121).

Set in a Tahitian landscape by the sea, the composition is divided into three horizontal bands. At the top, people perform ritual actions near a towering idol, which, like many figures in Gauguin's Tahitian images, derives from photo-graphs the artist owned of carved reliefs adorning the Buddhist temple complex at Borobudur (Java). In the middle band, three symmetrically disposed nudes stand out against a field of pink earth. The woman in the center, formally linked to the idol above, plays with her hair and dangles her legs in a pool. She is flanked by two sleeping figures of ambiguous gender. The lower portion of the composition is devoted to an evocation of water so stylized as to defy the laws of representa-tion. With this frieze of amorphous, organic shapes in brilliant, contrasting hues, Gauguin posited color as "the language of dreams" (to quote a later text by the artist), or the primal essence of visual communication—a notion that was to resonate through the history of abstract painting.

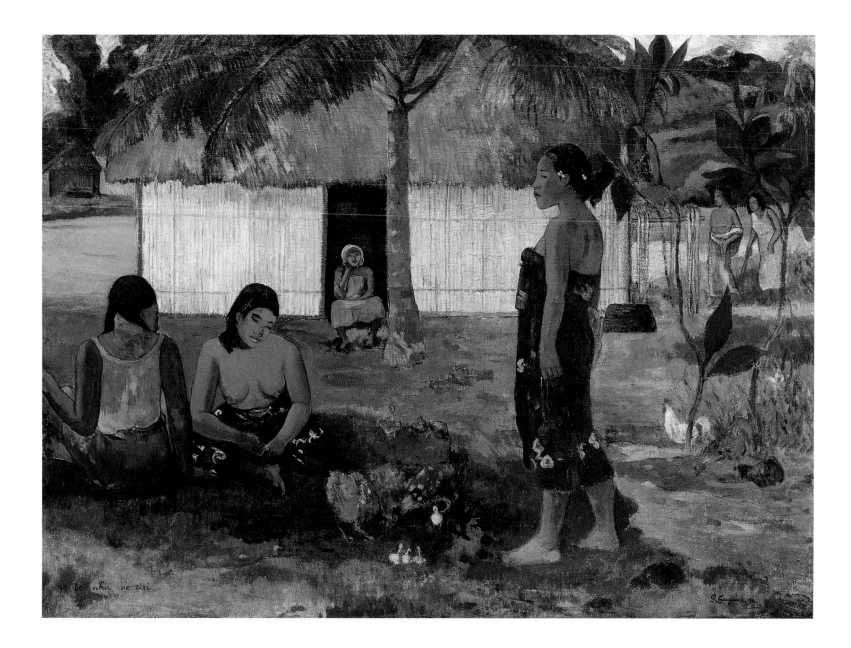

Paul Gauguin
French; 1848–1903

Why Are You Angry? (No Te Aha Oe Riri), 1896
Oil on canvas
95.3 x 130.5 cm (37½ x 51⅜ in.)
Mr. and Mrs. Martin A. Ryerson Collection,
1933.1119

Why Are You Angry? (No Te Aha Oe Riri) is one of six large canvases of identical dimensions that Paul Gauguin painted during the first months of his second Tahitian sojourn (1895–1903). Like the other works in the group, it exhibits a compositional amplitude and chromatic subtlety that were new to the artist's work. One senses here the examples of Pierre Puvis de Chavannes (see p. 120)

and Georges Seurat (see p. 79) behind Gauguin's assured disposition of figures in space.

Gauguin based *Why Are You Angry?* on a painting from his first Tahitian sojourn (1891–93), *The Big Tree (Te Raau Rahi)* (1891; Cleveland Museum of Art and anonymous collector), but in the Art Institute's canvas, the figures are more prominent. The interrogative title invites narrative readings, but the composition itself resists definitive interpretation. We are probably meant to associate the question with the pouting, bare-chested woman in the foreground; perhaps it is being posed by her companion. These languorous, young women—there are no men in the picture—sit on the ground in front of a thatched house of mysterious character. Its prominent,

black door, a void "guarded" by an older woman, may be an oblique sexual allusion. The proximity of two hens and several chicks to the brooding figure, together with the latter's milk-heavy breasts, suggests that recent motherhood is the cause of her discontent. Perhaps she is jealous of the woman standing at right, whose elegance and serene self-satisfaction point to a sensual existence unfettered by familial obligations. This implied drama of frustrated desire is complicated by the presence of a pair of women in the right background, one of them young and nubile, the other old and bent. But even this evocation of physical decline does not solve the solve the picture's riddle, which seems to have been carefully devised by Gauguin.

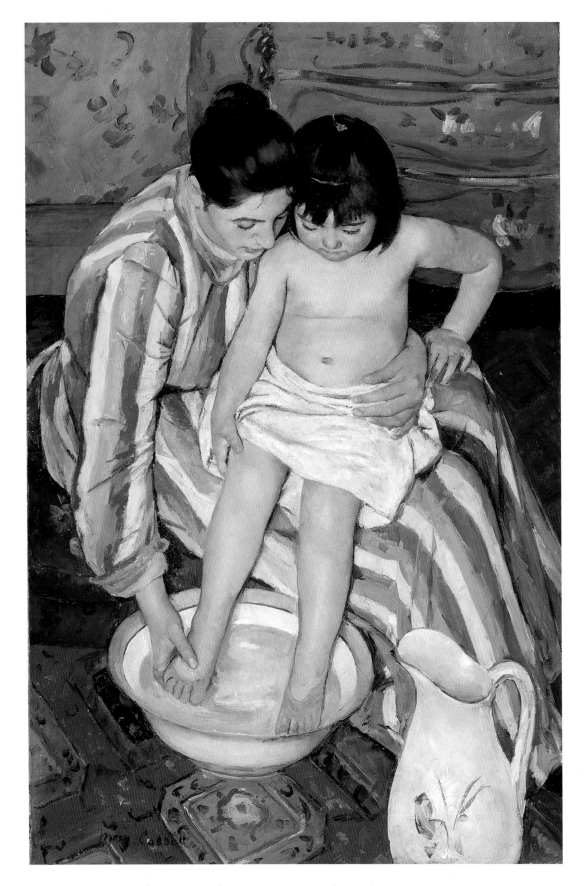

Mary Cassatt
American; 1844–1926

The Child's Bath, 1893
Oil on canvas
100.3 x 66 cm (39½ x 26 in.)
Robert A. Waller Fund, 1910.2

Created in an era that romanticized maternity, Mary Cassatt's images of women caring for children display remarkable honesty. Cassatt relied upon keen observation, rather than idealization, to portray a relationship built upon nurturing care and innocent trust. In *The Child's Bath*, the woman's gestures—one firm hand securing the child in her lap, the other gently caressing its small foot—are fully natural and routine, but they also communicate her tender concern for the child's well-being. In response the child is quiet and calm, assured in an embrace of maternal care and competence. Rather than glance at each other, the two figures gaze in the same direction, looking together at their paired reflection in the basin of water. Wrapped in a moment of mutual absorption, they seem to exist as a single entity.

Cassatt always identified herself as an Impressionist. She exhibited with the group in the 1870s and 1880s, and more importantly shared her colleagues' commitment to modern-life subjects. Her point of view—derived from her experience as a genteel, upper-middle-class, American woman—provided a domestic counterpart to the more public imagery of cafés, street scenes, and horse races painted by Edgar Degas and other male Impressionists. In *The Child's Bath* and other works, Cassatt presented her own response to the enduring theme of the bather. However, if examples by Degas such as *The Morning Bath* (p. 124) or *The Tub* (p. 125) arguably provide voyeuristic glimpses of adult bathers caught unawares, Cassatt by contrast was protective of her subjects. Compressing the compositional space and utilizing a high vantage point, she established an aura of intimacy, while keeping the viewer at a respectful distance.

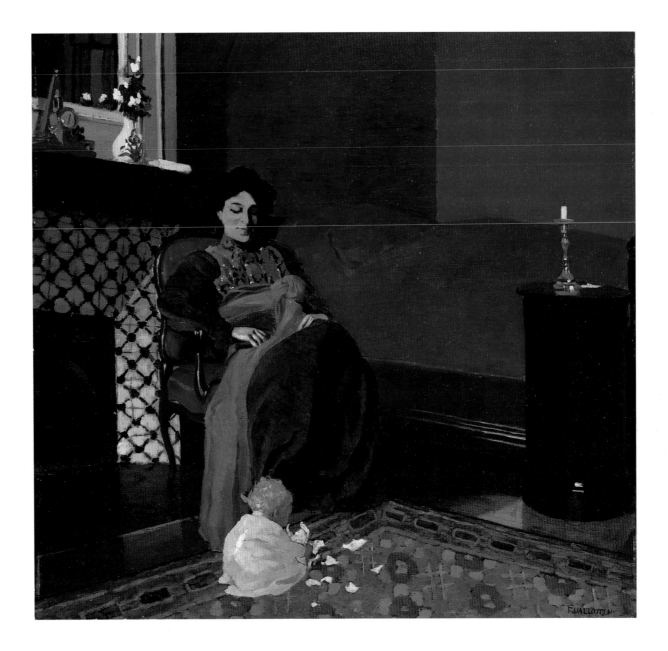

Félix Vallotton
French, born Switzerland; 1865–1925

*Madame Vallotton and Her Niece Germaine
Aghion*, 1899
Oil on cardboard
49.2 x 51.3 cm (19⅜ x 20⅜ in.)
Bequest of Mrs. Clive Runnells, 1977.606

Known primarily as a printmaker, particularly for the bold woodcuts of contemporary urban life he began publishing in fashionable illustrated journals in the 1890s, Félix Vallotton was also an accomplished painter of portraits and interiors. Moving to Paris from his native Switzerland in 1882, he enrolled as an art student in the prestigious Académie Julian. In 1892 he joined the avant-garde Nabis group—whose members included Pierre Bonnard, Maurice Denis, and Edouard Vuillard (see p. 155)—and began to practice a style known as Intimism, favoring domestic subjects and compressed compositions. Vallotton and the other Nabis were among the first artists who readily adopted the camera to document scenes that they would later paint; this surely influenced the formal structure of works such as this portrait, known to have been based on a photograph.

Executed late in 1899, the year of Vallotton's marriage to Gabrielle Rodrigues-Henriques, a widow with three children and the daughter of wealthy, retired Parisian gallery owner Alexandre Bernheim-Jeune, this work shows the artist's wife comfortably nestled in a chair. Vallotton painted the left side of the composition from a photograph he took of Gabrielle at the Château d'Etretat, where the couple had stayed that summer and autumn, making slight modifications. Gabrielle seems to gaze down at her young niece Germaine Aghion, crouched at her feet and scattering crumpled pieces of paper as if they were flower petals; these bright, white fragments stand out against the deep, warm hues of the carpet. In fact Vallotton added the child and the flat, tightly interlocking planes of rich colors that form the background to the independently conceived portrait of his wife, linking the two figures in an image of maternal tenderness that appears perfectly unified.

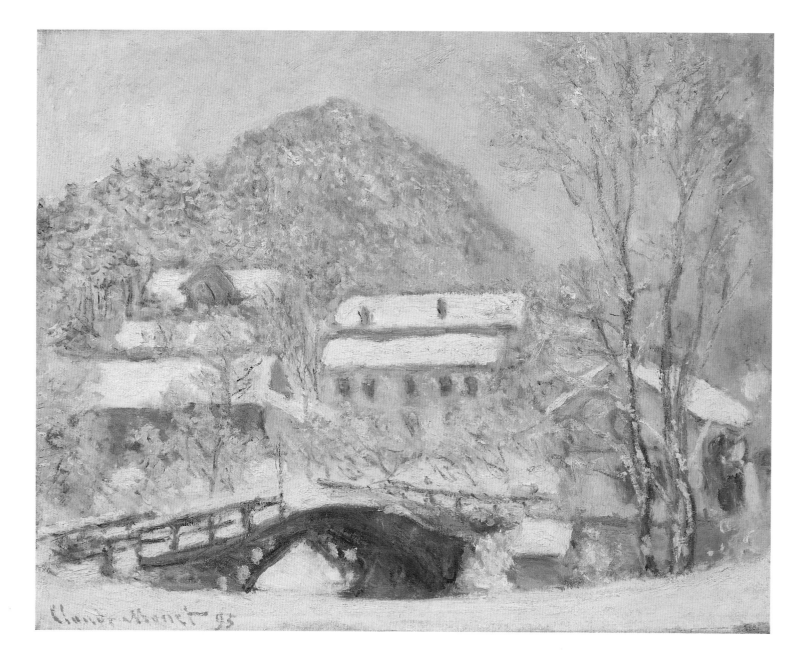

Claude Monet
French; 1840–1926

Sandvika, Norway, 1895
Oil on canvas
73.4 x 92.5 cm (28⅞ x 36⅜ in.)
Gift of Bruce Borland, 1961.790

In the 1880s, Claude Monet undertook several painting campaigns, some of them to extremely rugged areas (see p. 130). Although he traveled less in the 1890s, Monet was still curious about sites beyond the realm of his house and garden at Giverny. An unusual opportunity presented itself in February 1895: his stepson Jacques Hoschedé, who was married to a Norwegian

woman, had to go to Christiania (now Oslo) on business. Monet accompanied him, staying in Norway for two months.

Hoschedé took Monet to the fjordside village of Sandvika, about nine miles south of Christiania, where there was an artists' colony. There, Monet executed views of the village and of Mount Kolsaas. Although he was somewhat perturbed by the interest taken in him by local painters, he probably added to his celebrity by stubbornly insisting on working outdoors in the poorest of conditions. He wrote to a friend in Paris: "You would have laughed if you could have seen me completely white, with icicles hanging from my beard like stalactites."

Monet knew that he approached the Scandinavian landscape as an outsider, with an interest more visual than cultural or historical. Perhaps this distance allowed him a freedom he would not have felt in front of a French motif. He compared Norwegian scenery to that seen in Japanese woodblock prints, likening Mount Kolsaas to Mount Fuji; the silhouette of the peak in the Art Institute's painting, as well as the presence of a bridge in the foreground, are elements reminiscent of the Japanese prints Monet had been collecting for years. In *Sandvika, Norway*, Monet addressed the specific conditions of a northern winter, and also explored the universal appeal of landscape.

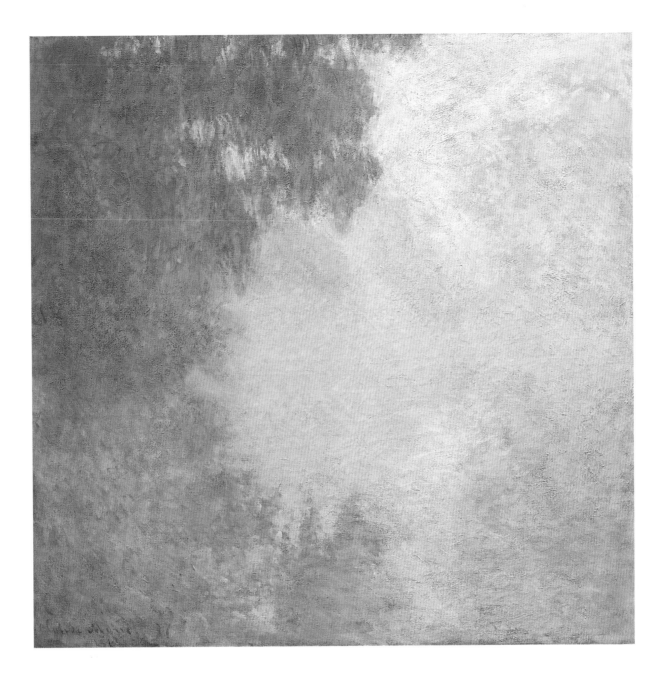

Claude Monet

French; 1840–1926

Branch of the Seine near Giverny (Mist), from the
Mornings on the Seine series, 1897
Oil on canvas
89.9 x 92.7 cm (35⅜ x 36½ in.)
Mr. and Mrs. Martin A. Ryerson Collection,
1933.1156

In the summer of 1897, Claude Monet began a
new series of paintings set around Giverny,
Mornings on the Seine. The motif is a riverbank
overhung with trees whose reflections shimmer
on the moving water; the time is daybreak. Monet
worked in a boat that he had equipped as a stu-
dio, accompanied by one of his gardeners, who
handled the canvases-in-progress, putting one
aside for another as the artist responded to chang-
ing light conditions.

Limiting his palette to a range of delicate,
matte lavenders, ivories, and greens, Monet also
restrained his brushwork. He established a hazy
atmosphere that dissolves the outlines of forms,
making it difficult to distinguish trees from their
reflections. Like all the paintings in the series,
Branch of the Seine near Giverny (Mist) is nearly
square in shape, a format that allowed the artist
to play with the concepts of symmetry and bal-
ance. For example the viewer intuitively under-
stands the presence of a horizon line separating
foreground from background, even though Monet
did not delineate it in paint; one senses the hori-
zontal axis of the canvas and interprets the cloud-
like masses of tone accordingly.

Thus, Monet worked on two kinds of illu-
sion, both of which would be central to his
slightly later paintings of the water-lily pond at
Giverny (see pp. 159, 163, 166): the equivalence of
object and reflection, and the tension between the
two-dimensionality of the canvas and the three-
dimensional space depicted on it. Looking back
respectfully to the idyllic riverscapes of his cele-
brated predecessor Camille Corot (see p. 17),
Monet—freeing his vision from naturalism and
narrative—also pointed toward abstraction.

Hilaire Germain Edgar Degas
French; 1834–1917

Breakfast after the Bath, 1895/98
Pastel on paper
93 x 81.9 cm (36⅝ x 32¼ in.)
A Millennium Gift of Sara Lee Corporation,
1999.365

Breakfast after the Bath exemplifies the astonishing
vigor, complexity, and richness of Edgar Degas's
late pastels, many of which—including this
sheet—were seen by no one until 1918, a year
after the artist's death, when thousands of works
that remained in his studio were auctioned.

Degas made this drawing in the last years of
the nineteenth century. His eyesight was failing,
and he had no patience with the art world, but he
continued to explore, almost compulsively, his fa-
vorite themes, one of which was the female toi-
lette. Probably tracing earlier drawings and
studying his own wax sculptures, rather than
sketching from a live model, Degas here depicted
a forceful nude in the act of climbing out of a
tub. The scene is frozen at the moment immedi-
ately preceding the bather's acknowledgment of
her maid, who approaches carefully bearing a
breakfast tray. Chromatic zones—the unmodu-
lated yellow of the dressing gown draped over a
chair, the red-and-pink fabric at the lower right,
the maid's blue dress—surround the central
figure. The artist's total concentration on the
woman's movement is reflected in the sketchiness
of her surroundings, which he indicated with
bold, gestural notations.

Breakfast after the Bath is certainly an intimate
image, but, at three feet tall, it is not small in
scale. The human figure, as always in Degas's
work, retains a monumental aspect. In his late
pastels, Degas brought to bear his formidable
knowledge of past and present art, aspiring to the
formal integrity of the Old Masters while also
achieving the decorative harmony of his younger
colleagues, the Nabis (see p. 155).

Edouard Jean Vuillard
French; 1868–1940

Interior with Pink Wallpaper I, 1899
Color lithograph on grayish-ivory laid chine
Image: 35.3 x 27.4 cm (13 15/16 x 10 3/4 in.);
sheet: 39.3 x 30.7 cm (15 7/16 x 12 1/8 in.)
Gift of Walter S. Brewster, 1936.198

In addition to executing large-scale, decorative projects (see p. 158), Edouard Vuillard experimented in the 1890s with much smaller works representing his domestic milieu. He composed these so-called Intimist images using simplified forms, dense patterns, and bright colors; it is often difficult to tell whether the decor reflects the mood of the people, or whether the inhabitants have absorbed the nuances of their surroundings.

Vuillard's interest in the Lithography Revival that was under way at this time was consistent with his openness to alternative materials and techniques. Moreover, the refined, limited-edition portfolio format suited the Intimist sensibility. In 1899, assisted by the expert printer Auguste Clot, Vuillard executed twelve color lithographs, published under the title *Landscapes and Interiors* and exhibited in the Paris gallery of Ambroise Vollard.

Interior with Pink Wallpaper I is one of three images in this series depicting the same room in the apartment Vuillard shared with his mother and sister. A dense, regular, floral pattern nearly covers the sheet, which might itself be a swatch of wallpaper—except for the fact that Vuillard shaped the pattern into a room by adding a molding that defines a corner at the top, interrupting the wall with a picture and an open doorway, and introducing a large chandelier hanging from the ceiling. In color lithography, tints are printed from separate stones, one at a time, in careful alignment. Vuillard employed five stones for *Interior with Pink Wallpaper I*, each an independent, abstract pattern that coalesces with the others into a complex yet legible image. The subtle, earthy pink of the wallpaper predominates, enlivened by touches of fresh, electric blue and lemon yellow—colors that one critic described as "marvelously transposed but always respectful of memory and life."

Claude Monet

French; 1840–1926

Waterloo Bridge, London, Gray Weather, 1900
Oil on canvas
65.4 x 92.4 cm (25¾ x 36⅜ in.)
Gift of Mrs. Mortimer B. Harris, 1984.1173

Claude Monet first traveled to London in 1870, to escape from the Franco-Prussian War that was devastating Paris at that time. He does not seem to have done much painting on that trip, but he did visit the city's museums. The atmospheric marine scenes of Joseph Mallord William Turner (see p. 15) particularly fascinated him.

Monet went back to London with the intention of painting in the fall of 1899. His seventh-floor suite at the Savoy Hotel had a view of the Thames River, with Waterloo Bridge and the factories of Southwark visible to the east, and Charing Cross Railway Bridge and the Palace of Westminster to the west. He spent six weeks executing quick studies with the intention of finishing them in his Giverny studio. He returned to the Savoy in February 1900 (this time staying on the sixth floor), and again in 1901. This nearly obsessive sequence of campaigns resulted in the largest series that the artist painted away from Giverny.

London's notorious fog captivated Monet, as is evident in *Waterloo Bridge, London, Gray Weather*. But the fog's industrial causes—coal-burning factories, boats, and other vehicles—no longer directly interested him. Now he was an observer of atmospheric effect, not a participant in a scene, as he had been when painting *Arrival of the Normandy Train, Gare Saint-Lazare* (p. 54) in 1877. Although smokestacks appear in the background of the Art Institute's London view and traffic moves along the bridge, these features may as well be poplars or poppies; their purpose is to catch the light and lend variety to the composition, and they are unified by the pervasive blue-gray of the air.

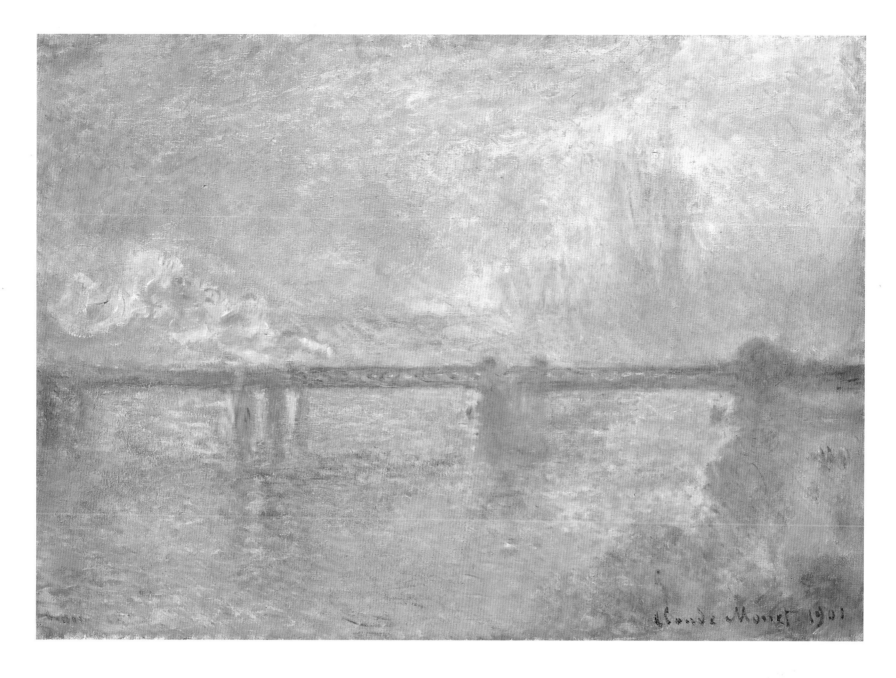

Claude Monet

French; 1840–1926

Charing Cross Bridge, London, 1901
Oil on canvas
65.4 x 92.4 cm (25¾ x 36⅜ in.)
Mr. and Mrs. Martin A. Ryerson Collection,
1933.1150

Claude Monet painted *Charing Cross Bridge, London* in 1901, during the last of three consecutive winter trips to the English capital (see also p. 156). The artist stayed on the sixth floor of the Savoy Hotel; looking to his right he could see the railway bridge running from Charing Cross Station and beyond it the neo-Gothic towers of the Palace of Westminster. The Art Institute's canvas reveals Monet's fascination with the golden light of early morning, filtered through London's characteristic fog, which is dispersed and transformed into veils of lavender-pink, lemon yellow, and powder blue. The overall mood is expansive, encompassing the past, as seen in the city's historicist architecture, as well as the present, represented by a speeding train.

While awaiting the arrival from customs of multiple crates of unfinished canvases from his previous London sojourns, Monet engaged in two activities that may have had an indirect effect on this and other paintings he took up subsequently: he read excerpts from the journals of the great Romantic painter Eugène Delacroix, and he made pastels of Thames motifs from his hotel-room window. Perhaps Delacroix's belief in the expressive potential of color, together with the soft, matte quality of pastel pigments, helped Monet to conceptualize and achieve this poetic yet energetic depiction of a city that had fascinated him for decades.

Edouard Jean Vuillard
French; 1868–1940

Landscape: Window Overlooking the Woods, 1899
Oil on canvas
249.2 x 378.5 cm (96⅛ x 149 in.)
L. L. and A. S. Coburn, Martha E. Leverone, and
Charles Norton Owen funds, and anonymous
restricted gift, 1981.77

Edouard Vuillard, Pierre Bonnard, and Maurice
Denis—members of a group of vanguard artists
called the Nabis—were responsible for the revival
of decorative painting in France at the end of the
nineteenth century. Their aim was twofold: to
redefine the artwork as an arrangement of line
and color that could function as a visual equiva-
lent for nature, ideas, and emotions; and to re-
store painting to its traditional role as an integral
element in an interior.

An extremely versatile artist, Vuillard pro-
duced lithographs (see p. 155) and created designs
for porcelain, stained-glass windows, stage decors,
and book illustrations, in addition to executing
oil paintings. He also received important commis-
sions from members of his social circle for large-
scale canvases to decorate the interiors of their
urban apartments. *Landscape: Window Overlooking
the Woods* is one of a pair (the other is in the
Norton Simon Museum, Pasadena) painted for
the wealthy Parisian banker Adam Natanson.

Here, Vuillard played with the traditional de-
scription of an easel painting as a "window onto
the world," redefining the viewer's relationship
with the landscape realm and composing the
scene so that the bottom edge of the canvas repre-
sents a window frame. The borders on the other
three sides evoke the festoon motif that com-
monly appears along the edges of late sixteenth-
and early seventeenth-century tapestries. Vuillard's
muted palette also links this modern mural to
tapestry traditions, while its ambitious scale
reflects the artist's experience with theatrical de-
sign and panoramas. Although Vuillard simplified
his forms and organized them into a series of hor-
izontal bands, he retained a belief in direct obser-
vation of nature. *Landscape: Window Overlooking
the Woods* represents a real place, the area around
Etang-la-Ville, a suburb west of Paris where
Vuillard often visited his sister, Marie, and her
husband, the painter Ker Xavier Roussel.

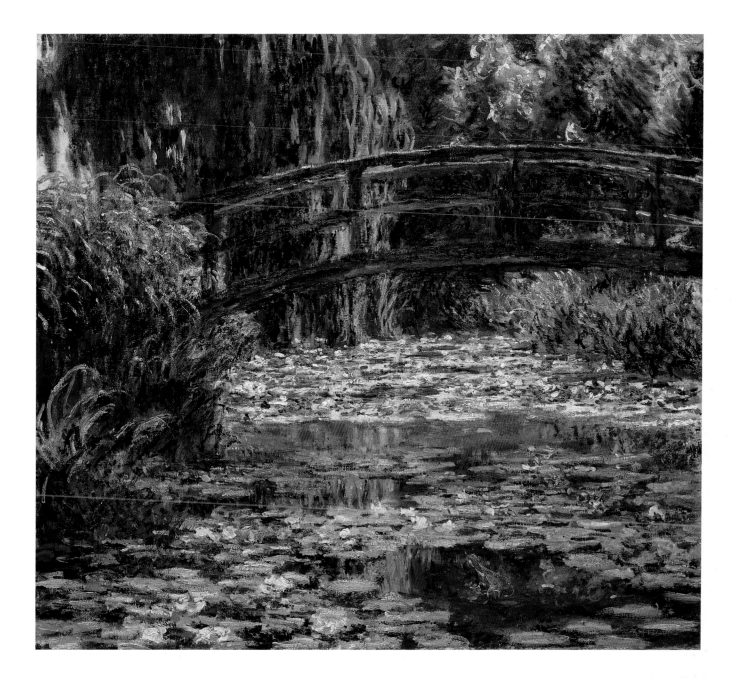

Claude Monet

French; 1840–1926

Water Lily Garden, 1900
Oil on canvas
89.9 x 100.1 cm (35⅜ x 39⅜ in.)
Mr. and Mrs. Lewis Larned Coburn Memorial
Collection, 1933.441

In the 1890s, Claude Monet dedicated himself to designing an ideal natural environment around his farmhouse at Giverny. In one part of the property, he created a water garden by diverting a tributary of the Epte River. The curvilinear pond, planted with water lilies and surrounded by weeping willows and other trees, reeds, and irises, is

crossed at its narrowest point by a Japanese footbridge (built in 1893). Monet's goal was to cultivate beautiful motifs for his art, and indeed his garden would be his primary subject for the last twenty-five years of his life.

Monet began to paint what he referred to as "water landscapes" in 1899. Many of the works from this initial series, including the Art Institute's canvas, represent the footbridge, the design of which derived from a Japanese print in the artist's collection. In this view, water lilies cover most of the pond's surface, so that only small areas capture reflections of the surrounding trees. The scene is detailed and even claustrophobic, as if Monet felt compelled to examine every aspect of

his newly created environment: the feathery texture of dangling willow branches, the dull sheen of lily pads, the fluffy, white-and-pink petals of blossoms, the murkiness of the water. The bridge, echoing the horizon line, helped him to organize all these observations into a nearly square, symmetrical composition that is both a decorative pattern of colors and a representation of nature. The strokes of thick paint on the surface of the canvas seem as moist, variegated, and intricately entwined as the plants themselves. The viewer, like the artist, is enclosed in a lush, sultry world that engages all the senses.

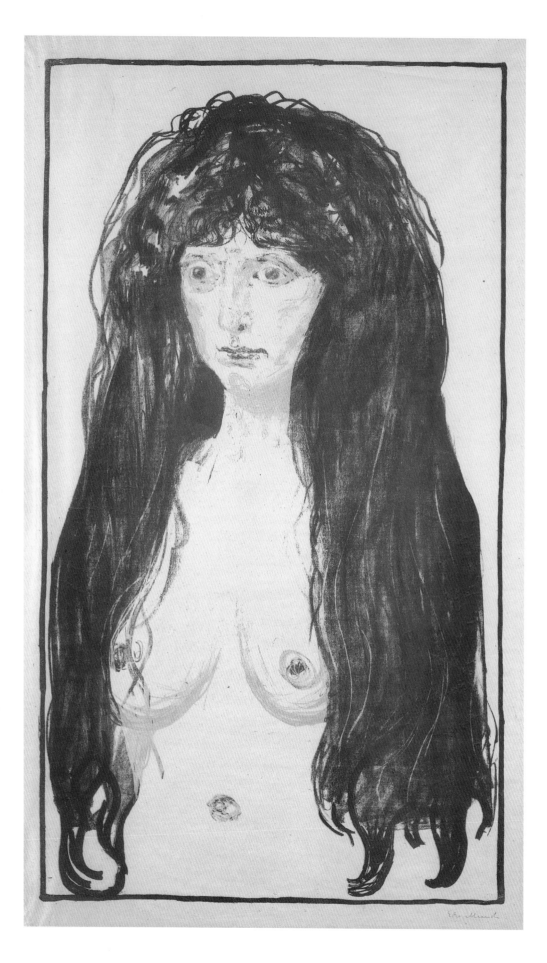

Edvard Munch

Norwegian; 1863–1944

The Sin, 1901
Color lithograph on paper (second state)
77.7 x 48 cm (30 9/16 x 18 15/16 in.)
Robert A. Waller Fund, 1950.1457

A prolific artist who spent most of his time in Paris and Berlin during the 1880s and 1890s, Edvard Munch took up printmaking in 1894. He quickly produced a large and accomplished body of work, particularly in the medium of color lithography, of which *The Sin* is an outstanding example. Printed in three colors, this image is notable for the extraordinarily subtle overlapping of tones, especially in the detailed features of the model's face and in the tresses of hair that fall over her right breast. To achieve this effect, Munch executed an initial drawing on lithographic stone and transferred it to two additional surfaces, one for each color; then he printed the three in precise registration. For the second of four states, shown here, the artist reworked the brown-red stone by incising sinewy lines in the figure's long, red hair, and by using tusche (a greasy, liquid drawing medium) to emphasize its curls.

Thought to be a portrait of Tulla Larsen, with whom Munch had a troubled affair that would end the following year, *The Sin* demonstrates the artist's longstanding infatuation with the *femme fatale*. Simultaneously threatening and alluring icons of femininity such as this appear frequently in Munch's work and have often been interpreted as emblematic of his failed relationships. The symbolic content of *The Sin* may be both general—in terms of Eve's original sin—and personal. When he was a young boy, Munch suffered the devastating loss of both his mother and older sister to tuberculosis. His fanatically religious father perceived these terrible misfortunes as "God's punishing illnesses," instilling fears in his son that would remain with him throughout his life.

Auguste Rodin
French; 1840–1917

The Walking Man, 1900
Bronze
84.1 x 27.3 x 59.1 cm (33 ⅛ x 10 ¾ x 23 ¼ in.)
Bequest of A. James Speyer, 1987.217

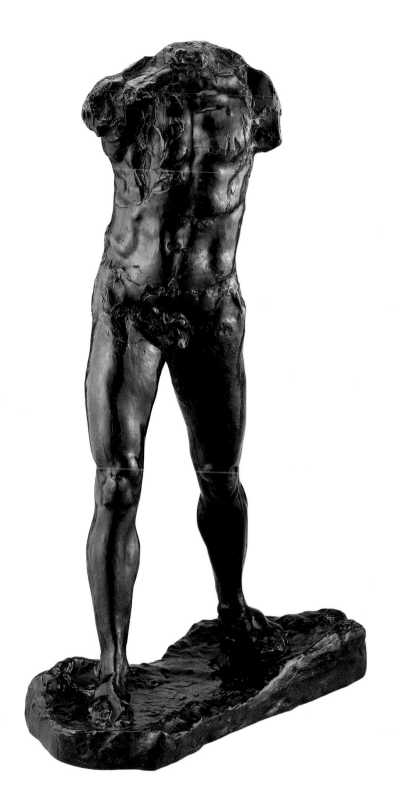

A major achievement in the history of modern sculpture, Auguste Rodin's *Walking Man* is unusual for its radically fragmented human anatomy: both the head and arms are absent, and portions of the back and buttocks are deeply gouged. Such disfigurements are marks of the artist's creative methods, records of studio accidents that reveal the work's transition from plaster to bronze. Rodin's deliberate disavowal of the refined execution and polished veneer of classical sculpture was decisively innovative. Moreover, it parallels many key aspects of Impressionist painting, including an emphasis on process and spontaneity.

The Walking Man, which developed over a period of more than twenty years, derives from Rodin's studies for *Saint John the Baptist Preaching*, a life-sized sculpture completed in 1878. The model for *Saint John* was a peasant from the Abruzzi region of Italy who, according to the artist, entered his Paris studio one morning in search of work: "He planted himself, head up, torso straight, at the same time supported on his two legs, opened like a compass," Rodin later recalled. "The movement was so right, so determined, and so true that I cried: 'But it's a walking man!' I immediately resolved to make what I had seen."

Rodin modeled separate plaster impressions of the torso and legs, and later unified these halves into a single bronze cast that he exhibited for the first time at the Salon of 1900. Although critics felt that the figure seemed too firmly posed to represent motion convincingly, Rodin defended the stance, arguing that the artist's task is to convey the overall "impression" of a physical act, not a conventional rendition or scientific analysis of it.

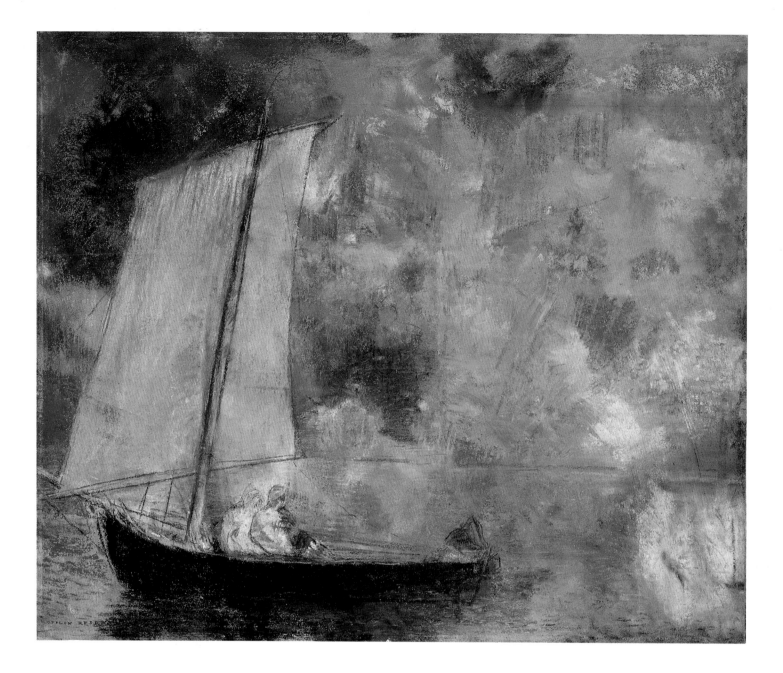

Odilon Redon
French; 1840–1916

Flower Clouds, c. 1903
Pastel with touches of stumping, incising, and
brushwork on blue-gray wove paper with multi-
colored fibers, altered to tan
44.7 x 54.2 cm (17⁹⁄₁₆ x 21⁵⁄₁₆ in.)
Through prior bequest of Mr. and Mrs. Martin A.
Ryerson, 1990.165

Upon completing this brilliantly colored pastel,
Odilon Redon recorded the following entry in
one of his notebooks: "A ship on a stretch of
water and under a sky whose clouds are like
flowers." Accordingly, he entitled the work *Flower

Clouds*. A spectacular mosaic of luminous hues,
the pastel marks the union of two previously dis-
tinct and important genres within Redon's
oeuvre—his floral still lifes and his mystical
paintings of boats—while simultaneously mark-
ing a bold foray into chromatic abstraction.

Around the turn of the twentieth century,
Redon, responding to the pressures of the market,
began to produce large quantities of brightly col-
ored, floral still lifes. Although this decision en-
tailed a certain thematic repetitiveness, the artist
did not abandon the esoteric iconography of the
Symbolists, with whom he had associated in the
1890s (see p. 144). Sharing their preference for
motifs that could evoke moral concerns and

emotional states, Redon focused on the boat as a
symbol for a spiritual journey, returning to it re-
peatedly in his pastels and paintings. In *Flower
Clouds*, a small skiff carries two hastily sketched
passengers over a calm sea or lake. The figures
seem to surrender themselves to fate, huddling to-
gether away from the rudder, relinquishing con-
trol of the vessel as they observe the spectacular
effects of the setting sun against the sky. Vivid
reflections of the "flower clouds" in the water
below create a visual echo, blurring the boundary
between illusionistic representation and abstract
patterning. Redon used similar strategies in the
decorative panels, screens, and tapestries that he
started making at around this same time.

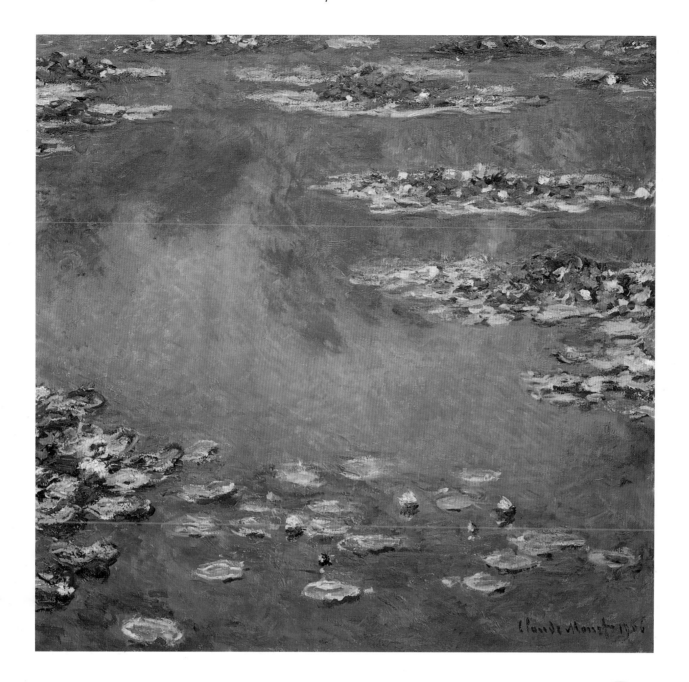

Claude Monet
French; 1840–1926

Water Lilies, 1906
Oil on canvas
87.6 x 92.7 cm (34½ x 36½ in.)
Mr. and Mrs. Martin A. Ryerson Collection,
1933.157

Claude Monet began to paint his water-lily garden at Giverny in 1899 (see p. 159) and continued to do so until his death in 1926. Over time he became less and less concerned with conventional, illusionistic pictorial space. By 1904 the horizon line of the "water landscapes," as he described them, had crept to the very top of the canvas, and by 1906, when he executed the Art Institute's *Water Lilies*, Monet had eliminated the horizon line altogether. No longer addressing the picturesque bridges and borders of the pond as his primary subjects, the artist fixed his gaze on the water's surface, which both mirrored the world above the pond and served as a window into the world within it.

This was a radical approach to painting. In a single, continuous, flat plane, Monet represented both sky and water, achieving an equilibrium on the pond's surface between the reflected forms of trees and clouds and the floating water lilies. Yet *Water Lilies* is not an abstract work, for the artist's connection with nature always remained paramount. Monet explained: "I applied paint to these canvases in the same way that monks of old illuminated their books of hours; they owe everything to the close union of solitude and silence, to a passionate and exclusive attention akin to hypnosis."

Monet struggled with his water-lily paintings, suffering from self-doubt, boredom, eye problems, and depression. In 1907 he destroyed at least fifteen images of the pond and canceled a show at Durand-Ruel's Paris gallery, in which they were supposed to appear. Fortunately, he spared the Chicago *Water Lilies*, including it in an exhibition of forty-eight paintings of the subject in 1909.

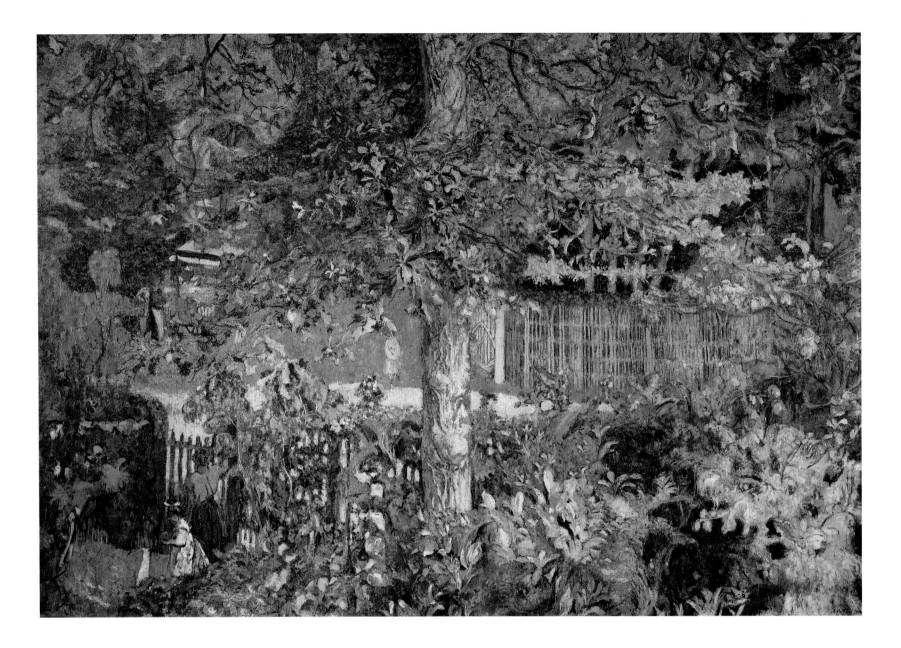

Edouard Jean Vuillard
French; 1868–1940

Foliage—Oak Tree and Fruit Seller, 1918
Distemper on canvas
193 x 284.8 cm (76 x 111½ in.)
A Millennium Gift of Sara Lee Corporation,
1999.373

Edouard Vuillard continually explored the decorative potential of painting, using a harmonious palette and graceful forms to convey a scene's emotional content without relinquishing the natural light and atmosphere so revered by his Impressionist predecessors. When he was only in his midtwenties, Vuillard was engaged in filling important commissions for large-scale, interior decorations (see p. 158). As he matured, he continued to work in this mode, making a quiet claim for its validity even while World War I raged across Europe.

Vuillard adapted his painting materials to meet his goals, inspired perhaps by other forms of decorative art such as tapestry and fresco. His medium here—distemper—is particularly interesting. Composed of powdered pigments and hot-glue binder mixed with water, distemper must be used while still warm, requiring the artist to work quickly and confidently. This difficult process yields colors that are matte and vibrant, as well as permanent. Vuillard prized this effect; he had first used distemper for theatrical scenery in the early 1890s, and after 1900 employed it almost exclusively for paintings of all kinds. He refrained from varnishing his works, in order to preserve their dry, opaque appearance.

In *Foliage—Oak Tree and Fruit Seller*, Vuillard took advantage of distemper's quick drying time, building up thick layers of paint that have an almost stuccolike texture. He established an interplay between this unusual surface and the intricacy of the composition, producing an image of illusionistic space and flat pattern. Originally installed in the Parisian dining room of the art dealer Georges Bernheim, this painting must have asserted the importance of beauty and peace after a time of conflict and anxiety.

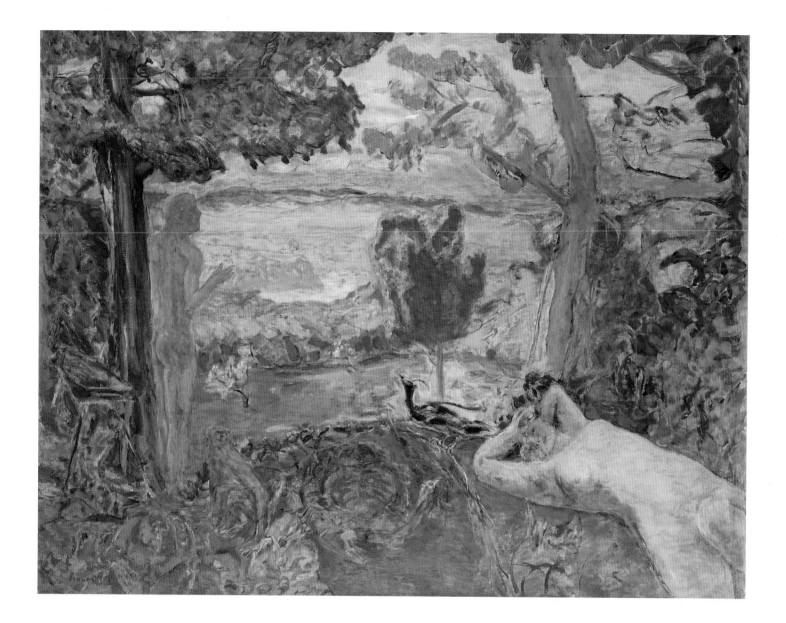

Pierre Bonnard
French; 1867–1947

Earthly Paradise, 1916–20
Oil on canvas
130 x 160 cm (51³/₁₆ x 63 in.)
Estate of Joanne Toor Cummings; Bette and
Neison Harris and Searle Family Trust endow-
ments; through prior gifts of Mrs. Henry Woods,
1996.47

In the 1890s, Pierre Bonnard became known for
small-scale, densely patterned, Intimist (see p. 155)
images of domestic interiors. In the twentieth cen-
tury, however, he reinvented his art, placing new
emphasis on bold forms, brilliant colors, and ex-
pansive space. While acknowledging a debt to
Impressionist investigations of light, Bonnard
wanted to go beyond a literal representation of
nature, in favor of more expressive hues and fan-
ciful compositions.

At the same time, Bonnard addressed several
narrative subjects that he had not previously ex-
plored, including the theme of the pastoral land-
scape seen in *Earthly Paradise*. Part of a cycle of
four decorative panels commissioned by the
artist's dealers Joseph and Gaston Bernheim, this
canvas (the other three are in a private collection;
Galerie Bernheim-Jeune, Paris; and the Museum of
Modern Art, Tokyo) functioned both as part of an
ensemble, harmonizing with furniture and other
art objects in a room, and as an independent work.

Here, the artist carefully framed the lush,
somewhat unruly garden with tree trunks and fo-
liage; balanced its warm yellows and browns with
cool blues, greens, and violets; and included
alongside the expected bird of paradise and ser-
pent the less conventional turkey and heron. A
more striking, odd note is the contrast Bonnard
established between the rigid figure of Adam, who
gestures with his right hand, and the langorous
form of the recumbent Eve. Perhaps the artist
wished to comment upon the conflicts that divide
the genders. Moreover, since he began the painting
at the height of World War I, he may have in-
tended to make an oblique reference to political
discord through the juxtaposition of light and
dark, the strange assortment of animals, and
Adam's tense posture. Thus, Bonnard's modern
depiction of a Garden of Eden is not without
its shadows.

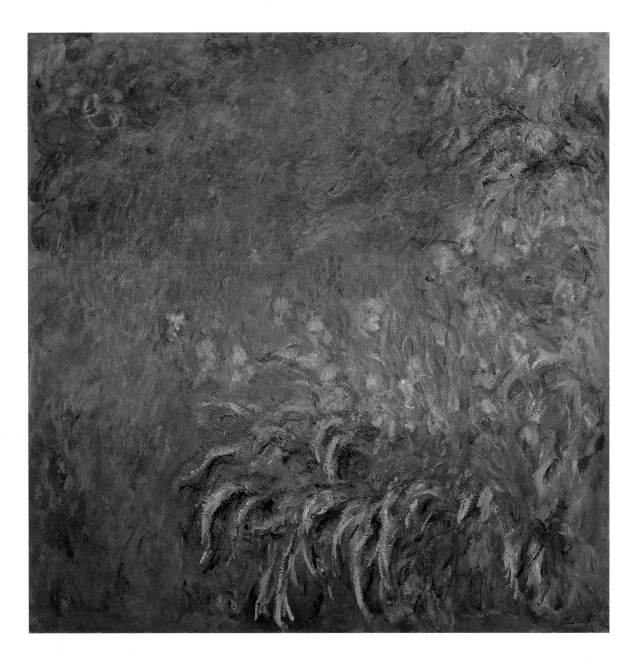

Claude Monet
French; 1840–1926

Iris, 1922/26
Oil on canvas
200 x 201 cm (78¾ x 79⅛ in.)
Purchase Fund, 1956.1202

Claude Monet's career extended well into the twentieth century. During his last decades, he was primarily engaged with painting his water garden at Giverny (see pp. 159, 163). His final project was an immense decorative ensemble of horizontal canvases that he imagined encircling a room in a continuous array. (Although the artist did not fully resolve the cycle before his death in 1926, the French government purchased several of the murals and installed them in the Orangerie, Paris, in 1927.)

Despite advancing age and failing eyesight, Monet worked indefatigably, at heavy easels installed by the edge of the pond and in his studio. Having eliminated the horizon line from his paintings of the water's surface (see p. 163), he concentrated on fragments, transforming their scale—*Iris* is over six feet square—and dispensing with the notion of three-dimensional space. The canvas is no longer a window, but rather a decorative surface.

Iris is a kind of study for the Orangerie murals, a close-up in which reflections and objects are not logically connected to one another. Monet formed the flowers and leaves of the iris plant with energetic, broad strokes of a pigment-laden brush; these marks fill the lower-right portion of the canvas, but do not establish a border between ground and water, instead becoming intertwined with the blues, greens, and browns that suggest reflections of sky, plants, and trees on the pond's surface. Forms disintegrate into patterns of texture and color, based on the artist's memories of the site as much as on observation. Monet never completed *Iris* and perhaps did not intend to. Thus, the painting's rough surface and constantly shifting perspective reveal the artist's struggle to push the boundaries of painting further than ever before, to a transcendent realm of pure visual sensation.

Index of Artists